DUE

Degas to Matisse

The Maurice Wertheim Collection

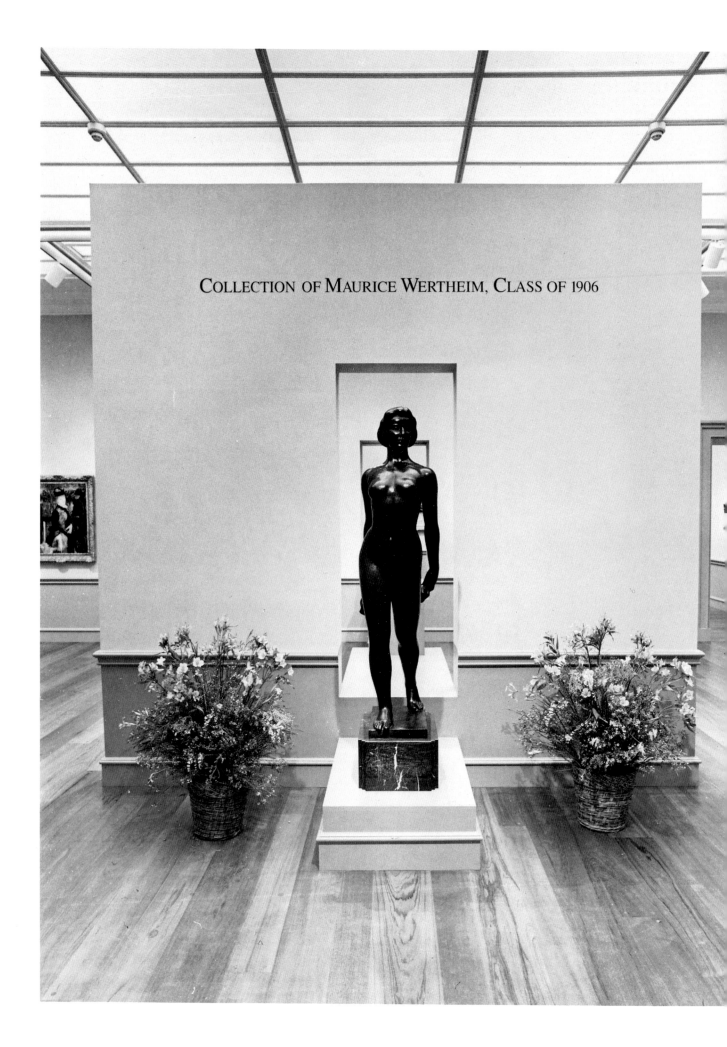

Degas to Matisse

The Maurice Wertheim Collection

John O'Brian

Preface by Barbara Wertheim Tuchman

and Anne Wertheim Werner

Harry N. Abrams, Inc., Publishers, New York

and the Fogg Art Museum, Harvard University Art Museums

Project Director: Margaret L. Kaplan
Editor: Mark D. Greenberg
Designer: Katy Homans

Library of Congress Cataloging-in-Publication Data

O'Brian, John.
 Degas to Matisse : the Maurice Wertheim Collection / John O'Brian.
 p. cm.
 Bibliography: p. 160
 Includes index.
 ISBN 0–8109–1138–8. ISBN 0–916724–65–4 (Fogg Art Museum : pbk
 1. Art, French—Catalogs. 2. Art, Modern—19th century—France—
 Catalogs. 3. Art, Modern—20th century—France—Catalogs.
 4. Wertheim, Maurice, 1886– —Art collections—Catalogs. 5. Fogg
 Art Museum—Catalogs. I. Fogg Art Museum. II. Title.
 N6847.03 1988
 759.4′074′01444—dc19 87–21933
 CIP

On the front cover:
Henri Matisse, *Geraniums* (cat. 28) [detail]

On the back cover:
Edgar Degas, *Grande Arabesque, Third Time* (cat. 38)

Picture reproduction rights for Henri Matisse, *Four Self-Portrait Drawings* (cat. 30–33, fig. 1) © 1988 S.P.A.D.E.M., Paris/VAGA, New York

Published with the support of funds provided by the National Endowment for the Arts, a Federal agency

A Times Mirror Company

Typeset in Monotype Walbaum by Michael and Winifred Bixler
Printed and bound by Amilcare Pizzi S.p.A., Milan

Contents

Foreword

Maurice Wertheim, a graduate of Harvard College (Class of 1906), approached the collecting of art with disciplined enthusiasm. Although he did not purchase a major painting until 1936, when he had already turned fifty, within two or three years he had made himself a major contender in the field. In the next decade and a half he succeeded in assembling one of the most remarkable and focused collections of modern European art in this country.

At his death in 1950, Maurice Wertheim bequeathed his collection to Harvard for "the benefit and use of the Fogg Art Museum." Since 1974 the collection has been permanently installed in the museum, where it has given pleasure and instruction to numerous students and scholars as well as to many visitors. In recognition of the importance of the extraordinary paintings and sculptures in the collection, the galleries where they are installed were completely redesigned in 1986 to provide a more spacious and congenial setting in which to be seen.

That this catalogue should be published now, not long after the reinstallation, is timely. The catalogue is the culmination of a long, concerted effort to produce a carefully researched and readable account of the Wertheim Collection. In this respect, the catalogue follows the example of other publications prepared by the Harvard University Art Museums on its collections in recent years. Notable among these is the volume on the Charles A. Loeser Bequest of old master drawings and volumes on the museums' collections of Arab and Persian paintings, works by Jean-Auguste-Dominique Ingres, sculpture by Antoine-Louis Barye, and the Straus collection of prints by Edvard Munch.

We are deeply indebted to John O'Brian, now of the University of British Columbia, who devoted a great many of his graduate student days at Harvard to his lively and thoroughly documented account of the collection and of the circumstances under which Maurice Wertheim put it together. We also wish to acknowledge with thanks the generous support of the National Endowment for the Arts and the enthusiastic help of Margaret Kaplan of Harry N. Abrams, Inc., which published his work in this handsome volume.

Edgar Peters Bowron
Elizabeth and John Moors Cabot Director
Harvard University Art Museums

Preface

Father assembled his superlative collection of Impressionist paintings and sculpture in the same style as he did most of his various activities —with vigorous enthusiasm and determination to achieve the best. From his mid-forties until his death at sixty-four, the collection was a central source of pleasure and enormous satisfaction to him.

The engine that drove him was the desire to play an active role in a variety of endeavors—cultural and intellectual, philanthropic and sporting—aside from the business of finance that was the substance of his career. The distinctive quality of his bent was its diversity, but MW, as friends and family called him, almost always wanted to be in a position to give the activity form and direction, to innovate and create. He was not by nature a subordinate, nor content with the second-rate. He searched for excellence and for undertakings that were first class of their kind.

Impressionism, in fact art in general, was not a youthful interest. MW began finding his own way early, leaving his father's business to join the investment banking firm of Hallgarten & Company. He was made a partner before he was thirty and within seven years took the risky step of leaving Hallgarten, to the concern of family and friends, to found his own firm of Wertheim & Company, which he headed for the rest of his life.

Father was a passionate fisherman, so much so that when his first grandchild was born, he announced that he had been awake all night figuring out how old he would be when the baby boy could take his first salmon, in order that he could teach him the fine points of the sport. Another passion was chess, a skill much practiced at the Manhattan Chess Club, and with chess-by-correspondence, which required agonizing waits for the next move to arrive by postcard. He did more than simply play; becoming president of the Club, he organized a chess team to compete with the USSR team and led it in person to Moscow, a daring and successful adventure.

Participating in Jewish affairs, MW was a trustee of the preeminent Mount Sinai Hospital and of the Federation of Jewish Philanthropies, and at a crucial time—1941–1942—president of the American Jewish Committee, the body of entrenched conservatives who possessed considerable prestige and power. Against the antagonism of many old friends and associates, MW prodded the AJC out of its rigid hostility to Zionism. He was able to turn it around to support the movement for statehood that was an answer to Hitler, probably the most difficult and historically the most important action of his career.

He had already undertaken two cultural exploits of some note. As small girls, we went with him to Broadway opening nights of productions presented by the Theatre Guild, of which he was a founder and director, along with five self-assured, strong-minded, and temperamental individuals. No one short of Julius Caesar could have

dominated these personalities—actress Helen Westley, director
Philip Moeller, stage designer Lee Simonson, father's fellow business-
man Lawrence Langner, and Teresa Helburn, who eventually took
over direction of the Guild. They met by turn in each other's homes,
and we can well remember the raised voices from the dining room
when they came to our house, the shrieks of argument and laughter,
and the often stormy departures as the choice of plays and performers
for the new season was being decided. Out of all that discord and
violent brouhaha—as it seemed to us eavesdropping children, for there
was something quite exciting about adults in such unbuttoned
behavior—they produced an outstanding record of the best theatre with
the best plays and performances in the land.

There was excitement of a different sort about MW's purchase
of *The Nation* magazine. Through association with Freda Kirchwey,
Mother's friend and *Nation* editor, Father became concerned at the
magazine's drooping fortune during the Depression, and he bought
it to enable it to continue with Freda in charge. He took on this new
and to him unfamiliar activity with an ability, unusual for a man
of his type, to seek out someone who could give him sound and
reliable advice and, what is more, to accept it. In this instance the
person was Alvin Johnson, president of the New School, for whom, as
a kind of universal teacher, MW had great respect, and he was glad
of his guidance through the thorny business of publishing a journal
of opinion.

In his accustomed active fashion, MW relished our Connecticut
home, where we spent summers and winter weekends. He fished in
the lake, supervised the farming, set up a model dairy and a chicken
coop, and one year he imported several flamingos and black swans,
having glimpsed their like in a European castle pond. He rode horse-
back with his wife and three daughters, setting a breakneck pace.

When his pace was slowed by some fundamental personal disrup-
tions, Father was advised to find a new interest. And he did.

He immersed himself in the art world, starting almost from zero.
With the same instinct for finding the right advisor, he sought out
Alfred M. Frankfurter, editor of *Art News*, an expert in the subject of
art. Frankfurter and others took the zealous student on a round of
galleries and museums at home and abroad. Bookcases were rear-
ranged to accommodate tall, heavy art books, talk was of auctions,
dealers, private showings. Soon Father focused his enthusiasm on the
French Impressionists . . . and the collection was underway.

Huge, crated canvases arrived at our terraced apartment on
East 70th Street in New York. There were intense conferences about
framing, hanging, lighting, and about next acquisitions. Friends were
impressed with each new purchase. MW's butler, Charles, a gentle-
man's gentleman right out of "Upstairs, Downstairs," speedily learned

Maurice Wertheim with his wife, Cecile, fishing on the Gaspé Peninsula in Canada.

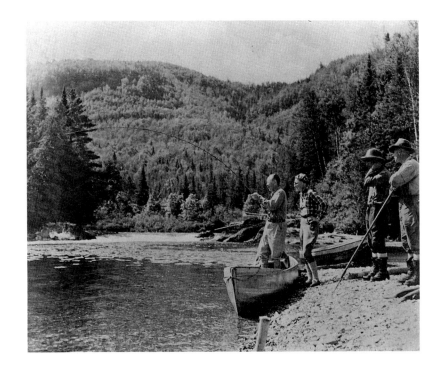

Maurice Wertheim taking his Irish hunter, Blarney, over the jumps at a horse show.

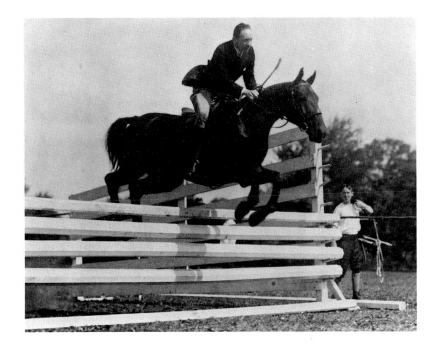

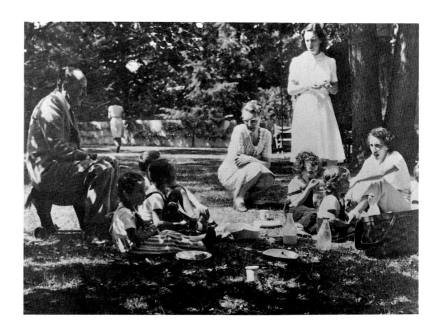

Maurice Wertheim with his daughters Barbara (standing) and Anne (sitting, at far right), and his granddaughters (from left to right) Lucy Tuchman [Mrs. David Eisenberg], Betsy Langman [Mrs. Budd Schulberg], Pamela Pomerance [Mrs. Henry Steiner], and Lynne Langman [Mrs. Philip Lillienthal]. In the center, kneeling, is Maurice Wertheim's wife, Cecile.

a store of anecdotes about the works to tell visitors whom he showed through the collection.

The three of us failed to provide much in the way of applause. Jo, the eldest, who died some years ago, was engrossed in starting married life; Barbara, already a journalist, was abroad and hardly noticed MW's new undertaking; Nan, with a teenager's untutored eye, was not impressed by breakfasting with Renoir's nude bather. Later, Father and youngest daughter had a mighty battle when she refused to get married under Picasso's Blue Period painting of a syphilitic mother and infant, which was hung over the fireplace, and he refused to take it down. The family lawyer resolved the deadlock with a diplomatic compromise—a smilax curtain draped over the painting to be removed instantly after the ceremony.

Father's new enthusiasm absorbed most of his nonbusiness time and dictated the way he lived. Most Saturdays he devoted to looking at art with his new wife, the former Cecile Seiberling, a knowledgeable art enthusiast in her own right. When the collection grew too large for the apartment, MW bought a capacious town house a few doors down the street, with high-ceilinged rooms to give the paintings needed space.

As his appreciation grew, MW determined upon acquisition of the Impressionists' finest works. With his own decisive taste and Frankfurter's guidance, the collection, always highly selective and never succumbing to the merely popular or well known, included original and exciting examples of each painter's and sculptor's art—van Gogh's *Three Pairs of Shoes*, Lautrec's *The Black Countess*, Degas's *Singer*

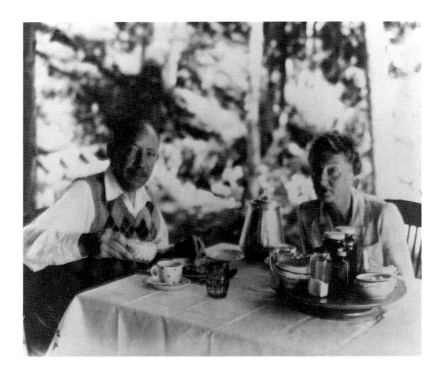

Maurice Wertheim and his wife, Cecile.

with a Glove—these and other works of equal quality give the Wertheim Collection its distinction.

MW had endless meetings and spent much thought on the ultimate disposition of his paintings and sculpture, bargaining hard with one museum or another for conditions that he thought appropriate. He was intent on keeping the collection together, believing it had more meaning as a group of works that complemented each other, and so turned a deaf ear to any institution that would have separated it or sold part of it, and just as firmly ignored all hints, suggestions, and outright pleas from members of his family who cherished fantasies of inheriting a favorite masterpiece. An ardent member of the Harvard Class of 1906, he was gratified to reach agreement with his alma mater as the collection's ultimate home, and surely, were he alive to do so, he would have enthusiastically written this preface himself.

Barbara Wertheim Tuchman
Anne Wertheim Werner

Acknowledgments

This catalogue has been a while in the making. The idea was, as best I can tell, first proposed in 1974 when the Maurice Wertheim Collection was installed permanently in the Fogg Art Museum, Harvard University, following the death of Mrs. Wertheim. The strength and focus of the collection argued for the publication of an up-to-date and well-documented catalogue of its contents. The only authoritative source on the collection was an exhibition catalogue prepared in 1946 by Frederick B. Deknatel, Agnes Mongan, John Rewald, and Frederick S. Wight—a publication long out of print. To remedy the situation, Seymour Slive, then Director of the Fogg Museum, organized a graduate seminar in 1976 in the Department of Fine Arts at Harvard from which it was hoped that a catalogue might emerge. Although the work of the seminar was never published, a great deal of valuable research by the students has found its way into this volume.

To Professor Slive and those students, therefore, I owe my first debt. The members of the seminar were Suzanne Barakoff, Sheila Bonde, Margaret Morgan Grasselli, Elizabeth ten Grotenhuis, Elenor Hight, Steven Naifeh, and John Spike. Margaret Morgan Grasselli, now at the National Gallery of Art, Washington, D.C., deserves particular mention for her continuing commitment to the proposed catalogue after the seminar had ended.

My second debt is to the writers of the first Wertheim catalogue. I have relied on their scholarship and have taken the liberty of quoting from their original entries (about half were the work of John Rewald) when I have felt that nothing I could say would make for any improvement. Miss Mongan and Professor Rewald have both taken a lively and solicitous interest in the present catalogue. In conversation and in correspondence, they have given me the benefit of their firsthand knowledge of Maurice Wertheim as a collector and have passed along information about particular objects in the collection and about when and under what circumstances they were acquired.

Members of the Wertheim family demonstrated an early enthusiasm for the project by providing information and offering suggestions. Maurice Wertheim's daughters, Barbara W. Tuchman and Anne Wertheim Werner, and his sister, Viola W. Bernard, are chief among those I should like to thank. I am also particularly grateful to two grandchildren: Betsy Schulberg and Pamela Steiner provided me with access to fascinating family papers and photographs in their possession. Among Maurice Wertheim's business associates, I received help from Frederick A. Klingenstein at Wertheim & Co., Inc., and William I. Riegelman at Fried, Frank, Harris, Shriver & Jacobson, New York. I am also indebted to Melissa Brown, M. Knoedler & Co., Inc.; Pierre Matisse, Pierre Matisse Gallery Corp.; Alexandre Rosenberg, Paul Rosenberg & Co.; and Mary McKenna, Wildenstein & Co., Inc., for answering inquiries about Maurice Wertheim's transactions with their galleries.

Librarians and archivists have responded patiently to repeated

requests for information. In Cambridge, I have used the Baker Library of the Harvard Business School, the Harvard Fine Arts Library, the Harvard Theatre Collection, the Harvard University Archives, the Manuscript Division of the Houghton Library, the Schlesinger Library, the Widener Library, and the Fogg Art Museum Archives. At the latter, which contains extensive correspondence and information relating to the Wertheim Collection, I benefited from the scrupulous ministrations of Phoebe Peebles and her assistant Abby Smith. Elsewhere, I have used the resources of the Archives of American Art, Smithsonian Institution; the Cone Archives, Baltimore Museum of Art; and the Frick Art Reference Library, New York.

Friends and colleagues at the Harvard University Art Museums have been generous and forbearing. Among the staff members, past and present, who have facilitated the production of the catalogue are Louise T. Ambler, William C. Ameringer, James B. Cuno, Maureen Donovan, Kate Eilertsen, Lisa Flannagan, Elizabeth Gombosi, Landon Hall, Caroline Jones, Mary Rose Maybank, Jane Montgomery, Michael Nedzweski, Konrad Oberhuber, Eric Rosenberg, Rick Stafford, Miriam Stewart, Diane Upright, Jeanne Wasserman, and Henri Zerner. I would especially like to acknowledge Peter Walsh for encouraging me to take up the project in the first place and then helping to see it through to completion. Most of all, I wish to express my gratitude to Marjorie B. Cohn and members (again past and present) of the Conservation Department, particularly Arthur Beale, Craigen Bowen, Pia de Santis, Sandy Easterbrook, Eugene Farrell, Teri Hensick, Richard Newman, Kate Olivier, and Carolyn Tomkiewicz. With a care and a deliberation that were exemplary, they reexamined the medium and condition of every object in the collection and condensed their findings in the admirable Technical Appendix.

Among the scholars and museum curators who have assisted me, I should especially like to thank Iain Boal, the Pumping Station Collective; Jean Sutherland Boggs, Ministry of Communications, Ottawa; Janet M. Brooke, Montreal Museum of Fine Arts; Claude Duthuit, Matisse Archives, Paris; Elisabeth Higonnet-Dugua, Cambridge; Vojtech Jirat-Wasiutynski, Queen's University, Kingston, Ontario; Michael Leja, Harvard University; Gary Tinterow, Metropolitan Museum of Art, New York; Paul Tucker, University of Massachusetts, Boston; and Alan Wilkinson, Art Gallery of Ontario, Toronto. In addition, three formidable readers offered comments on the manuscript: T. J. Clark at an early stage and Ann Blum and Theodore Reff at the end. I am grateful to all of them.

Finally, I should like to thank a string of Directors at the Fogg Art Museum: John Coolidge, Agnes Mongan, Seymour Slive, John Rosenfield, and Edgar Peters Bowron. All played a part in the preparation and production of this catalogue, and all supported the enterprise by their help and enthusiasm.

John O'Brian

Introduction to the
Maurice Wertheim Collection

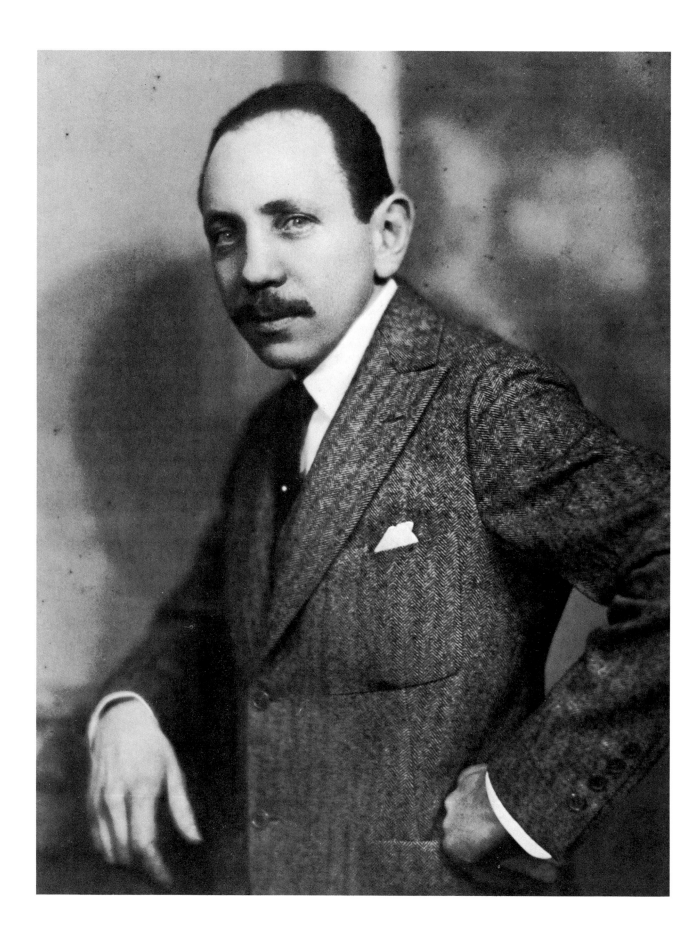

Introduction

. . . I would like to say a special word for Who's Who. *For one thing, it is likely to be accurate because its entries are written by the subjects themselves. For another, it shows them as they wish to appear and thus often reveals character and something of the times. H. H. Rogers, a Standard Oil partner and business tycoon of the 1890s, listed himself simply and succinctly as "Capitalist," obviously in his own eyes a proud and desirable thing to be. The social history of a period is contained in that self-description. Who would call himself by that word today?*

Barbara W. Tuchman
"History by the Ounce," 1965

When Maurice Wertheim wrote his first entry for *Who's Who* in 1928, he listed his occupation as "Banker." He was the senior partner of a singularly successful Wall Street firm, founded by him in 1927 and bearing his name. His self-description was, in the later words of his daughter, historian Barbara W. Tuchman, "obviously in his own eyes a proud and desirable thing to be."

However, Wertheim did not care to attach to himself the epithet used by H. H. Rogers in the quotation at the head of this page. The times in which he rose to prominence in America were not generally receptive to the swagger favored by the "capitalists" of the 1890s. Wertheim and his generation made their financial and cultural mark during the decades between the two world wars, when notions about free enterprise had changed from the days when H. H. Rogers and his colleagues such as Andrew Carnegie and J. Pierpont Morgan had dominated the scene, settled their remarkable bequests upon the nation, and passed on.

Wertheim's contributions to *Who's Who* are informative, but not nearly as informative as the accounts he wrote of himself for his graduating class at Harvard (1906). It was, and is still, the practice of each Harvard class to publish at regular intervals a yearbook of record for circulation among its members. Wertheim was a faithful contributor to these publications and took care with his submissions. There is every reason to suppose—again following Mrs. Tuchman—that in his reports he showed himself as he wished to appear. By the same token, his self-description evokes the social history of the period.

Wertheim's fullest report about himself was written in 1931, about five years before he began seriously to purchase art and about ten years before he began to formulate the idea of leaving an art collection, in memoriam, to his college. In that sense the report is peripheral to the main interest of this introduction. However, as a statement about what Wertheim thought had counted in his life up to that time, it makes compelling reading; and in a larger

Figure 1.
Bachrach, photograph of Maurice Wertheim, 1929. Collection of Barbara W. Tuchman.

sense, it is the necessary prologue to what follows. It is reprinted here in its original form:

Maurice Wertheim—1931 Report to the Harvard Class of 1906
Born: New York, N. Y., Feb. 16, 1886.
Parents: Jacob Wertheim, Hannah Frank.
Prepared at: Dr. J. Sach's School, New York, N. Y.
Years in College: 1902–06.
Degrees: A.B., 1906; A.M., 1906 (1907).
Occupation: Banker.
Married: Alma Morgenthau, New York, N. Y., 1909 (divorced 1929); Ruth White Warfield, 1930.
Children: Josephine Alma, 1910; Barbara, 1912; Anne Rebe, 1914.
Address: (home) 176 East 75th St., New York, N. Y., and Cos Cob, Conn.;
 (business) 57 William St., New York, N. Y.

During the twenty-five years since graduation, my work has been directed chiefly along three lines—business, the theatre, and certain public activities.

After graduation I tried my hand at publishing, then entered my father's company, the United Cigar Manufacturers Company, of which I was an officer for seven years. Finally, in 1915, I went into Wall Street, and, in 1919, became a partner in the investment banking firm of Hallgarten & Company. I remained a partner until 1926, and, in the following year, formed my own investment firm, known as Wertheim & Company, of which I am still the senior partner.

My chief outside interest during these twenty-five years has been the theatre. From the time of graduation until 1919, I was connected with various amateur theatre groups, whose activities culminated in 1919 in the New York Theatre Guild. Ever since its formation, I have been a member of the board of managers and active in its operations. Up to date the organization has produced over seventy-five plays. I have enjoyed the work very much, since it has more or less balanced the activities of a busy business life.

In 1913 I was appointed a member of the New York State Industrial Board, and served on that board for two or three years, chiefly engaged with my associates in drawing a new labor law for the state. During the war I worked with the war savings committee in Washington, and later went to Persia as finance member of the American Persian Relief Commission, under the leadership of the late Dr. Harry Pratt Judson, then president of the University of Chicago.

*I have traveled much, particularly in the Near East, and
in almost every European country, except Russia, which I am
hoping to visit very shortly, as I feel that no one should miss the
present opportunity of studying there one of the most interesting
experiments in the development of a new social order that has ever
been attempted.*

*As to recreation, my chief one is fishing—principally fresh
water fishing for trout and salmon. I can hardly remember any
month of May that I have not been on some trout stream or other,
and one of the favorite gibes of my friends is their reminder
to me that I was admitted to partnership in Hallgarten & Com-
pany on May 1, 1919, and that on the 8th of May I went on a
fishing vacation.*

*Sometimes, in a light moment, I say about myself that my
chief interests in life are banking, the theatre and fishing, but that
their importance to me is in the inverse of the order named* (HUA,
1931 Class Report).

Apart from the closing sentences, with their obligatory good
humor and self-effacement, there is nothing "light" or modest about
Wertheim's recitation of his achievements and interests. We are
struck, or should be struck, by the straightforward matter-of-factness
of his statements. Without doubt, here is an individual clear about his
identity and his accomplishments. There is no attempt to disguise the
ambition and energy with which he has pursued his principal interests.

The picture that Wertheim presents of himself is corroborated by
other evidence of his activities. When Eugene O'Neill needed a firm
decision from the New York Theatre Guild on the production of his
trilogy, *Mourning Becomes Electra*, he appealed by letter to Wertheim
for help in resolving an impasse—at the same time incorporating a
lengthy apologia of his dramatic intention in the plays (WFP, 15 June
1931). O'Neill clearly believed that Wertheim could be counted on to
provide the decisive action he needed. His appeal was not misdirected,
for at the time Wertheim was one-third owner of the Theatre Guild
and held himself responsible for reading all scripts submitted to it
for consideration.

Professor George Pierce Baker of Harvard also believed that
Wertheim, who had once been Baker's student, could be counted on
for decisive action in a matter involving American theatre. In 1924
Baker put forward a plan for the foundation of a drama department at
Harvard and the construction of an adequate theatre to stage his
pioneering productions. Wertheim agreed to organize a fund-raising
drive to see them launched (HTC, Wertheim to Baker, 10 January
1924). Along with Paul J. Sachs, a childhood acquaintance and by then
Associate Director of the Fogg Art Museum, Wertheim was a com-
mitted admirer of Baker's experimental work in American theatre.

However, President Abbott Lawrence Lowell rejected the proposals, brushing aside Baker's appeal and Wertheim's offer to help meet it. As a result, Baker departed the following year for Yale (Kinne, 1954, p. 247). Wertheim and Sachs, however, renewed a friendship that became significant for both when, some years later, Wertheim began to collect modern European art and asked Sachs for advice on acquisitions (FMA, Correspondence, 1922–1949). Their relationship was a major factor in Wertheim's decision to leave his collection eventually to Harvard.

The desire expressed in 1931 by Wertheim to visit the Soviet Union ("one of the most interesting experiments in the development of a new social order that has ever been attempted") was met in 1934. The experiment and the country fascinated him. At the end of the trip he wrote a long letter to his family. "It will seem strange," he wrote, "to get back to a capitalistic country and bourgeois society after having this experience and reading the Communist Manifesto of Karl Marx. It is certainly a shattering document! . . . I came here to see if people could get along without the profit motive. . . . I shall have to have the leisure of much thinking before it will all take shape" (WFP, 6 August 1934).

His subsequent thinking led him in 1935 to purchase the financially troubled *Nation*, the oldest liberal weekly in the United States. He had supported the *Nation* and its publisher, Oswald Garrison Villard, since the 1920s (HL, Wertheim-Villard Correspondence, 1928–1938). Within two years, he had largely set the magazine back on its feet by arranging for independent funding. He then sold it to Freda Kirchwey, who had helped arrange Wertheim's trip to the Soviet Union and who was pro-Soviet in her political convictions (SL, Wertheim-Kirchwey Correspondence). In the phrasing of Wertheim's press release, she was "one of the truest liberals in the country" (*New York Times*, 4 June 1937, p. 6).

Another consequence was a follow-up visit to the Soviet Union after the war. In 1946 Wertheim led the American chess team as its nonplaying captain (although not of championship caliber himself, he was reputedly a good player) against the Soviet team in Moscow. Wertheim conceived of the match as a gesture of political goodwill; the Russians won. "I thought it was up to the private citizens of this country," he reflected, "to do what they could to support the efforts of the State Department to encourage a relationship with Russia on a basis other than business or war. I'm afraid I didn't accomplish my purpose in a long-range way, but I did a lot at the moment" (*New Yorker*, 14 August 1948, p. 20). The short-run impact may be gauged in part by the fact that the matches were played in a huge hall before two thousand spectators, and that each move in the games was transmitted by telegraph to chess halls throughout the rest of the country. In response to Wertheim's overtures of friendship in his opening

Figure 2.
Maurice Wertheim, captain of the American chess team, addressing spectators at the opening of the U.S.–Soviet matches, Moscow, September 1946. Collection of Betsy Schulberg.

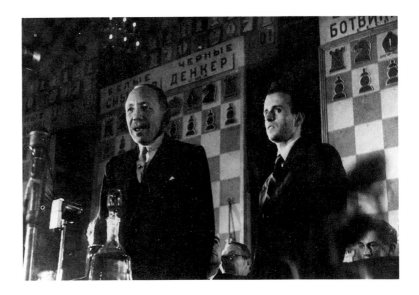

remarks on the first day (fig. 2), the *New York Herald Tribune* reported that "the cheers and shouts shook the rafters until [it seemed] the lid would come off the place" (28 September 1946, p. 13). Small wonder Wertheim felt he was accomplishing something, at least at the time, for Soviet-American relations.

By contrast, Wertheim's passion for fishing was played out in relative private. He derived particular pleasure from leading parties of friends to the Gaspé Peninsula in Canada to fly-fish for salmon at his "camp" on the Ste. Anne des Monts River. Even in this activity, however, he was disciplined. It is clear from the appreciative letters he received from visitors that his camp was one of the best appointed and equipped of its kind; and in case visitors misunderstood the seriousness of Wertheim's attachment to the sport, they could read the short book, *Salmon on the Dry Fly*, which he wrote and published, with illustrations by Ogden M. Pleissner, in 1948.

In short, Wertheim was the disciplined enthusiast of half a dozen interests, with the financial means and the capability to leave his mark on each of them. His commitment to collecting art was no exception. Although he did not purchase a major painting until 1936—just past his fiftieth birthday—he made himself a contender in the field within two or three years. By the time of his death fourteen years later, he had succeeded in assembling one of the most remarkable and focused private collections of late nineteenth- and early twentieth-century European art in the United States. It is this collection—forty-three paintings, drawings, and sculptures—that, under the terms of his will, was left to Harvard. And it is this collection that is catalogued here for the first time in full.

Among the works purchased by Wertheim are several that have been more extensively written about than the others. They are: *The Rehearsal* and *Singer with a Glove*, by Degas (cats. 2 and 3); *Skating*,

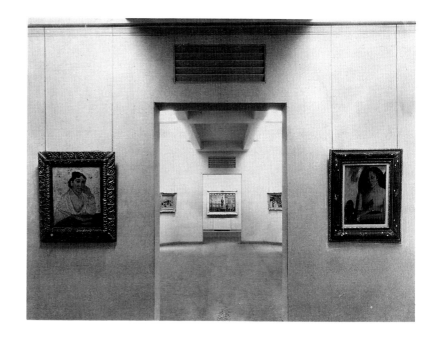

by Manet (cat. 11); *The Gare Saint-Lazare: Arrival of a Train*, by Monet (cat. 5); *Seated Bather*, by Renoir (cat. 8); *Still Life with Commode*, by Cézanne (cat. 17); *Self-Portrait Dedicated to Paul Gauguin*, by van Gogh (cat. 19); *Poèmes Barbares*, by Gauguin (fig. 3, cat. 20); and *Mother and Child*, by Picasso (cat. 24). It is not surprising, therefore, to find in the literature on Impressionism, Post-Impressionism, and early Picasso that these paintings have become standard points of reference. They highlight and crystallize major aesthetic achievements and issues; and for this reason several of them receive extended coverage in this catalogue, as well as consideration later in the introduction. The other works in the collection—by the artists mentioned above, as well as by Seurat, Toulouse-Lautrec, Guys, Pissarro, Rousseau, Matisse, Dufy, Bonnard, Despiau, and Maillol—are hardly less remarkable and have also received close attention in this volume.

The real story of Wertheim's activities as an art collector begins in 1935 when he moved to a new apartment in New York, the penthouse at 33 East 70th Street. The apartment spoke for the values of "streamlined modernity" and contained "not a sliver or stitch of the antique" (Frankfurter, 1946, p. 30). Nor did it contain original works of art. "When I first visited [the apartment] in 1934," wrote Alfred M. Frankfurter, editor of *Art News* and Wertheim's principal adviser and confidant on matters relating to art, "the rooms were hung exclusively with reproductions—large collotype facsimiles of the identical French nineteenth-century masters who are now represented on the same walls by not merely originals but monuments" (ibid., p. 30). Frankfurter's observation about the interior of the apartment coincides with the memories of members of the Wertheim family. But the family recalls more; namely (and Frankfurter left this out), that the reproductions were not even selected by Wertheim but by his oldest

daughter, Josephine, who was an accomplished painter. Presumably some space was reserved for her own paintings, and one must wonder what role she played in encouraging her father, a few years later, to begin collecting art.

We are told by Frankfurter that Wertheim was attracted above all to the art of the Quattrocento and then to the paintings of Dürer, Grünewald, and Cranach. He reportedly thought Masaccio's fresco cycle in the Brancacci Chapel, Sta. Maria del Carmine, Florence, the greatest work of art ever executed; he even wanted to commission, in fresco, a full-scale replica of *The Expulsion from Paradise* for the hall of his country house—also modern, like the interior of the apartment—at Cos Cob, Connecticut. But he held no illusions about being able to afford major original Quattrocento paintings, even if they were to be found. He knew very well that as a result of the programs of accumulation mounted by J. Pierpont Morgan and other American collectors before World War I, the Quattrocento was not a field in which he could hope to excel as a collector. At the same time, Frankfurter informs us, "his business sense told him to concentrate on a single epoch" (ibid., p. 31).

In deciding to collect French nineteenth- and early twentieth-century art, Wertheim placed himself in a growing company of American collectors. Aline B. Saarinen, in her near-contemporary account of art collecting in the United States, analyzed the shift of interest to modern French art that began after the First World War as almost inevitable: "The old-master market was dwindling. Their prices were high. The French 'modern' paintings were plentiful, and just expensive enough to be trustworthy. . ." (Saarinen, 1958, pp. 375–376). Saarinen had in mind a long list of American collectors active between the wars. Among them were Albert C. Barnes, Leigh Block, Robert Sterling Clark, Stephen C. Clark, Ralph Coe, Claribel and Etta Cone, Maud and Chester Dale, Mrs. David Levy, Sam A. Lewisohn, Duncan Phillips, Edward G. Robinson, several Rockefellers, John T. Spaulding, Carroll Tyson, and John Hay Whitney. Many of these collectors were well known to Wertheim. Also contributing to the shift in buying tastes toward modern French art was what Saarinen termed, one presumes with irony, a change in the nature of "dwelling units of the Collector Class." "The exodus from mansions," she continued, "to townhouses and to apartments meant smaller rooms and lower ceilings, a shift from ponderous English furniture to lighter French furniture, from Persian rugs to gray wall-to-wall carpeting, from dark, wood-paneled walls to pale, painted ones. In these new living quarters, English eighteenth-century portraits, such as those with which Huntington filled his California palace, were too large; tapestries ridiculous; and most old masters too dark. The French paintings—right in scale, light in hue and charming in Louis XV gold frames—seemed appropriate" (ibid., p. 376). Saarinen might

Figure 4.
Photograph of the living room of
Maurice Wertheim's townhouse,
43 East 70th Street, New York.

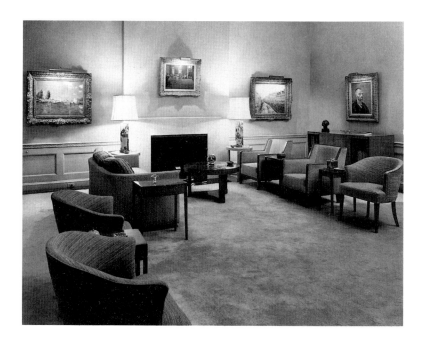

have been describing Wertheim's apartment at 33 East 70th Street or
the townhouse that he moved into at No. 43 just down the street in
1947 (fig. 4).

It bears pointing out, however, that the work of Picasso's Blue
Period (considered French by dealers and collectors because School of
Paris) is rarely "light in hue" and may not look "charming" in what-
ever kind of frame it is placed. But this is the work that Wertheim
chose to collect when he started out. In less than two years he pur-
chased five works executed by Picasso in the period between 1901 and
1906 (see Appendix A). His first acquisition was Picasso's *The Blind
Man* (1903, cat. 25), a stark representation of poverty, the figure
characterized by the elongated limbs and the pathos found in the
artist's work at the time. Within a year, Wertheim had bought the
large *Mother and Child* (1901, cat. 24), also an image of wretchedness
and destitution. There is no doubt that he felt strongly about these
acquisitions. Just how strongly is related in the preface by his youngest
daughter, Anne, in connection with preparations for her own wedding
reception in early 1937. The irony of the compromise reached about
Mother and Child, so Baudelairean in its twists, cannot have been lost
on the guests for whom the painting was both hung and hidden.

Two years later Wertheim purchased another painting that
stirred controversy. The painting in question was van Gogh's
Self-Portrait Dedicated to Paul Gauguin (cat. 19). The work had
been denounced by the Nazis as "degenerate" (along with many
other examples of modern art), and in June 1939 it was sold at
auction by the Nazis through the Fischer Gallery in Switzerland.
Some American collectors—Etta Cone, for example—chose not to
participate in the auction on the grounds that any transaction involv-

ing the Nazis could be construed as support for the regime. Because of Etta Cone's interest in Matisse, the European dealer Siegfried Rosengart wrote to her with the information that two paintings by Matisse in the sale had been sold to American collectors at very low prices (CA, 26 July 1939). He also wrote that "Dr. Frankfurter of the *Art News* bought for a private collector" the van Gogh *Self-Portrait*. He did not approve of these transactions. But Wertheim held to a view that support for what the Nazis thought reprehensible was hardly reprehensible in itself. He must have successfully parried whatever criticism he received from the American Jewish community (its extent is unclear), for in November 1941 he stood as a candidate for the presidency of the American Jewish Committee and was elected (*New York Times*, 19 November 1941, p. 15).

The significance of his position as head of the American Jewish Committee elicited a remarkable letter from Joseph Willen, an important committee member (WFP, 29 January 1942). In his letter, Willen urged Wertheim to shed his persona of "banker" and, *pro bono publico*, emphasize the side of his personality that exhibited the temperament of an "artist." About Wertheim the "banker," Willen wrote as follows:

> *I trust that our friendship gives me the right to speak plainly. For thirty years you have been a banker—or so you like to describe yourself. Of course, a banker who has played an impressive role in the American theatre, in liberal journalism, and in the world of art. But always you insist upon the term "banker." I won't quarrel unduly with this, having my own healthy respect for what is indicated by the term "banker." I know your great capacity for seeing facts and understanding them, that tough-mindedness (in the sense that William James used it), that acumen and sober judgment that so characterize you and several other successful bankers of my acquaintance. I believe that [the presidency] calls upon you for a kind of human expression that perhaps is not synonymous with the concept of "banker." The sober fact is, like it or not, you, more than any rabbi, are now the spiritual leader of a great section of American Jewry* (ibid., p. 3).

In order to convince Wertheim that he had, in fact, "the temperament and capacity of the artist," Willen recalled Wertheim's enthusiastic response to the *Self-Portrait Dedicated to Paul Gauguin*. "Of course this is true [that you possess the temperament of the artist]," Willen wrote, "as anyone knows who has heard you let yourself go on the subject of van Gogh's Self-Portrait—that picture of a man who, in your words, suffered so much, was disillusioned by so much, and yet looked upon the world without hatred or judgement." To make his case, to convince Wertheim that he had a personality that might be

termed artistic, it was almost as if Willen was prepared to equate Wertheim's admiration for art with an actual production of art.

There is nothing to suggest that Wertheim accepted the dubious logic of Willen's argument. He was too much the "banker," of course —tough-minded and with a "great capacity for seeing facts," as Willen himself observed. But if Wertheim lacked "the temperament and capacity of the artist," this is not to say that he was cool toward his purchases. Indeed, he strongly identified with many of the subjects represented in the paintings—a partial extension, one might reasonably conjecture, of his long-standing interest in the theatre. His acquisitions of the 1930s, in particular, seem to have been impelled by an attraction to a certain kind of subject matter, to images of suffering and indigence of the sort exemplified in Picasso's Blue Period. Just once did Wertheim venture outside the Blue Period in purchasing a work by Picasso, and he counted the experiment a failure. In 1936 he bought *Nude on a Red Background* (1906, fig. 5), only to sell the painting a short time later.

In an important sense *Nude on a Red Background*, with its radical depersonalization of the nude figure, represented the limit of Wertheim's taste for the modern. Henceforward, he would avoid the acquisition of any work that aligned itself with Cubism or abstraction. Though he was to purchase objects executed after 1910, for example, Bonnard's *Interior with Still Life of Fruit* (1923, cat. 35) and Dufy's *Race Track at Deauville, the Start* (1929, cat. 36), these paintings look back to the example of late Impressionism more than they do to subsequent idioms in modern art. At the same time, Wertheim would purchase no work, with the exception of a drawing by Guys from ca. 1860 (cat. 1), executed prior to the early 1870s. When his father's collection, containing works by Thomas Lawrence, Eugène Boudin, Narcisse Diaz, Corot, and several major nineteenth-century American artists, was dispersed in 1936, he did set aside for himself the Corot, as well as a landscape by George Inness. However, he chose not to count the Corot as part of his main collection of French art. Most of the objects in Jacob Wertheim's collection were sold at auction by the American Art Association and Anderson Galleries in New York (New York, 1936).

Many of Wertheim's most significant acquisitions were made during the war years. They include *The Rehearsal*, by Degas (Wertheim's favorite painting—no mistaking his affinity for the theatre here); *Red Boats, Argenteuil*, by Monet (cat. 4); *Seated Figures, Study for 'A Sunday Afternoon on the Island of the Grand Jatte,'* by Seurat (cat. 13); *Three Pairs of Shoes*, by van Gogh (cat. 18); and *Mardi Gras on the Boulevards*, by Pissarro (cat. 21). Renoir's *Seated Bather*, though not acquired until 1946, should also be thought of as an acquisition made during the war. It was bought with the tacit understanding that the purchase price—$125,000, a near-record sum for a

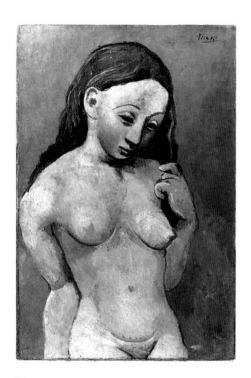

Figure 5.
Picasso. *Nude on a Red Background*, oil on canvas, 1906. Musée de l'Orangerie, Paris. Jean Walter–Paul Guillaume Collection.

Renoir—would launch a fund-raising drive for health facilities in France. Wertheim was the "anonymous buyer" in the newspaper accounts of the transaction—announced at a gala dinner on board the liner *Ile de France*. One set of headlines read: "Renoir Painting Sold, Proceeds to Aid France" (*New York Herald Tribune*, 21 November 1946, p. 48).

The wartime circumstances under which Wertheim acquired these works were particular and specific. They profoundly altered the structure of the art market in America. With the advent of war, New York found itself for the first time the undisputed center of the international art market. Prices in New York for some categories of European art, especially French art, accelerated markedly beginning in 1940 when a rising number of buyers entered a market in which there was, for obvious reasons, a shrinking number of available objects for sale. Moreover, the ownership and loan of French art for exhibition in America came to be viewed as an act of patriotism, an expression of support for the liberation of Europe and its culture from totalitarian domination.

Even before the First World War, America's capacity to purchase had led to its domination of the international art market. But it took the Second World War to shift the location of the market itself to the United States. Evidence of the transfer from Europe may be found in any number of telling signs. In 1943, for example, *Art News* added an advertising supplement to its already enlarged editions, introducing it with these words: "If ever there were a suitable moment to inaugurate in America the established custom of European art magazines to carry an annual advertising section which illustrates momentary prizes in the art market, this is surely the time. Today America, and particularly New York, is virtually the art center of the world" (*Art News*, 1943, p. 31). The editorial went on to offer the opinion, gratuitously one must think, that "Americans have reason to be grateful for the results of these conditions as deeply as they deplore the circumstances that brought them about" (ibid., p. 31). Looking back on the situation twenty years later from the European perspective, Gerald Reitlinger, no less gratuitously, lamented that "the season which ended in July 1941 [in New York] was said to have been the best since 1929, a sad proof of how little Europe meant now in the top market" (Reitlinger, I, 1961–1970, p. 221).

Wertheim's modus operandi in the purchase of paintings was much the same as that in his purchase of businesses. Both were cause for intense excitement and concentration. Experts would be consulted—on art, Frankfurter, Sachs, and others—and their opinions held up to scrutiny. If he decided to proceed, Wertheim moved swiftly to secure the object of his interest. In the art market (though not so often in business), this meant being prepared to pay top prices. Judging from those few instances where the price of a work is known, Wertheim did

not hesitate once his mind was made up. At the well-publicized auction in 1937 of works belonging to Mrs. Cornelius J. Sullivan, one of the founders of The Museum of Modern Art, New York, he paid the highest price fetched at the sale: $5,700 for Seurat's drawing *Woman Seated by an Easel* (cat. 14; Lynes, 1973, p. 149). Similarly, he topped the bidding at the Sir William Van Horne auction in 1946. "The outstanding item of this auction," *Art News* reported, "was Toulouse-Lautrec's important *The Hangover*, also known as *The Drinker*, which a private collector purchased for $30,000" (*Art News*, 1946, p. 10). Wertheim chose this Toulouse-Lautrec (cat. 16) over another in the sale, the no less remarkable *Redhead in Mr. Forest's Garden* (D P343). The article also informed its readers that "the most salient fact that emerges from the results of the Van Horne Sale—the first large auction of Impressionists in about three years—is that prices have enjoyed about a 50% rise over that time, matching parallel gains on the stock market" (ibid., p. 10).

The last observation, equating prices of paintings with prices of stocks, speaks for the blue-chip status that modern French art had acquired in America. During the war the collection and public exhibition of French art had become synonymous with support for the Allied war effort, and there is little doubt that the conflation benefited art prices just as it benefited the war effort by raising funds from special exhibitions. A good deal of rhetoric on the theme of cultural solidarity accompanied the proliferation of exhibitions of French art in New York. The preface to the exhibition *French Painting from David to Toulouse-Lautrec*, held at The Metropolitan Museum of Art in 1941, and to which Wertheim was a lender, is a case in point. "At a time when the world hangs in breathless suspense and free nations are invaded and subjugated, when vision is blurred and emotions inflamed by smoke and the dust of war, when bureaus of enlightenment purvey misleading propaganda, at such a time it should be edifying, at least in some degree, to reconsider one full century of the art [of France], and thus of the essential spirit of the nation which is for the present more painfully distracted and humiliated than any other" (New York, 1941B, p. ix). This kind of rhetoric often concluded that French civilization was richer, greater, more to be protected than any other, that "the preservation of France [was] vital to world civilization" (New York, 1943–1944, Paris, p. iii).

It is appropriate that when Wertheim joined the War Production Board in Washington and moved there in 1942, he should have taken his art collection with him. By removing the collection from New York to the capital, he was presenting the proper credentials. The admiration for French art had become not only a tangible American manifestation of support for France but also a cultural mediator of sorts in the abrupt transition of the United States from a position of isolationism to principal actor on the world stage. It had become a badge represent-

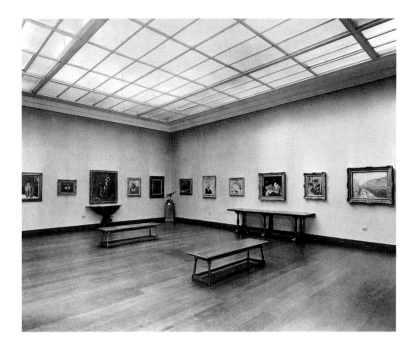

ing the fitness of the nation for its new role as a leader. In recognizing
the superiority of French culture—the preservation of which was
"vital to world civilization"—the United States found a reason (among
many reasons) to think of itself as the champion of what was proper
and just.

The Wertheim Collection was exhibited at the Fogg Art Museum,
Harvard University, from June 1 through September 7, 1946 (fig. 6).
It was the first time the collection as a whole had been publicly shown,
and Harvard and the Fogg were clear and obvious choices for the
occasion. Wertheim was a loyal supporter of the Harvard class of 1906,
which marked its fortieth reunion in 1946. The exhibition was organ-
ized to celebrate that event, as well as a "Victory meeting of the
Associated Harvard Clubs, their first meeting since the beginning of
the war" (Cambridge, 1946, p. 3). The idea for the exhibition was
almost certainly advanced by Sachs, who had reason to hope that the
collection would be left to the museum. Sachs's first indication that
Wertheim was thinking of a bequest came during a visit to Wash-
ington in 1942. "Now that I am back in Cambridge," Sachs wrote
following the visit, "I should like to say to you once again how pro-
foundly impressed I was by the quality and importance of your
remarkable collection. . . . May I say also how deeply touched I am by
the thought that you have in mind of possibly remembering the Fogg
at a day which I trust is far distant" (FMA, 22 December 1942).
 Once Sachs had learned of Wertheim's intention of "possibly
remembering the Fogg at a day which I trust is far distant," he lost
no opportunity to inform Wertheim about the expansion and growing
importance of the museum as an institution. In 1943 he mailed

Wertheim a copy of the latest Fogg *Bulletin*, devoted, as he explained in his covering letter, to "the wealth of the Winthrop collection to which we have fallen heir." "I might add," Sachs continued, "that the Harvard Alumni Bulletin in January will be largely devoted to the Winthrop collection and that Art News proposes to devote an entire number to the collection in the near future. . . . When you are next in Cambridge I do hope you will come here so that we may show you these new acquisitions. . . . Perhaps you feel as [Edward] Forbes [Director of the Fogg] and I do that this institution is growing in importance as a place where teachers of art and music and museum officials are trained to serve throughout the country" (FMA, 18 December 1943). As a tangible demonstration of the Fogg's training program, Sachs orchestrated visits by his Harvard classes to Wertheim's New York apartment. Wertheim himself led the classes through the collection, just as Grenville Winthrop had led them through his collection in New York at an earlier time (Cohn and Siegfried, 1980, p. 8).

Sachs also made certain that the 1946 exhibition was properly accompanied by a well-illustrated, scholarly catalogue. John Rewald, who had been publishing extensively on the Impressionists and Post-Impressionists since coming to the United States in 1941 (see Bibliography) and who was just completing the manuscript of *The History of Impressionism* for The Museum of Modern Art, agreed to prepare half the entries, and Frederick B. Deknatel, Agnes Mongan, and Frederick S. Wight agreed to prepare the remainder. The catalogue became, and remained, the standard reference on the collection. Wertheim was evidently impressed with the product and subsequently sought out Rewald's advice on works by Renoir. "It may interest you to know," Rewald wrote to Sachs, "that Mr. Wertheim asked for my advice yesterday as to whether he should buy the large Renoir drawing [cat. 9] for the 'Baigneuses.' I very strongly urged him to do so, whereupon he told me that you had done the same" (FMA, 17 March 1947). Wertheim also consulted Rewald, as well as Meyer Schapiro, before acquiring Renoir's *Seated Bather* (Rewald to the author, 16 June 1984). On the evidence, one might conclude that Wertheim's judgment about whom to consult on possible acquisitions was as developed as his judgment of what to purchase.

Also accompanying, or coinciding with the exhibition, was Frankfurter's article on Wertheim as a collector, published in the June 1946 issue of *Art News* (Frankfurter, 1946). The article was the perfect foil to the scholarly catalogue. It was written in the tone of a privileged insider. Because Frankfurter enjoyed the trust of his subject, he could gently chide him about his taste in furniture; and, because he had so often advised on the objects considered for purchase, he could also furnish useful information about the motivations for and the sequence of Wertheim's acquisitions. However, Frank-

furter neglected to mention one significant fact about Wertheim's activities in art: that he was on the Board of Trustees of Frankfurter's magazine.

The significance of this connection lies in the mechanisms by which art writing was related to art collecting in New York in the 1940s. Frankfurter, for example, made an effort to convince Wertheim to collect contemporary American art. In a coda to his article, Frankfurter observed that Wertheim already owned works by Marion Greenwood, Leon Hartl, Gaston Lachaise, Henry Mattson, Georgia O'Keeffe, and George Schreiber, but that he had yet to purchase "the living Americans who [could] stand up to the competition from the French immortals" (ibid., p. 65). One wonders exactly what "living Americans" Frankfurter had in mind—Jackson Pollock, Willem de Kooning, Mark Rothko, Arshile Gorky, and David Smith were hardly subjects of close critical attention in the pages of *Art News* at the time—but the point remains that he thought such Americans existed and that Wertheim should be buying their work. Wertheim, however, was not persuaded. He continued to prefer, as he continued to collect, the "French immortals."

Wertheim died at his estate in Cos Cob on 27 May 1950; he was sixty-four. His obituary in the *New York Times* (28 May) reported that late in life, despite his continuing business interests and commitments, "he preferred to be considered a sportsman." "He was," the *Times* observed, "a trustee of the American Wildlife Foundation, a noted fisherman and a tournament chess player." The *Times* also reported that he was "a founder of the New York Theatre Guild, a patron of exhibitions sponsored by the Sculptors Guild . . . [and] on the advisory committee of the New York University Institute of Fine Arts." Wertheim's membership on the Visiting Committee of the Fogg Art Museum was not reported, nor was the fact that he had put together an exceptional art collection. This information was mentioned only later when the terms of his will (dated 28 September 1948) became known, and it was announced that he had bequeathed the art collection to Harvard for "the benefit and use of the Fogg Museum of Art."

Attached to the Wertheim bequest were certain stipulations. The collection was to remain as a single entity; it was to be placed on permanent exhibition; and it was to be made available for the use of Mrs. Wertheim for as long as she was alive *and* still living at 43 East 70th Street in New York. In practice, this meant that for most of each year from 1950 until 1974, when Mrs. Wertheim died, the collection remained in New York. Only during the summer months, when she vacated the townhouse, was the collection sent to Cambridge for temporary installation or loaned to other museums for exhibition. On such a limited schedule the collection traveled far, being exhibited in twelve different museums from Texas to Maine

(see Appendix B for the places and dates of these exhibitions). Since then, except for a brief return visit to New York in the spring of 1985, the collection has remained in Cambridge.

Wertheim specified in his will which paintings, drawings, and sculptures were to go to the museum at his death. They comprised the objects he valued most, those he thought to be of outstanding quality. From the list he drew up in 1948, he subsequently subtracted one painting, Soutine's *Boy in a Green Coat* (Cambridge, 1946, pp. 60–61), as it seemed to him not to measure up. But he added several works to take its place, notably Degas's *Singer with a Glove* (cat. 3) and Maillol's *Ile de France* (cat. 41). It had always been his practice as a collector to add and subtract from the collection. "You may be interested to know," he had written to Sachs in 1946, "that I have just completed a trade for two of the less important pictures in my collection, viz.: the Renoir *Straw Hat* (ibid., pp. 16–17) and the Matisse *Girl with Violin* (ibid., pp. 58–59). For these and some additional cash consideration I have acquired Renoir's *Self-Portrait* (cat. 7) of 1876" (FMA, 23 December 1946). However, he was not at all inclined to subtract paintings he really prized. The works Maurice Wertheim wished to be remembered by were given to Harvard to form the permanent exhibition at the Fogg Art Museum in his name.

Note to the Catalogue

Degas to Matisse: The Maurice Wertheim Collection is designed for use by both general and specialized audiences. The publication follows the aims and format established by the preceding volumes in the series of catalogues published by the Harvard University Art Museums on their collections.

The catalogue is divided into two sections: Paintings and Drawings, and Sculpture. In each section, catalogue entries are arranged chronologically except where there is more than one work by an artist, in which case the subsequent entries of that artist follow immediately after the first entry regardless of date. Each entry begins with the artist's name, the title of the work, and the date of execution, followed by a description of medium and size. All inscriptions are given, whether by the artist or by later hands. Conjectural information is denoted by [square] brackets.

In measurements of paintings and drawings, height precedes width; in measurements of sculpture, height precedes length. The length of a sculpture is measured as the longest distance between two points, which often extends beyond the base. Discrepancies in lengths given by other sources, therefore, may indicate that in those cases the length of the base was measured. Measurements of all objects are in centimeters, followed in brackets by measurements in inches.

The references listed under Provenance at the foot of each entry record the object's previous owners. The sequence in which Maurice Wertheim purchased objects for the collection is summarized in Appendix A. The references listed under Bibliography after each entry indicate, in short form, those sources in which the work has been published or discussed. References to loan exhibitions are included here only if there was a published catalogue. However, exhibitions of the entire Wertheim Collection, whether or not accompanied by a catalogue, are listed in Appendix B.

Full bibliographic citations for abbreviated references in the text are given in the Bibliography at the end of the book. Bibliographic and exhibition data for several works that are well documented elsewhere have been condensed. In such instances, the additional documentation will be found in those citations referred to simply by the initial(s) of the author(s). For example, "W" is the short form for Daniel Wildenstein, *Claude Monet: Biographie et catalogue raisonné*, 3 vols., Paris and Lausanne, 1974–1978. All early citations are included in the condensed data as well as substantial later ones. Particular attention has been paid to finding and incorporating relevant citations between 1936 and 1950, the period when Maurice Wertheim was forming the collection.

Additional information on the materials, techniques, and condition of works in the collection is provided in Appendix C. Cross-references in the text to works in the collection are identified by catalogue numbers in parentheses.

Constantin Guys

Flushing (Holland) 1802–Paris 1892

1. *A Lady of Fashion,* ca. 1860

Brown ink and blue, brown and gray washes over graphite on cream wove paper, 37.9 x 26.5 cm. (15 x 10½ in.)

Guys chronicled, in numerous drawings and watercolors, the pleasures and pastimes of French society under the Second Empire—balls, promenades, military parades, and life in the dance halls and brothels. These representations, of which *A Lady of Fashion* is a typical example, were the subject of one of Baudelaire's most celebrated essays, "The Painter of Modern Life." "Monsieur G.," wrote Baudelaire, "is particularly given to portraying women who are elaborately dressed and embellished by all the rites of artifice, to whatever social station they may belong. Moreover, in the complete assemblage of his works, no less than in the swarming ant-hill of human life itself, differences of class and breed are made immediately obvious to the spectator's eye, in whatever luxurious trappings the subjects may be decked" (Baudelaire, 1863, p. 34).

There is little doubt about the "luxurious trappings" worn by the woman in this drawing. From her elaborate coiffure down to her pointed walking boots, so prominently displayed beneath the ostentatious crinoline dress, the fashions are those of Paris about 1860 (Uzanne, 1899, pp. 165–175). The image was not intended to function as a contemporary fashion plate, but it has the air of one. Nor can there be much doubt about the woman's class and station in society. Judging from the way she raises her expensive skirts, she represents a well-to-do courtesan—"a creature of show, an object of pleasure," as Baudelaire phrases it (Baudelaire, 1863, p. 36).

Guys's drawing technique in this sheet corresponds closely to Baudelaire's description of the artist's usual working method. "Monsieur G. starts with a few slight indications in pencil, which hardly do more than mark the position which objects are to occupy in space. The principal planes are then sketched in tinted wash, vaguely and lightly colored masses to start with, but taken up again later and successively charged with a greater intensity of color. At the last minute the contour of the objects is once and for all outlined in ink" (ibid., p. 17). In many of his drawings, however, Guys completed only one or two of the steps described by Baudelaire. Two compositions identical to *A Lady of Fashion,* but less finished and presumably preparatory to it, are in the Musée Carnavalet, Paris (Dubray, 1930, pl. 47; Hall, 1945, pl. 27).

Provenance: Marquis de Biron, Geneva and Paris; Knoedler, London; Carroll Carstairs Gallery, New York; Maurice Wertheim, by 1946.

Bibliography: San Francisco, 1940, no. 452; San Francisco, 1942, no. 36; Hall, 1945, pl. 41; Frankfurter, 1946, p. 64; Cambridge, 1946, p. 64, repr. p. 65; Quebec, 1946, no. 27, pp. 71–72; Raleigh, 1960, p. 62, repr. p. 63; Houston, 1962, pl. 22, pp. 56–57; Augusta, 1972A, no. 11. Bequest—Collection of Maurice Wertheim, Class of 1906, 1951.68

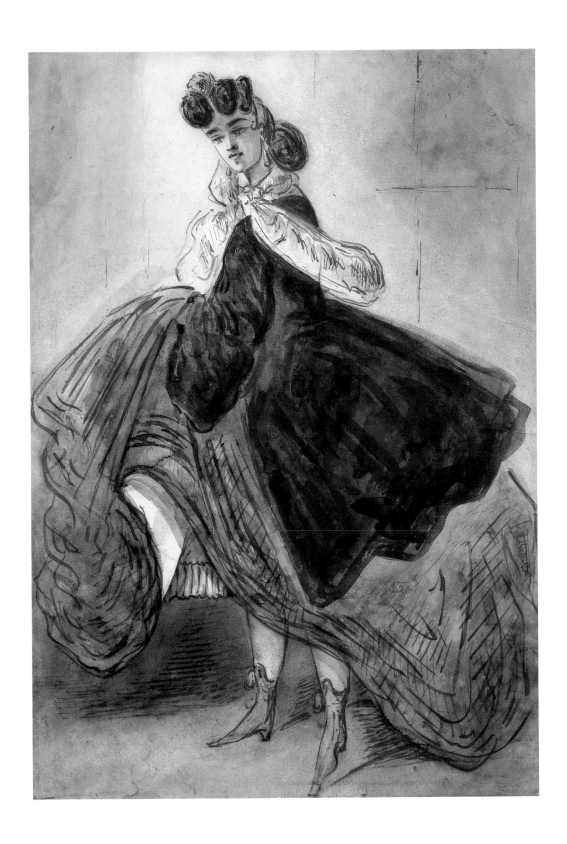

Edgar Degas

Paris 1834–1917

2. *The Rehearsal,*
ca. 1873–1878

Oil on canvas, 47 x 61.7 cm.
(18½ x 24⅜ in.)
Signed in black paint, lower right:
Degas

The Rehearsal is one of Degas's earliest paintings of dancers, the most insistent theme in his art from 1869 to the close of his working life forty years later. It represents ballet dancers, accompanied by a violinist (partially cropped by the left framing edge of the painting), practicing in one of the rehearsal rooms of the old Paris Opéra, a building that burned in October 1873 about the time Degas is thought to have been working on the painting (Browse, 1949, p. 57). The practice room is cast in a cool light from three windows that open on to exterior fragments—chimney pots, green trees, a bit of blue sky —of the urban landscape. This partial view contrasts sharply with the empty, gray floor space spreading out axially from the violinist's feet.

In tackling scenes of dancers, Degas chose to undertake a kind of urban subject matter proposed by Baudelaire in the essay "The Painter of Modern Life" (1863). For Baudelaire and Degas, as for upper-class Parisians in general, the ballet was a familiar spectacle and the Opéra one of the city's most visible places of entertainment. There were performances three times a week, and subscribers (the *abonnés*) had free reign to circulate where they pleased in the theatre —in the rehearsal rooms, the dancers' dressing rooms, and the wings of the stage (Washington, 1984, p. 14). Degas knew both the place and the spectacle intimately. He had friends among the musicians in the orchestra and, from sketching dancers in the rehearsal rooms behind the scenes, knew at first hand the system that brought young dancers to the Opéra at the age of seven or eight, usually from lower-class families, to begin competing and drilling for permanent positions in the company (Browse, 1949, pp. 68–69). At the age of ten or eleven they were either let go or taken on. If the latter, they could expect a salary for their work and, in due course, the opportunity to maneuver for a husband or a "protector" from among those who circulated back-stage (Reff, 1978).

Edmond de Goncourt, when he visited Degas's studio in 1874, was struck by the artist's commitment to dancers as a subject for painting. "Yesterday I spent the whole day in the studio of a strange painter called Degas," he wrote in his journal. "After a great many essays and experiments and trial shots in all directions, he has fallen in love with modern life, and out of all the subjects of modern life he has chosen washerwomen and ballet dancers. When you come to think of it, it is not a bad choice. It is a world of pink and white, of female flesh in lawn and gauze, the most delightful of pretexts for using pale, soft tints. . . . Among all the artists I have met so far, he is the one who has best been able, in representing modern life, to catch the spirit of that life" (De Goncourt, 13 February 1874).

In preparing to paint *The Rehearsal*, Degas proceeded in a care-fully deliberated manner. A number of drawings have survived that are directly related in composition to individual figures in the painting. Ranging from rapid notations to precisely executed studies from the

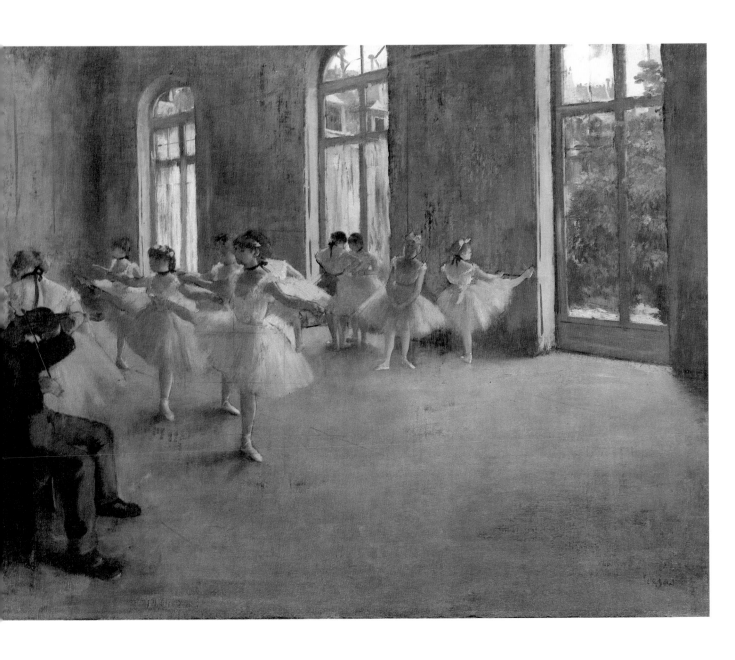

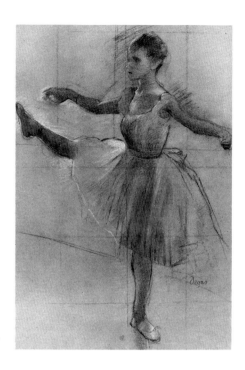

Figure 1.
Edgar Degas. *Study for "The Rehearsal,"* charcoal heightened with white, ca. 1873–1878. Norton Simon Foundation, Los Angeles.

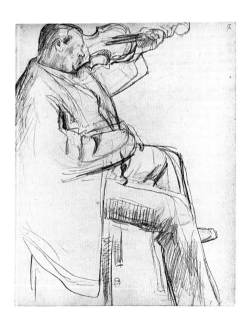

Figure 2.
Edgar Degas. *Study for "The Rehearsal,"* crayon and white chalk, ca. 1878. From Notebook 30, p. 17. Bibliothèque Nationale, Paris.

model, the drawings were reproduced after Degas's death in the catalogues from the sales of the contents of his studio (Paris, 1918–1919: Sale II, nos. 227 and 247; Sale III, nos. 343, 357, 359, and 567; Sale IV, no. 284). They relate to the dancer standing behind the violinist, to the dancer exercising at the barre, and, preeminently, to the dancer in the middle foreground, her arms spread and her right foot raised in the attitude of a *développé à la seconde*.

However contemporary Degas's choice of subject matter, his procedures for representing that subject matter were grounded in tradition. The drawings he produced illustrate not only a conviction about the need for continual drawing, an article of faith inherited from a long line of draftsmen up to and including Ingres, but also a conviction about the essential contribution of drawing to the organization of the painting and its particulars. In this respect, a charcoal study relating to the central figure is instructive (fig. 1). This highly finished drawing, which is squared for transfer to the canvas, corresponds precisely to the figure in the painting, demonstrating Degas's fidelity to his preparatory work.

It was Degas's practice to paint in his studio from memory, aided by drawings. Despite the apparent informality of *The Rehearsal*—an informality suggested by the sketchiness of the figures, torsos, and limbs intersecting at odd angles and by the strangely diagonal composition—it could have been produced no differently. The boldly arresting composition was clearly premeditated. Moreover, the presence of *pentimenti* in the positioning of several dancers' feet seems to indicate that Degas reworked the canvas at least once.

It is probable that portions of the painting were reworked at some point after the painting was ostensibly finished. This would be consistent with what is known of Degas's working habits—notably his penchant for retouching—without throwing into question the generally accepted date of 1873–1874 arrived at on stylistic grounds (Pickvance, 1963, p. 265). The likelihood of a later reworking is supported by several disparate bits of evidence. First, a study relating to the central figure has been dated by Lillian Browse to 1878 (Browse, 1949, pl. 69, p. 361), although it is possible that the study was executed after the painting. Second, a study of a violinist (fig. 2) in one of Degas's notebooks, in use from 1877 to 1883, has been identified by Theodore Reff as corresponding in pose to the violinist in the painting (Reff, 1976, I, pl. 35, p. 133). Originally, the position of the violinist in the painting was even closer to the drawing; infrared examination shows that the violinist's right leg was forward before being swiveled to the right and back. And third, evidence of a technical kind has demonstrated that the picture was heavily reworked in the vicinity of the central dancer (see Appendix C). Another composition from approximately the same period, *The Dance Class* (ca. 1875, L 341), has been exhaustively documented as having proceeded

Figure 3.
Edgar Degas. *The Rehearsal*, oil on canvas, ca. 1873–1874. The Frick Collection, New York.

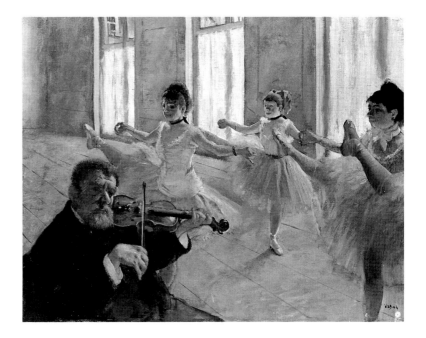

through at least two distinct stages of development on its way to completion (Washington, 1984, pp. 43–62).

Degas painted two other versions of *The Rehearsal*. The variation in the Frick Collection (fig. 3), focusing on the central grouping of dancers and the violinist, is more loosely handled and drier in texture than the Wertheim painting; and the variation in the Shelburne Museum, Vermont, in which the view through the windows is veiled, is executed in distemper (L 399).

Provenance: M. Manzi, Paris; Harris Whittemore, Naugatuck, Connecticut, by 1911; Whittemore to Maurice Wertheim, 1942.

Bibliography: Cambridge, 1911, no. 4; Cambridge, 1919; Lafond, 1919, II, p. 28; Naugatuck, 1938, no. 7; Boston, 1939, no. 34, pl. XX; Waterbury, 1941, no. 8; Frankfurter, 1941, p. 19 (ill.); Rewald, 1946A, repr. p. 16; Frankfurter, 1946, p. 64, repr. p. 30; Cambridge, 1946, pp. 6–9, repr. p. 7; Quebec, 1949, no. 2, pp. 6–8; Browse, 1949, pl. 37, pp. 349–350; Coolidge, 1951, repr. p. 754; Raleigh, 1960, p. 8, repr. p. 9; Houston, 1962, pl. 2, pp. 14–15; Pickvance, 1963, p. 265; Berlin, 1969, p. 112 (ill.); Augusta, 1972A, no. 3; Augusta, 1972B, p. 3 (ill.); Coolidge, 1975, repr. p. 1; Reff, 1976, 1, pl. 50, p. 133; Harrison et al., 1983, pl. II 52; Brame and Reff, 1984, no. 60; Friesinger, 1985, p. 39 (ill.); Rewald, 1985, p. 53 (ill.). Bequest—Collection of Maurice Wertheim, Class of 1906, 1951.47

Edgar Degas

Paris 1834–1917

3. *Singer with a Glove*, ca. 1878

Pastel and liquid medium on canvas,
52.8 x 41.1 cm. (20¾ x 16 in.)
Signed in red pastel, upper left: Degas

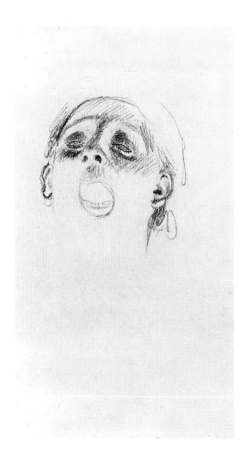

Figure 1.
Edgar Degas. *Head of Thérésa,
Study for "Singer with a Glove,"*
charcoal, ca. 1878. Private Collection.

The performer in *Singer with a Glove* is represented by Degas as pressed against the footlights of a stage, her black-gloved arm raised toward an unseen audience. The location is a café-concert, a popular place of entertainment where the social strata of Paris mingled during the second half of the nineteenth century. Economically, it has been observed, the café-concert "was a form of speculation, a café with a stage, floodlights, a lead singer and a couple of third-rate comedians: it was a way to sell more lukewarm beer at more exorbitant prices. . . . It occupied, positively invaded, the great spaces Haussmann created in the 1850's and 1860's, the sidewalks and squares of a city built for trade, traffic and swift movement of troops. And as one kind of private enterprise among others, the café-concert was at first sight a perfectly appropriate form of life to be spawned in Haussmann's boulevards" (Clark, 1977, p. 239).

Degas did not paint *Singer with a Glove* at a café-concert, any more than he actually painted *The Rehearsal* (cat. 2) in one of the practice rooms at the old Opéra. Like all his finished works, it was an elaborate contrivance, painted in his studio with the use of models, from memory, and with the aid of preparatory sketches. In this work the singer—with her hooded eyes, wide mouth, and double chin—has been identified as Thérésa, the most popular café-concert performer of the day (Clark, 1984, pp. 220–221). She is the same chanteuse represented by Degas in *At the Café-concert, le chanson du chien* (ca. 1875–1877, L 380). Thérésa is reported to have exerted an extraordinary hold on her audience, including Degas himself. "Go quick and hear Thérésa at the Alcazar . . . ," Degas advised a friend, "she opens her great mouth and out comes the most grossly, delicately, wittily tender voice imaginable. And feeling, and taste, where could one find more? It is admirable" (cited in Shapiro, 1980, pp. 158–159). Thérésa's "great mouth" is also the focus of two preliminary drawings (fig. 1; and Paris, 1918–1919, Sale III, no. 342.2) for *Singer with a Glove*. In two other related works (L 477 and 478), however, Thérésa's distinctive features are replaced by the more conventional features of Alice Desgranges, a classically trained singer who posed for Degas (ibid., pp. 161–162). In one of the pictures of Alice Desgranges (L 477, Art Institute of Chicago), the singer is represented backed by a trellis and framed by leaves in the upper left corner, indicating that the setting is an outdoor stage of a café-concert (Chicago, 1984, p. 88). It is likely this is a finished variant on the Wertheim painting rather than a preparatory version (Edinburgh, 1979, no. 43).

Singer with a Glove was exhibited by Degas at the Fourth Impressionist Exhibition in 1879. Some critics wrote of Degas's works in that exhibition as if the artist were observing fully the conventions of figural representation—as if he had pinned down the expressions and gestures of modern life with physiognomic precision. Other critics,

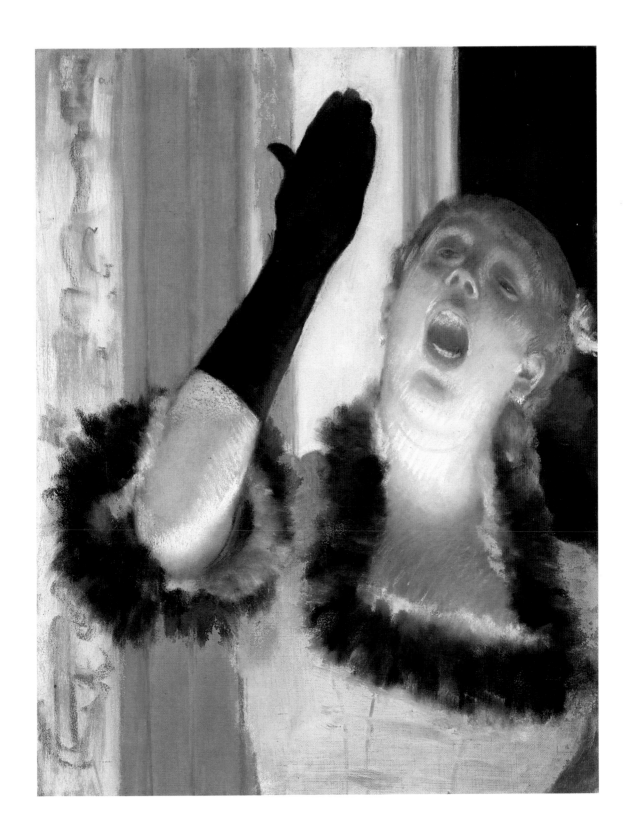

however, saw in them willful and incoherent distortions of the human body. Louis Leroy, in a passage that refers to *Singer with a Glove*, held the latter conviction: "This artist excells in cutting a figure in two, in making one leg thrust out of the frame, and sometimes two hands as well, as in the rough sketch of the woman, remarkable for its extraordinary tones, with her arms truly independent of her thin chest! Not far from that is a black glove, prodigious in intensity, this too by M. Degas. Oh, what a glove, my friends!" (Leroy, 1879).

Almost all of Degas's café-concert compositions, including his monotypes (Cambridge, 1968, checklist nos. 23–53), demonstrate a highly experimental use of medium. Degas frequently combined techniques to achieve vivid textural effects not possible in a single medium. In *Singer with a Glove* he combined normal dry pastel with a liquid medium (see Appendix C). The main composition was drawn in dry pastel, while the colored stripes of the background, as well as the pink bodice of the singer's gown, were executed with wet pigments. In certain places, most notably at the junction of the cuff on the singer's raised arm and the green and red stripes beneath it, the combination of wet and dry media has caused a beading of the boundary, a feathering effect, that conjures up the stuff and texture of the singer's ostrich plumes.

Provenance: Camille Groult, Paris, by 1879; Dr. Heer, Zurich; César de Hauke, New York, to Maurice Wertheim, May 1949.

Bibliography: Paris, 1879, no. 70; Leroy, 1879; L 478 bis; Venice, 1948, no. 67; Quebec, 1949, no. 7, pp. 20–22; New York, 1950, foreword, no. 6; Rich, 1951, p. 68; Raleigh, 1960, p. 10, repr. p. 11; Houston, 1962, p. 16; Augusta, 1972A, no. 4; Coolidge, 1975, p. 1; Dunlop, 1979, pp. 151, 153 (ill.); Edinburgh, 1979, pp. 30–31; Shapiro, 1980, pp. 161–162, fig. 10; McMullen, 1984, pp. 314, 315 (ill.), 325; Chicago, 1984, pp. 88–89 (ill.); Clark, 1984, pp. 220–221 (ill.); San Francisco and Washington, 1986, p. 257. Bequest—Collection of Maurice Wertheim, Class of 1906, 1951.68

Claude Monet

Paris 1840–Giverny 1926

4. *Red Boats, Argenteuil*, 1875

Oil on canvas, 61.9 x 82.4 cm.
(24⅜ x 32½ in.)
Signed and dated in dark blue paint,
lower left: Claude Monet 75

During most of the 1870s Monet lived in Argenteuil, a suburban town on the Seine seventeen miles downriver from Paris. No place is more associated with Monet and the Impressionist group, many of whom worked there at some point during the decade. Argenteuil, only fifteen minutes from the city by rail, was well known as a convenient destination for recreational pursuits—boating and Sunday outings. "The town of Argenteuil lies in front of you," one observer wrote in 1869, "with its quays bordering its entire length. Right away you notice the magnificent basin of the Seine, where in the summer season, the happy boaters come to indulge in their nautical pastime; then you notice some small houses serving as *pieds à terre* for their owners in the pleasant part of the year. Then further, a magnificent promenade shaded by majestic trees" (cited in Tucker, 1982, p. 9).

In *Red Boats, Argenteuil* Monet has painted a picture that seems to confirm this account of Argenteuil as a pastoral retreat. From a vantage point on the water, the painting encompasses a view downriver in the direction of the basin—that part of the river popular with the "happy boaters"—which lies beyond the sailboats that are represented riding on their anchors. We can even see on the left bank of the river several of the suburban villas used by vacationing Parisians, one of which was apparently owned by Gustave Caillebotte, Monet's friend and fellow Impressionist (Houston, 1976). The painter's sun-drenched colors add to its leisurely air.

Thus the painting would appear to be an accurate transfiguration of a pleasurable stretch of the Seine at Argenteuil. However, the idyll is not quite as it seems. For Monet, like the writer in 1869, has chosen in *Red Boats, Argenteuil* to ignore the urban side of Argenteuil and to overlook the town's attraction as a place for industry as well as for pleasure. This becomes evident upon comparing the Wertheim painting with Edouard Manet's picture *Monet Working on His Boat in Argenteuil* (fig. 1), which was executed from almost exactly the same location on the river. The same sailboats are pictured at anchor in both paintings, the same small dock, the same suburban villas—but not, it will be observed, the same buildings on the horizon line. In Manet's version there are two smokestacks on the far shore, rhyming with the masts of the sailboats, while in Monet's painting there is no smoke in the background and the chimneys have been obliterated (Tucker, 1982, p. 118). Monet painted two slightly smaller variations of the scene (W 368 and 370), which, by ignoring Argenteuil's urban sprawl, also attempt to preserve the motif within category of landscape painting (see Clark, 1984, pp. 163–204).

Red Boats, Argenteuil gives the impression of having been painted rapidly, spontaneously. The surface of the canvas has an improvisatory air, and the forms are indistinct in places. However, the painting must have been worked on over a period of time. At least two parts were painted out and reworked (see Appendix C).

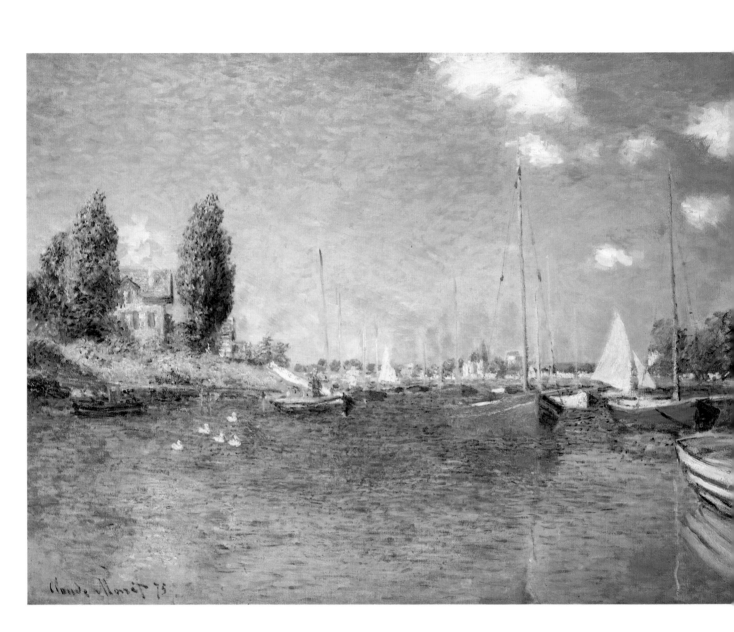

Figure 1.
Edouard Manet. *Monet Working on His Boat in Argenteuil*, oil on canvas, 1874. Bayerischen Staatsgemäldesammlungen, Munich.

Moreover, the water is made up not only of shades of blue but of multicolored reflections from the large boat, ostensibly red but also containing strokes of blue and purple in the shadows and bright yellow in the highlights. Several days, perhaps weeks, would have been required to permit some of the thicker, textural strokes of paint to dry before some of the thinner strokes of pigment could be applied over them (Herbert, 1979, p. 108). The surface buildup on the canvas is most readily traced in the foliage around the villas, as well as in the water reflections.

Provenance: [J. B. Faure, Paris, 1876]; Durand-Ruel to James F. Sutton, New York, 1893; Durand-Ruel (Sutton Sale, Plaza Hotel, New York, 16–17 January 1917, no. 137); E. Laffon, Paris; Paul Rosenberg, New York, to Maurice Wertheim, June 1943.

Bibliography: [Paris, 1876, no. 160]; [Paris, 1889, no. 27]; Alexandre, 1933, pp. 182, 193; Frankfurter, 1946, p. 64; Cambridge, 1946, p. 10, repr. p. 11; Rewald, 1946, repr. p. 285; Reuterswärd, 1948, p. 282; Quebec, 1949, no. 3, pp. 9–10; New York, 1950, no. 4; Raleigh, 1960, p. 28, repr. p. 29; Houston, 1962, pl. 11, pp. 32–33; Augusta, 1972A, no. 20; W 369; Herbert, 1979, p. 108; Tucker, 1982, pl. XX, pp. 118–120, 149; House, 1986, pl. 20, pp. 18, 83. Bequest—Collection of Maurice Wertheim, Class of 1906, 1951.54

Claude Monet

Paris 1840–Giverny 1926

5. *The Gare Saint-Lazare; Arrival of a Train,* 1877

Oil on canvas, 83.1 x 101.5 cm.
(32¾ x 40 in.)
Signed and dated in black paint,
lower left: Claude Monet 77

Figure 1.
Claude Monet. *The Gare Saint-Lazare,*
oil on canvas, 1877. Musée d'Orsay
(Jeu de Paume), Paris.

The Gare Saint-Lazare, subtitled *Arrival of a Train,* is the largest of a series of twelve paintings by Monet on the same theme (W 438–449). The series was begun in January 1877, and within three months Monet had completed at least eight paintings. He made this octet the centerpiece of his contribution to the Third Impressionist Exhibition of April 1877, which, like the two preceding ones, drew extensive critical fire (Levine, 1976, pp. 27–33). Roger Ballu, who was Inspector of Fine Arts, dismissed Monet's work for its "profound ignorance of drawing, composition and color," and Baron Grimm, pseudonym for Pierre Véron, dismissed the work for its "disagreeable" subject matter (ibid., p. 27).

Other writers concurred in this kind of criticism, their objections being leveled more at Monet's choice of modern-life subject matter than at his paint handling and compositional organization. There were also, however, critics favorably disposed toward Monet and the other Impressionists. The most partisan of these was Georges Rivière. As an apologist for Monet's work, Rivière focused on the Gare Saint-Lazare series and found it to be "enormously varied, in spite of the monotony and aridity of the subject" (Rivière, 1877A, pp. 9–10). Whether the subject is monotonous or not, Rivière's criticism reads more like a panegyric to the locomotive and industrial architecture than praise of Monet's paintings: "In one of the biggest paintings [the Wertheim painting] the train has just pulled in, and the engine is going to leave again. Like an impatient and temperamental beast, exhilarated rather than tired by the long haul it has just performed, it shakes its mane of smoke, which bumps against the glass roof of the great hall. Around the monster, men swarm on the tracks like pygmies at the feet of a giant. Engines at rest wait on the other side, sound asleep. One can hear the cries of the workers, the sharp whistles of the machines calling far and wide their cry of alarm, the incessant sound of ironwork and the formidable panting of steam" (ibid., p. 10).

Rivière's mythopoeic rhetoric had for some time been common currency in writings on the locomotive. Notwithstanding anxieties about the nature of the railroad's impact on the modern environment, it was often mythologized. The painter Couture, for example, spoke of it as "a monster with a bronze shell and a tongue of fire," while the writer Champfleury described it as a "huge machine whose belly sows fire in the countryside at night, flying like the wind with its large red eyes" (Washington, 1983, p. 55).

These are hardly attitudes Monet brings to his treatment of the subject. In *The Gare Saint-Lazare* and its sunnier analogue in the Louvre (fig. 1)—indeed, in the series as a whole—he seems not at all preoccupied with Rivière's "impatient and temperamental beast" or with Couture's "monster with a bronze shell." Nor are these attitudes that characterize Monet's earlier paintings of locomotives and the

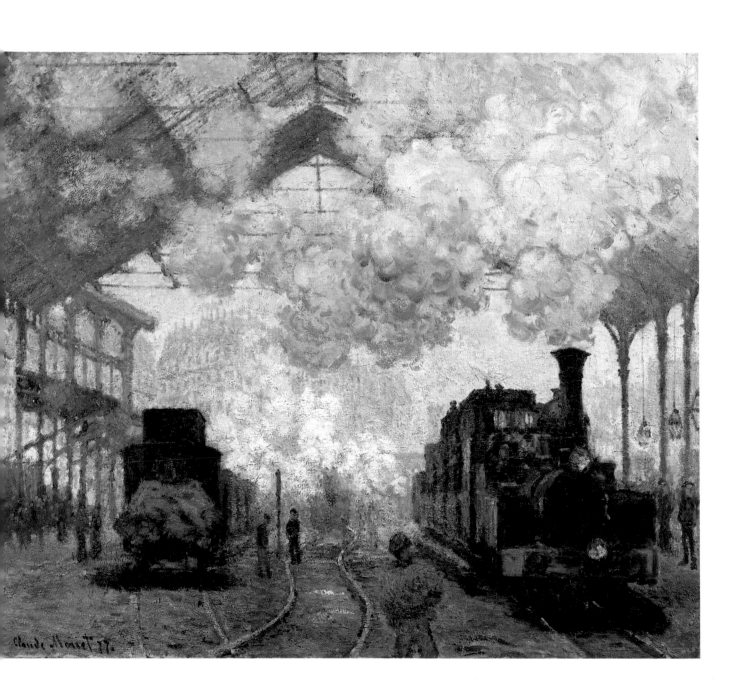

Figure 2.
A. Lamy. *The Pont de l'Europe and the Gare Saint-Lazare*, wood engraving. From *L'Illustration*, 11 April 1868. Widener Library, Harvard University.

railroad (W 153, 194, 213, 242, 356, and 364). Instead, in the Wertheim painting he has concerned himself with trying to organize a set of notations on canvas dealing in some way with the push and pull of steel and the diffuse billowing of evanescent smoke—all in a shifting blue-gray light. To accomplish this, he positioned himself inside the largest of the glass-and-steel sheds that covered the platforms of the station and faced in the direction of the Pont de l'Europe on the outside (fig. 2). Rivière, in fact, grasped Monet's primary preoccupation when he wrote that in the series, "more than anywhere else, Monet displays the knowledge of arranging and distributing elements on a canvas, which is one of his master qualities" (Rivière, 1877A, p. 10).

In *The Gare Saint-Lazare* the arrangement of elements is essentially bipartite. In the bottom half there are clear indications—despite the looseness of the painted surface—of spatial depth and the hard solidity of metal objects. In the top half of the painting, by contrast, the existing spatial clues contradict one another, and the weightiness at ground level gives way to an impression of insubstantiality. This, too, was deliberate on Monet's part—or so it seems, for he traced the metal grid over the steam and smoke rather than contriving to place the metal crossbars *behind* the rising steam and smoke.

There were good reasons why Monet chose the Gare Saint-Lazare to paint rather than one of the other five stations in Paris. The station serviced the line to Argenteuil, where his family was still living, so it was the terminus he used regularly to shuttle back and forth between the city and suburbia (Tucker, 1982, p. 169). It was also the terminus that had figured in Manet's *The Railroad* of 1872–1873 (RW 207) and Caillebotte's *The Pont de l'Europe* of 1876 (Petit Palais, Geneva). In order to paint the series, Monet obtained official clearance to work in the station (W, letter 100). He also rented, with help from Caillebotte, a small apartment nearby in the rue Moncey (W, letter 101).

In the months between January and April, Monet must have been working on several canvases in the series at the same time. *The Gare Saint-Lazare*, like *Red Boats, Argenteuil* (cat. 4), has an air of spontaneity, the quality of a painting improvised on the spot in exactly the kind of smoky blue light represented in the picture. But appearances are deceptive, and Monet, it has been observed, "was an artful contriver whose technique, only in appearance improvisatory, was as complicated as Cézanne's, and usually involved as many separate stages as those which lay behind a Renaissance landscape" (Herbert, 1979, p. 92; also discussed in Auckland, 1985, p. 12). While Monet began the painting in the station, much of the work on the canvas would have been done in his small rented apartment, the picture stacked against others when not on the easel. (It is still possible to discern at the four corners, and at the top and bottom in the center, circular indentations in the paint caused by the stacking.) The air of

Figure 3.
Detail, *The Gare Saint-Lazare;
Arrival of a Train*, reproduced actual
size.

spontaneity, therefore, is a tour de force of calculation. It springs from
the weight and variety of Monet's brushstrokes and from closely
valued hues that are overlaid with thinner surface colors, often
pulling in a different direction from those underneath (fig. 3).

Provenance: Monet to Ernest Hoschedé, Paris, March 1877; Charles Deudon,
Paris, October 1877; Paul Rosenberg, Paris, 1919; Mme. Emile Staub-
Terlinden, Männedorf, Switzerland, ca. 1923; Wildenstein, New York, to
Maurice Wertheim, June 1945.

Bibliography: Paris, 1877, no. 100; Rivière, 1877A, pp. 9–10; Rivière,
1877B, p. 301; Zurich, 1919; Deudon, 1920, p. 307; Geffroy, 1922, p. 92;
René-Jean, 1923, p. 472; Paris, 1925, no. 47; Courthion, 1926, pp. 42,
45; Amsterdam, 1930, no. 220; Paris, 1937, no. 374; Frankfurter, 1937,
repr. p. 11; Venturi, 1939, I, p. 152 and II, p. 312; New York, 1945B, no. 24;
Frankfurter, 1946, p. 64, repr. p. 28; Cambridge, 1946, pp. 12–15, repr.
p. 13; Reuterswärd, 1948, p. 281, repr. p. 108; Quebec, 1949, no. 5, pp. 14–
16; Seitz, 1960, pp. 29, 106–107; Raleigh, 1960, p. 26, repr. p. 27;
Houston, 1962, pl. 11, pp. 32–33; Gimpel, 1963, pp. 144–145, 177;
Augusta, 1972A, no. 21; W 439; Coolidge, 1975, p. 6; Levine, 1975, p. 7;
Levine, 1976, pp. 27, 30, 33; Isaacson, 1978, pp. 22, 45, 108 (ill.), 210–
211; White, 1978, pp. 9–10, fig. 4; Herbert, 1979, p. 108; Walter, 1979,
p. 52, repr. p. 55; Paris, 1980, p. 159; Tucker, 1982, p. 169, fig. 149; Gordon
and Forge, 1983, pp. 77, 78 (ill.); Auckland, 1985, p. 12; Friesinger, 1985,
p. 40 (ill.); San Francisco and Washington, 1986, pp. 189, 191 (fig. 2), 198.
Bequest—Collection of Maurice Wertheim, Class of 1906, 1951.55

Claude Monet

Paris 1840–Giverny 1926

6. *Madame Paul,*
1882

Oil on canvas, 65.2 x 54.6 cm.
(25¾ x 21½ in.)
Signed and dated in purplish-brown
paint, lower left: Claude Monet 82

Figure 1.
Claude Monet. *Paul Graff*, oil on canvas, 1882. Kunsthistorisches Museum, Vienna.

Madame Paul is a portrait of Eugénie, wife of Paul Graff, a pastry cook and innkeeper. It was executed at speed—probably in a single sitting—and the result, like the companion portrait of her husband (fig. 1), is summary. All areas of the head and bust, as well as the face of the terrier (reportedly named Follette) that accompanies her, are constructed from loose, rough strokes of paint in broken colors; and the ground of the canvas is clearly visible in most places.

It is likely that Monet painted *Madame Paul* while he was a guest at the Graffs' inn between mid-February and mid-April 1882. At the time he wrote of the couple as "these good people" who are "full of attentions for me" (W, letter 242). The inn was located in Pourville, a small fishing village on the Normandy coast near Dieppe and the place Monet chose as a principal base from which to strike out on painting excursions along the coastline during 1882.

Monet included the portrait of Paul Graff (though not the Wertheim painting) in an exhibition in Paris, at Durand-Ruel, in March 1883. He considered it a "curious sketch" (W, letter 320) and seems to have doubted its success. Paul Labarrière, a critic generally well disposed to Monet's work, echoed those doubts and faulted Monet for having painted the portrait as though it were a landscape (W, p. 14, note 158). But William Seitz, writing in 1960, commented favorably on the landscape affinity, pointing to Monet's turbulent cliff faces of the same period as having an analogous quality (Seitz, 1960, pp. 31, 116).

A small picture of the head of the terrier, not previously catalogued, appeared recently at auction (Sale, New York, Sotheby, 16 May 1984, no. 338).

Provenance: Paul Graff, Pourville, 1882; Knoedler; Durand-Ruel, Paris, 1899; Jules Strauss, Paris, 1900; Durand-Ruel (Strauss sale, Hôtel Drouot, 3 May 1902, no. 38); A. A. Hébrard, Paris, 1905; Prince de Wagram; Durand-Ruel, Paris, 1908; H. O. Miethke, Vienna, 1910; Paul Wittgenstein, Vienna; Jacques Seligmann (Wittgenstein sale, Stuttgarter Kunstcabinett, 18–20 May 1954, no. 355); acquired from Jacques Seligmann through the Wertheim Fund, Inc., in 1955.

Bibliography: Vienna, 1903, no. 38; Boston, 1905; Fitzgerald, 1905, pl. 41; Grappe, 1909, pp. 26, 78; Vienna, 1910, no. 26; Geffroy, 1920A, p. 60 (ill.); Geffroy, 1922, pp. 305–306; Reuterswärd, 1948, p. 143; Besson, 1949, p. 41; Deknatel, 1955, repr. inside front cover; Hoschedé, 1960, I, p. 119; Seitz, 1960, pp. 31, 116; Raleigh, 1960, p. 30, repr. p. 31; Seligman, 1961, pl. 91; Houston, 1962, pp. 32–33; Gimpel, 1963, p. 181; Augusta, 1972A, no. 22; W 745; Paris, 1980, pp. 235–236. Gift—The Wertheim Fund, Inc., 1955.98

Pierre-Auguste Renoir

Limoges 1841–Cagnes 1919

7. *Self-Portrait at Thirty-Five*, 1876

Oil on canvas, 73.2 x 57.1 cm.
(28¾ x 22½ in.)
Signed in brown wash, upper right:
Renoir (added subsequently at the
request of Ambroise Vollard)

In *Self-Portrait at Thirty-Five*, Renoir presents an idealized picture of himself at work on his own portrait. The profile he offers the viewer is serene (it might almost be described as bland), adorned with a fashionably trimmed beard and mustache above a silk lavalier knotted at the neck of a gray suit. A brushed bowler hat covers a slightly balding forehead that is apparent in a self-portrait from the year before (fig. 1). The outline of his easel, and of his hand grasping palette and brushes, can just be distinguished among the loosely delineated forms on the right side of the painting.

Renoir was above all a painter of portraits. He executed, by one count, over two thousand in the course of his life (Daulte, 1964, p. 75). Until the mid-1880s, the preponderance were portraits of friends—other Impressionist painters, musicians, critics, the circle at the Café Nouvelle-Athènes—and of the *haute bourgeoisie* who began to patronize him about the time he painted *Self-Portrait at Thirty-Five*. In particular, he was taken up by Georges Charpentier—the publisher of Flaubert, Alphonse Daudet, Maupassant, the Goncourt brothers, and Zola—who commissioned him to paint portraits of his wife and children (Rewald, 1973, pp. 381–382). By the late 1870s, Madame Charpentier had come to view Renoir as her "painter in ordinary," her own court artist, inviting him to attend the salon she organized as a meeting place for left-wing politicians and writers (London, 1985, p. 20). Moreover, Renoir's *Portrait of Madame Charpentier and Her Children* (1878, Metropolitan Museum of Art,

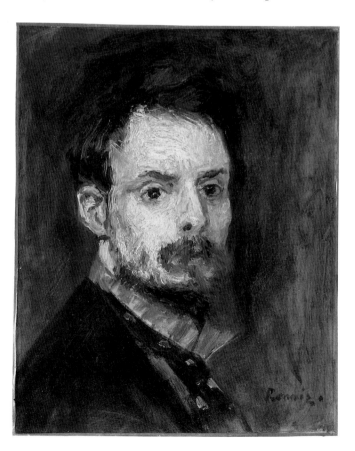

Figure 1.
Pierre-Auguste Renoir. *Self-Portrait*, oil on canvas, 1875. Sterling and Francine Clark Art Institute, Williamstown, Mass.

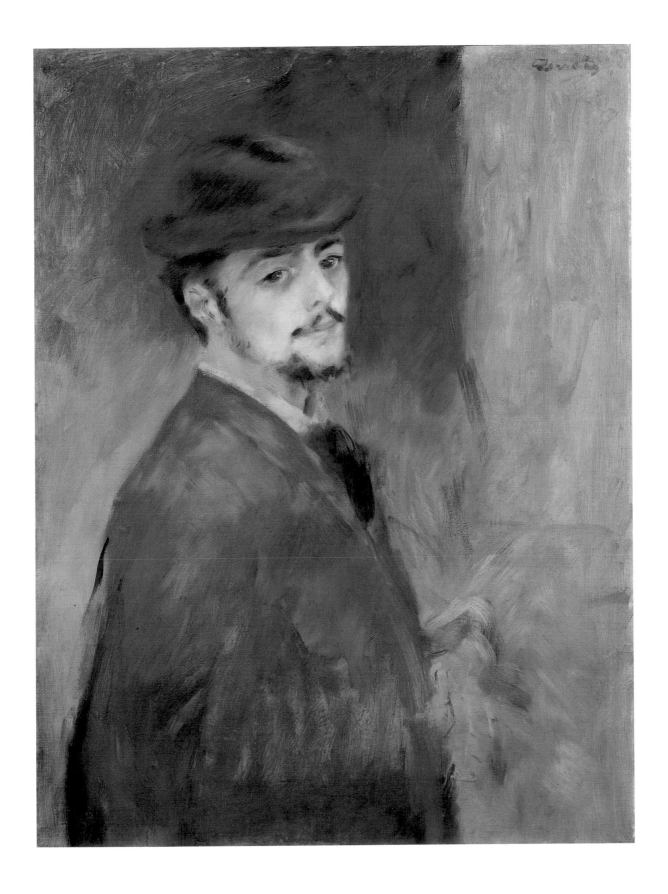

New York) was a success not only with the Charpentiers but also with critics of the 1879 Salon—and therefore helped gain him additional portrait commissions. However, after his marriage in 1885, Renoir turned his attention almost exclusively to the members of his own household as subjects for portraiture (see cat. 10).

Renoir's strategy for drawing attention to the face in *Self-Portrait at Thirty-Five* depends, in part, on careful and calculated shifts of geometry and color. The head is set at the juncture of two blurred, irregular triangles and is given emphasis by surrounding colors darker in value than those in the rest of the painting. These are devices that stand in marked contrast to the ones employed by Renoir in the more ruggedly painted self-portrait of 1875. It is also worth observing that the Wertheim self-portrait was executed extremely rapidly—so rapidly that in the lower portion of the painting Renoir did not even take time to define the placement of the right arm precisely. The arm may be read as descending straight down or as stretching horizontally across the body (see Appendix C). Renoir apparently changed his mind about situating the arm horizontally but felt no compulsion to erase it completely.

Provenance: Ambroise Vollard, Paris; Paul Guillaume, Paris, 1929; Brandon Davis, London; Josef Stransky, New York, by 1931; William H. Taylor, Philadelphia, by 1937; Knoedler, New York, to Maurice Wertheim, December 1946.

Bibliography: Vollard, 1918, I, no. 279, pl. 70; Vollard, 1920, repr. opposite p. 32; Flint, 1931, pp. 87–88, repr. p. 86; New York, 1931, no. 11; Philadelphia, 1933, p. 19, no. 158; Boston, 1935, no. 40; London, 1936, no. 10; McBride, 1937, p. 60, repr. p. 71; New York, 1938, no. 34; Wilenski, 1940, p. 339; New York, 1940B, no. 34; Goldwater, 1940, p. 14, repr. cover; New York, 1941A, no. 21; New York, 1943C, no. 89; Quebec, 1949, no. 4, pp. 11–13; Raleigh, 1960, p. 46, repr. p. 47; Houston, 1962, p. 44; Daulte, 1964, pl. 2, p. 75; D 191; Augusta, 1972A, no. 29; Fezzi, 1972, no. 233; White, 1984, pp. 57, 219, repr. p. 62. Bequest—Collection of Maurice Wertheim, Class of 1906, 1951.61

Pierre-Auguste Renoir

Limoges 1841–Cagnes 1919

8. *Seated Bather,* ca. 1883–1884

Oil on canvas, 119.7 x 93.5 cm.
(47⅛ x 36¾ in.)
Signed in blue paint, lower left:
Renoir

Seated Bather was painted ca. 1883–1884, just prior to the extended three-year period during which Renoir worked on the *Large Bathers* (see cat. 9). This was a period of crisis and transition for Impressionism and the Impressionists, not least for Renoir, as he later admitted to Vollard: "Around 1883 there occurred what seemed to be a break in my work. I had wrung Impressionism dry and I came to the conclusion that I didn't know either how to paint or to draw. In a word, I was at an impasse" (Vollard, 1938, p. 213). Although Renoir's memoir dramatizes and simplifies the impasse by focusing on departures and ignoring continuities, it is true that his work of the mid-1880s stands apart from that of the preceding and following periods. Albert Barnes, who by 1935 was the largest collector of Renoir in the United States with one hundred and seventy-five paintings, even went so far as to judge it with partisan excess "an excrescence upon the organic structure of his work as a whole" (Barnes and de Mazia, 1935, pp. ix and 76).

Without concurring with Barnes's rejection of Renoir's work of the mid-1880s, one can recognize in the *Seated Bather* a peculiar tension between the representation of the figure and its environment. The nude bather, given weight and solidity and painted in soft pinks and yellows, does not seem to be integrated with the rocks and water encircling her. There is a disjunction between the strongly outlined figure and the brilliantly colored landscape that seems to fall like a tapestry behind her, a disjunction emphasized by Renoir's handling of his medium. Renoir painted the bather's flesh smoothly and evenly, taking care in the modeling of forms. In the rocks and the water, on the other hand, the brushstrokes are clearly visible and applied with fluidity and apparent spontaneity. It is as if Renoir aimed to find in the human figure what was permanent and palpable, and in the natural environment what was fluctuating and contingent; that is, to inject form and structure into the Impressionist aesthetic of flux.

John House has an explanation for the discrepancy between Renoir's treatment of the figure and his treatment of the space around her (London, 1985, pp. 239–240). He argues that *Seated*

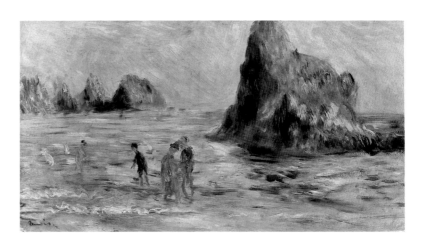

Figure 1.
Pierre-Auguste Renoir. *Moulin Huet Bay, Guernsey*, oil on canvas, 1883.
National Gallery, London.

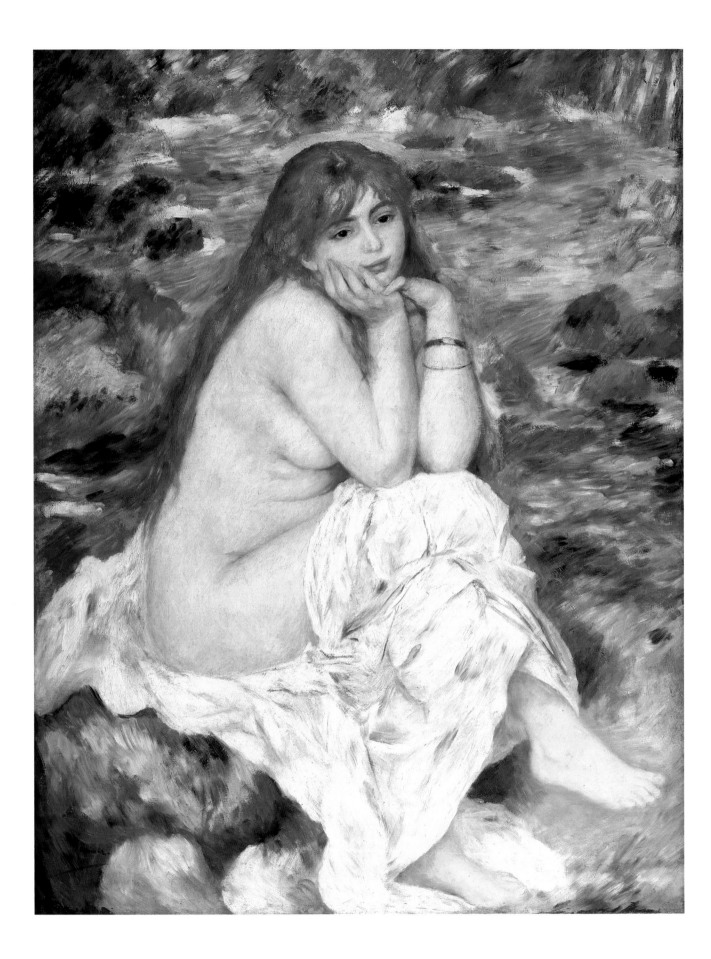

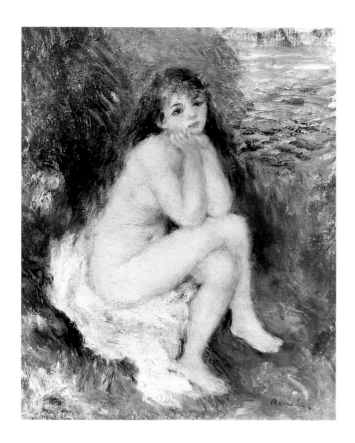

Figure 2.
Pierre-Auguste Renoir. *Naiad*, oil on canvas, 1876. Private Collection.

Figure 3.
Pierre-Auguste Renoir. *By the Seashore*, oil on canvas, 1883. Metropolitan Museum of Art, New York. H. O. Havermeyer Collection.

Bather was executed in a composite fashion—that the background was worked up from small sketches of rocky beaches that Renoir brought back to Paris from the island of Guernsey in the fall of 1883 (fig. 1), and that the figure was posed in his studio in Paris in the winter of 1883–1884, when he was concerned about giving the human form somatic substance. House points out that Renoir had written to Durand-Ruel from Guernsey on 27 September with the information that he would be returning to Paris with some "documents" and "pleasing motifs" that he hoped to be able to exploit in his painting (Venturi, 1939, I, pp. 125–126). In the same letter Renoir offered an account of bathing practices on the island: "Here one bathes among the rocks which serve as bathing cabins, because there is nothing else; nothing can be prettier than this mixture of women and men crowded together on the rocks. One would think oneself in a Watteau landscape rather than in reality. . . . Just as in Athens, the women are not at all afraid of the proximity of men on the nearby rocks." Renoir's reference to Athens was not a chance remark; it demonstrates, as this painting does, how much he was preoccupied with ideas about classical form.

House's argument is strengthened by the existence of a small oil, *Naiad*, executed in 1876 (fig. 2). Renoir borrowed the arrangement of the figure in this painting for the pose of the nude figure in *Seated Bather*. Therefore, just as he used the outdoor sketches made on the island of Guernsey for the background of the Wertheim painting, so

he used his own work of the 1870s for the composition of the figure. Until recently the painting has generally been dated to 1885. This date is plausible; Renoir did not deposit the painting with his dealer, Durand-Ruel, until January 1886. But both the stylistic evidence and the subject matter strongly suggest an earlier date of ca. 1883–1884 (London, 1985, pp. 239–240). The brushwork and handling connect it persuasively to *By the Seashore* (fig. 3), which is firmly dated to 1883, a painting in which the figure also seems to sit in an uneasy relation to the seascape behind it.

When Maurice Wertheim purchased the *Seated Bather* in November 1946 for $125,000, he paid close to the record price for a painting by Renoir up to that time. The transaction was accompanied by fanfare and newspaper headlines and was announced at a dinner aboard the French liner *Ile de France* to launch a fund-raising drive for health facilities in France. The headlines read: "Renoir Painting Sold, Proceeds to Aid France," for it had been arranged that the seller, Mrs. Jacques Balsan, would donate all proceeds to the financial organizing committee (*New York Herald Tribune*, 21 November 1946, p. 48). This direct association of French art with American funding of European postwar reconstruction followed the example set during the war, when support for French art became closely associated with support for the Allied war effort (see the Introduction).

Provenance: Deposited with Durand-Ruel by Renoir, January 1886; purchased by Durand-Ruel from Renoir, 1892; Mrs. Berthe Honoré Potter Palmer, Chicago, 1892; Durand-Ruel, New York, 1894; Mrs. Jacques Balsan, New York, 1930; Maurice Wertheim, through Durand-Ruel, November 1946.

Bibliography: Boston, 1913, no. 252; New York, 1914, no. 19; New York, 1917, no. 12; Geffroy, 1920B, p. 157; Rivière, 1921, repr. opposite p. 40; De Régnier, 1923, pl. 17; New York, 1924, no. 14; Coquiot, 1925, repr. opposite p. 40; Detroit, 1927, no. 91; Besson, 1929, pl. 16; Meier-Graefe, 1929, no. 179; London, 1932, no. 544; Paris, 1933, no. 78, pl. XLIV; Barnes and de Mazia, 1935, pp. 408–409, no. 142; Brussels, 1935, no. 64; Roger-Marx, 1937, repr. p. 105; *New York Herald Tribune*, 1946, p. 48; Quebec, 1949, no. 10, pp. 27–29; Raleigh, 1960, p. 42, repr. p. 43; Houston, 1962, pl. 17, pp. 44–45; D 490; Augusta, 1972A, no. 30; Fezzi, 1972, no. 620; Boggs, 1978, pl. XIX, p. 118; London, 1985, pp. 110–111 (ill.), 221, 239–240; Friesinger, 1985, p. 40 (ill.), p. 43. Bequest—Collection of Maurice Wertheim, Class of 1906, 1951.59

Pierre-Auguste Renoir

Limoges 1841–Cagnes 1919

9. *Two Nude Women, Study for the "Large Bathers,"* ca. 1886–1887

Red and white chalk on yellowed paper, 125 x 140 cm. (49¼ x 55⅛ in.) Signed in red chalk, lower right: Renoir

This drawing is an elaborate, full-scale study for Renoir's *Large Bathers*, 1887, in the Philadelphia Museum of Art (fig. 1). It is one preparatory study among many that Renoir made for the oil (Rewald, 1946B, pls. 52–43). In spite of numerous pentimenti, which indicate that the composition was still at a developmental stage at the time the drawing was done, the general outlines of the poses closely match those of the finished painting; only the right arm of the center bather does not correspond to its final position. The drawing was once attached to a smaller sheet, now in a private collection, representing the three figures on the right side of the painting (White, 1984, ill. p. 168).

Two Nude Women reflects the classicizing turn in Renoir's art. The change of direction began in the early 1880s, coinciding with Renoir's visit to Italy in the autumn of 1881. ("I have suddenly become a traveller," Renoir wrote to Madame Charpentier, "and I am in a fever to see the Raphaels" [Florisoone, 1938, p. 36].) This was a time, not coincidentally, when Impressionist practice—that of Monet, Pissarro, and Renoir in particular—was in crisis. The crisis was double-sided: first, what to paint; and, second, how to paint it. The strategies for representation that had worked for Renoir and the other Impressionists in the 1870s no longer seemed to them sustainable or even appropriate. Renoir's way around the impasse was to revert to the past. In place of themes from contemporary life, he substituted traditional themes; and in place of subtle imprecisions in style, he substituted a traditional emphasis on modeling and contour of the kind he admired in Raphael and Ingres.

Large Bathers takes as its major compositional source a seventeenth-century bas-relief sculpture by François Girardon, *Nymphs Bathing*, at the Fountain of Diana in the park at Versailles (fig. 2). Though Renoir's composition departs from Girardon's relief, the

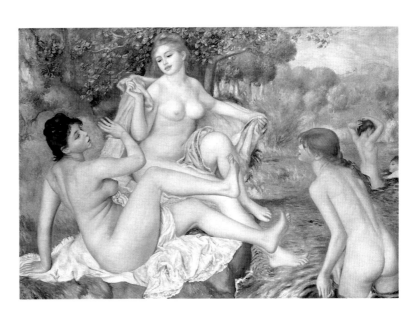

Figure 1.
Pierre-Auguste Renoir. *Large Bathers*, oil on canvas, 1887. Philadelphia Museum of Art. Mr. and Mrs. Carroll S. Tyson Collection.

Figure 2.
François Girardon. *Nymphs Bathing* (detail), bas-relief sculpture, 1668–1670. Fountain of Diana, Versailles.

general disposition of the figures (for which Suzanne Valadon posed) and many details of their gestures—for example, the raised arm of the foreground figure in the drawing—clearly derive from it. Renoir gives his figures a monumentality of form, an almost sculptural volume, that is closely allied to Girardon's. And as if to declare his allegiance to traditional procedures, he uses the medium of red chalk —by then anachronistic—to complete his study.

Provenance: Mme. Abel Desjardin, Paris; Knoedler Gallery, New York, to Maurice Wertheim, March 1947.

Bibliography: Meier-Graefe, 1929, p. 191, fig. 177; Paris, 1933A, no. 42; Rewald, 1946B, pl. 42, pp. 19–20; Quebec, 1949, no. 29, pp. 75–76; Reynolds, 1949, pl. 10, p. 22; Pach, 1950, p. 18, repr. p. 19; Fox, 1953, p. 1; Sachs, 1954, pl. 27; Hunter, 1958, pl. 13; Mathey, 1959, repr. p. 134; Raleigh, 1960, p. 68, repr. 69; Reiff, 1968, pp. 23–25, fig. 11; Fezzi, 1972, pl. 630J, p. 117; White, 1984, p. 168 (ill.). Bequest—Collection of Maurice Wertheim, Class of 1906, 1951.77

Pierre-Auguste Renoir

Limoges 1841–Cagnes 1919

10. *Gabrielle in a Red Dress*, 1908

Oil on canvas, 54.6 x 45.7 cm.
(21½ x 18 in.)
Signed in brown wash, lower right:
Renoir

Figure 1.
Pierre-Auguste Renoir. *Gabrielle with a Rose*, oil on canvas, 1911. Musée d'Orsay (Jeu de Paume), Paris.

Gabrielle Renard (1878–1959) became a servant in the Renoir household in 1894, shortly before the birth of Renoir's second son, Jean. She functioned as nursemaid to the children, as housekeeper, and, in due course, as model and companion to the aging and rheumatic invalid painter. She left the household only in 1914 to marry the American painter Conrad Slade. *Gabrielle in a Red Dress* was for a time in the collection of Jean, who many years later wrote warmly about Gabrielle in the book on his father (Renoir, 1962).

Gabrielle is the subject of over two hundred paintings by Renoir (Daulte, 1964, p. 75). She is also the principal figure (serving as model) in countless other paintings completed after 1903, when Renoir began to spend extended periods in the South of France for reasons of health. This painting presents the sitter at the age of thirty, and despite its roseate tones, it functions as a convincing portrait, one of Renoir's least idealized paintings of Gabrielle. Her broad shoulders are shown sloping heavily down, and her eyes, especially her oddly aligned left eye, are represented as passive. The portrait stands in marked contrast to a sequence of paintings of Gabrielle which Renoir executed around the time of its completion in 1908 (London, 1985, pp. 282–283). The sequence is comprised of works in which Gabrielle is displayed primarily as an object for sensual contemplation—blouse open, breasts bare, adorned with flowers and jewelry (fig. 1)—and as a pretext for broadly orchestrated painterly effects.

Shortly after *Gabrielle in a Red Dress* was painted, Renoir was questioned about his working procedures. He responded as follows: "I arrange my subject as I want it, then go ahead and paint it, like a child. I want a red to be sonorous, to sound, like a bell; if it doesn't turn out that way, I put more reds or other colors till I get it. I am no cleverer than that. I have no rules and no methods; anyone can look over my shoulder or watch how I paint—he will see that I have no secrets" (Pach, 1912, p. 610). However, at other times Renoir could admit to considerable sophistication in his painting procedures and the results that followed (Renoir, 1962, pp. 220–221).

Provenance: Jean Renoir, son of the artist, Paris; Albert Flechtheim, Berlin, 1927; A. Conger Goodyear, New York; Paul Rosenberg, New York, to Maurice Wertheim, December 1943.

Bibliography: Berlin, 1927, repr. p. 10; Philadelphia, 1933, p. 18; Elder, 1935, II, no. 367, pl. 117; New York, 1941A, no. 77; New York, 1948B, no. 26; Quebec, 1949, no. 23, pp. 63–64; Pach, 1950, p. 102, repr. p. 103; Raleigh, 1960, p. 44, repr. p. 45; Houston, 1962, p. 44; Augusta, 1972A, no. 31. Bequest—Collection of Maurice Wertheim, Class of 1906, 1951.60

Edouard Manet

Paris 1832–1883

11. *Skating*, 1877

Oil on canvas, 92 x 71.6 cm.
(36¼ x 28¼ in.)
Signed in red paint, lower right: Manet

The earliest account of Manet's *Skating*, written by Edmond Bazire and published in 1884, has not often been referred to by subsequent writers but deserves close attention. Bazire wrote: "A crowd of strollers forms a circle around the parquet floor where the skaters exercise. Against the railing covered in red velvet, on the outside among the spectators, a lady of fashion supports herself and watches those who arrive. Her face is charming despite her make-up (or because of her make-up) and is framed by hazy blond hair jutting out beneath a black hat. Her slender figure, under a capriciously braided dress in pearl gray, is appetizing. Behind this woman, another, more somber, calls or counsels her, while all around them is infernal movement" (Bazire, 1884, p. 130).

Bazire's observations merit investigation. He is surely correct in noticing the contrast between the main figure in the center of the composition and what he chooses to call the "infernal movement" of all those around her. The hard, flat contours of her made-up face and black dress do separate her from the skaters and the congregated onlookers at the rail on the far side of the rink. For Manet has painted the onlookers with broken, sketchy brushstrokes that have the effect of fusing the row of figures into an undifferentiated crowd. And he has painted the pair of skaters to the upper right in the same manner, oddly wedging them between the inclined heads of the two women looking out of the painting. These figures are disproportionately small in size for their place in the composition and, from the waist down, appear to dissolve into the surface of the rink.

Manet's abrupt transitions in the painting from foreground to background and from detailed head to dissolving figure are characteristic of his treatment in other paintings that take contemporary life as a subject (*Café-Concert*, 1878, RW 280, and *A Bar at the Folies-Bergère*, 1881–1882, RW 388). The abbreviations serve two purposes that reinforce one another. On the one hand, they deflect attention from the subject represented and toward the means of representation, the actual process of handling the paint; and, on the other hand, they make the subject matter, when it is reconsidered (as it must be if we look long enough), seem doubly incongruous and strange. The result is to give the painting, with its emphasis on the artifice of its own making, a status comparable to the uncertain appearance of modern life being offered for our inspection (Clark, 1984, chapter 4).

Bazire's account provides valuable evidence on exactly which activity of modern life the painting represents. His opening sentence describes the strollers as forming a circle around "the parquet floor" on which the skating takes place. Clearly, he considers that the kind of skating depicted is roller skating, a diversion that became suddenly fashionable in Paris in the winter of 1875–1876. The vogue caught on following the construction by an entrepreneur of a "skating rink"—the English term was retained to emphasize the novelty—in the

Figure 1.
Oswaldo Tofani. *The Skating-rink at the Closerie des Lilas*, steel engraving. From *L'Illustration*, 15 April 1876. Widener Library, Harvard University.

Figure 2.
Edouard Manet. *Nana*, oil on canvas, 1877. Kunsthalle, Hamburg.

Cirque des Champs-Elysées (*L'Illustration*, 4 December 1875, p. 359). And in the next two years others followed in the Faubourg Saint-Honoré, at the Closerie des Lilas (fig. 1), on the rue de Clichy, and on the avenue du Bois de Boulogne, each new rink hoping to outdo its rivals in scale and opulence. The interior of the huge structure on the avenue du Bois de Boulogne, when it opened after decoration on 2 March 1878, was reported to look like an "enchanted palace" filled with flowers and birds and places for dining, with an orchestra and a special salon where one could retire to "survey paintings, bronzes, statuettes and objets d'art." The spectacle itself could be viewed from raised promenades and boxes (*L'Illustration*, 9 March 1878, p. 158).

Until recently, however, it has been assumed that the setting depicted in the painting is an ice-skating rink (Gribbon, 1982, p. 193, corrects the assumption). Some accounts have even referred to the presence of artificial ice, perhaps to explain the green foliage above the heads of the onlookers or the absence of appropriately warm clothing on most of the participants (Moreau-Nélaton, 1926, p. 44; Hanson, 1976, p. 175). But any misreading should hardly be considered surprising, for Manet has not provided the necessary visual information that might permit a properly unambiguous reading. The reflecting surface of the rink (to emphasize the most salient ambiguity), which is painted mostly in parallel strokes of mixed grays, might reasonably represent ice, asphalt, or polished wood. Who can say? And the spinning feet of the male skater pirouetting over the left shoulder of the central figure might equally well be balanced on rollers as on blades. It is not a matter to be decided simply by *looking*.

There is no such ambiguity in Manet's handling of the central figure, at least on the level of detail. All the essential parts are clearly in place, from the modeled face to the embroidered dress to the gloved hands. But the social status of the figure is another question and no less problematical in its own way than the physical status of the skating rink's surface. Bazire's perception of that status is expressed in his choice of language; he describes the black dress as "capriciously braided," the face as "made-up," and the "slender figure" as "appetizing." In other words, for him she has the appearance of an elegantly dressed courtesan. But Bazire nowhere mentions that the woman is represented grasping the hand of a child. Instead of a courtesan, then, might she not be a well-to-do mother (also over-dressed, to be sure) taking her pink-faced child on an outing? On the basis of the evidence given in the painting, there is no deciding. It really does not alter the situation, though the information is of interest in other ways, that Henriette Hauser, whom Manet used for his model, was the celebrated mistress of the Prince of Orange when not posing for Manet or pursuing a career as an actress (New York, 1983, pp. 347 and 593). Manet used Mlle. Hauser as his model in *Nana* (fig. 2), another painting from 1877, in which she is represented as a

déshabillé figure powdering her nose in the presence of a gentleman.

All this indicates that Manet calculated the impact of the socially suggestive signifiers in this painting with considerable care. There is even evidence to indicate that he may have altered his original conception of *Skating* in order to enlarge on its areas of ambiguity. That he did alter his conception is not open to dispute, for the child's head, barely materializing in the bottom left corner, is unquestionably a late insertion. Underneath the thin impasto that forms it are still visible the black garments of the central figure and of the top-hatted gentleman exiting to the left. Moreover, X-ray photographs demonstrate that the position of the woman's right arm, which formerly extended diagonally across her body, was shifted by Manet to a perpendicular position so that it might link up with the child's hand (Appendix C, fig. 1). It is probable (again from the X-rays) that before this shift Manet had incorporated a taller, larger child into the immediate foreground, its head rising to the woman's waist. The substitution for that figure of one less obvious may have been a matter of compositional balance, or it may have been a matter of informational balance. Possibly it was both.

Provenance: In Manet's studio at his death (inventory no. 25); Emmanuel Chabrier (Vente Manet, Paris, Hôtel Drouot, 4–5 February 1884, no. 8); repurchased by Manet family (Vente Chabrier, Paris, Hôtel Drouot, 26 March 1896, no. 9); Durand-Ruel, Paris, 1897; Auguste Pellerin, Paris, 1897; Bernheim-Jeune, Paris, to Joseph Hessel, Paris, 1909; Mme. Fürstenberg-Cassirer, Berlin; Paul Cassirer, Berlin; Mme. Fürstenberg-Cassirer, Paris; Maurice Wertheim, by July 1949.

Selected Bibliography: Paris, 1880, no. 6; Bazire, 1884, p. 130; Paris, 1884, no. 8; Eudel, 1885, p. 173; J. L., 1896, p. 367; Duret, 1902, no. 225, p. 249; Munich, 1910, no. 17; Berlin, 1910; Proust, 1913, pp. 89–90, 101, repr. p. 24; Waldman, 1923, pp. 85, 109, repr. p. 119; Berlin, 1925; Moreau-Nélaton, 1926, II, pp. 44–45, 67, 107, fig. 224; Tabarant, 1931, pp. 314–315, no. 262; Jamot and Wildenstein, 1932, I, no. 279, II, fig. 160; Venturi, 1939, II, p. 214; Buenos Aires, 1939, no. 86; New York, 1941B, repr. no. 80, fig. 36; Tabarant, 1947, no. 280, pp. 314–315, 376, 491, repr. p. 612; Quebec, 1949, no. 6, pp. 17–19; New York, 1950, foreword, no. 5; Hamilton, 1954, p. 271; Raleigh, 1960, p. 20, repr. p. 21; Houston, 1962, pl. 7, pp. 24–25; Augusta, 1972A, no. 13; Hofmann, 1973, p. 11, fig. 12; RW 260; Hanson 1977, pp. 132, 175, 204, fig. 91; Gribbon, 1982, pp. 191–194, 199–204, fig. 79; Stuckey, 1983, pp. 14–15, repr. 14; New York, 1983, pp. 182, 407, 441; Friesinger, 1985, pp. 40, 41 (ill.). Bequest—Collection of Maurice Wertheim, Class of 1906, 1951.50

Georges Seurat

Paris 1859–1891

12. *Vase of Flowers,* ca. 1879–1881

Oil on canvas, 46.4 x 38.5 cm.
(18¼ x 15¼ in.)

This small still life, one of Seurat's earliest paintings, must be reckoned an oddity. It is the only still life he is known to have painted, and it dates from before 1881—before, that is, Seurat's precocious arrival at a mature style in 1882. De Hauke dates the painting to ca. 1879, after Seurat had finished his studies at the Ecole des Beaux-Arts but before he was called up for military service (DH 3). If this is accurate, the date puts *Vase of Flowers* among the earliest four of Seurat's surviving paintings. (Most of the early paintings were probably destroyed by Seurat himself [Herbert, 1962, p. 7].) Dorra and Rewald, however, prefer to date the painting to shortly after Seurat had been discharged from service in November 1880 (DR 7). Even this date places the painting among Seurat's earliest dozen surviving canvases.

In *Vase of Flowers* Seurat positions a cylindrical vase at the corner of a table draped with a white cloth and streaked with sunlight. Apart from the red flowers in the vase, which have been painted in impasto, the surface colors have been scumbled in thin layers over a broadly brushed ground that, in several parts of the painting, has been left visible. The effect is most obvious and striking on the upper portion of the vase, where broad, diagonal strokes of underpainting are played off against the muted, rubbed colors on top.

After returning to Paris in late 1880, Seurat undertook a program of intensive drawing, structuring his forms in terms of a balance of lights and shadows rather than line (see cat. 14). A similar preoccupation with tonalities is evident in *Vase of Flowers*. However, there is an equal preoccupation with juxtapositions of color. From the writings of Charles Blanc, Seurat had earlier become familiar with the color theories of Chevreul and the precepts of Delacroix. Seurat's notes on Delacroix's handling of color, made close to the time he must have been working on *Vase of Flowers*, are instructive. He wrote in a notebook on 23 February 1881: "Saw [Delacroix's] *Fanatics of Tangier* [Robaut, 1885, no. 662]. Effect of light concentrated on the principal fanatic. His shirt is streaked with delicate red strokes. Subtle tones of his head and arms. Yellowish or orangey trousers. . . . Delicacy of the orange-gray and blue-gray ground. Little girl in the left foreground. She is frightened. Gray-green white cloth accompanied by pink streaked undergarment, which is visible at the arm and at the lower part of the leg. Harmony of red and green" (Seurat, 1881, p. 13).

Provenance: Léon Appert, the artist's brother-in-law, Paris; Mme. Léon Roussel, née Appert, Paris, until June 1939; Galerie Bignou, Paris, June 1939; Bignou Gallery, New York, to Maurice Wertheim, March 1940.

Bibliography: Paris, 1933, Seurat, no. 155 (supplement); New York, 1942A, no. 15; Frankfurter, 1946, p. 64; Cambridge, 1946, p. 18, repr. p. 19; Rewald, 1948, pl. 17; New York, 1948C, no. 46; Quebec, 1949, no. 8, pp. 23–24; De Laprade, 1951, repr. p. 6; DR 7; Raleigh, 1960, p. 52, repr. p. 53; DH 3; Houston, 1962, p. 48; Augusta, 1972A, no. 33; Minervino, 1972, no. 5. Bequest—Collection of Maurice Wertheim, Class of 1906, 1974.100

Georges Seurat

Paris 1859–1891

13. *Seated Figures, Study for "A Sunday Afternoon on the Island of the Grande Jatte,"* 1884–1885

Oil on wood panel, 15.5 x 24.9 cm.
(6⅛ x 9¾ in.)
Inscribed in red paint (in a manner referred to as "cachet Moline" after the dealer responsible for the addition), lower right: Seurat

Few paintings from the late nineteenth century have been more insistently appropriated, for a variety of ends, than Seurat's *A Sunday Afternoon on the Island of the Grande Jatte* (Art Institute of Chicago, fig. 1). Not all of these ends have been equally flattering. Delmore Schwartz, profiting from an account of the painting written by Meyer Schapiro, made it the subject of a remarkable poem that begins by asking what the figures gaze at: "The sunlight on the river, the summer, leisure,/Or the luxury and nothingness of consciousness?" (Schwartz, 1959, pp. 190–196). On the other hand, an advertisement for a popular brand of beer, which fixes on a transmutated image of the painting, bears the fatuous caption: "As long as there are good times." The suggestion, of course, is that the particular beer is the complement to the "good times" represented in the painting.

But it is far from clear that the painting represents an equivalent of what today might be considered "good times." In Seurat's own time there was little consensus about the kind of leisure that a socially mixed, bourgeois populace might be said to enjoy on a recreational island in the Seine close to Paris, by rail about midway between the Gare Saint-Lazare (see cat. 5) and Argenteuil (see cat. 4). Thus Félix Fénéon described the idiosyncratic tableau of figures in Seurat's painting as a "fortuitous population enjoying the fresh air among the trees" (Fénéon, 1886, p. 110), while Alfred Paulet saw it differently as "the tedious to-and-fro of the banal promenade of these people in their Sunday best, who take a walk, without pleasure, in the places where one is supposed to walk on Sundays" (cited in Clark, 1984, p. 264).

Seated Figures is a finished oil sketch for the large canvas. Altogether, Seurat executed some thirty preparatory oil sketches and an equal number of preparatory drawings (DH 107–132, 135–142, and 616–644). The Wertheim sketch represents the site from almost the identical position as that chosen in the final version and, judging

Figure 1.
Georges Seurat. *Sunday Afternoon on the Island of the Grande Jatte*, oil on canvas, 1884–1886. Art Institute of Chicago. Helen Birch Bartlett Memorial Collection.

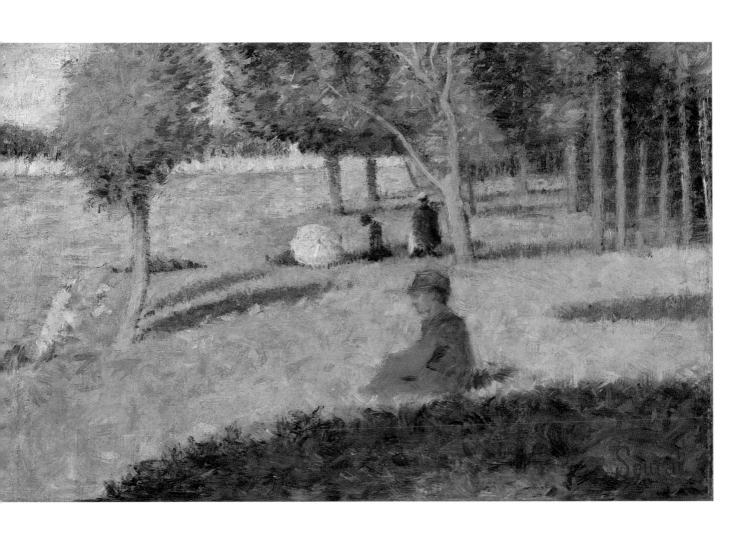

by the late-afternoon shadows, represents it at the same hour of the day (Cambridge, 1946, p. 24). In other details, however, the sketch corresponds less closely to the large canvas. Of the five figures seated or lying on the grass, only the central figure in the middle background has been incorporated without some alteration. Moreover, none of the figures exhibit the elements of peculiar, comic irony that are characteristic of the hieratically composed figures in the large canvas.

The sketch, or *croqueton* as Seurat liked to call his oil panels, is painted with short, crisscrossed, flickering brushstrokes of pure colors. Unlike the Impressionists, who favored a white ground, Seurat has used to advantage the rich, dark-toned surface of the wood panel, visible in most parts of the sketch, to help make the composition cohere. Strokes of lighter hues—yellow, orange, lighter green—are interspersed with darker complementary hues to construct the trees and the shadows. Except where the paint appears to have been applied wet-into-wet, as in the parasol, there is no obvious blending of colors (one account of Seurat's pointillist technique incorrectly asserts that there is no blending in this sketch at all [Homer, 1964, p. 122]).

Seurat set considerable store by his oil sketches for the *Grande Jatte*. Twelve of them were exhibited, with the assistance of Durand-Ruel, at the early date of 1885 in New York and subsequently in Paris (DH 216–221). De Hauke mistakenly identified the Wertheim panel as one of this group, and the error has been perpetuated (New York, 1977, no. 79). In fact, the panel now in the collection of the Barnes Foundation (DH 119) was the one exhibited in New York.

Provenance: Georges Lecomte, Paris; Alex Reid and Lefèvre, Glasgow and London, by 1927; D.W.T. Cargill, Lanark, Scotland, until 1932; Bignou Gallery, New York; Stanley L. Barbee, Beverly Hills; Maurice Wertheim (Barbee sale, New York, Parke-Bernet, 20 April 1944, no. 17).

Bibliography: Paris, 1908, no. 45; Glasgow, 1927, no. 39; Zervos, 1928, p. 366; London, 1932, no. 556; Chicago, 1935, no. 29; Cambridge, 1946, p. 24, repr. p. 25; New York, 1948C, no. 48; Quebec, 1949, no. 12, pp. 33–34; New York, 1950, foreword, no. 11; DR 122; Raleigh, p. 50, repr. p. 51; DH 123, p. 305; Houston, 1962, pl. 19, pp. 48–49; Homer, 1964, pp. 120–122; Russell, 1965, pl. 144, p. 157; Augusta, 1972A, no. 35; Minervino, 1972, no. 131; New York, 1977, no. 79. Bequest—Collection of Maurice Wertheim, Class of 1906, 1951.62

Georges Seurat

Paris 1859–1891

4. *Woman Seated by an Easel*, ca. 1884–1888

Black chalk on cream wove paper, 30.5 x 23.3 cm. (12 x 9¼ in.)
Watermark: MICHALLET
Inscribed on the verso: G–Seurat (twice in black chalk and once in blue chalk, all three in the same hand); £ (in blue chalk); 100 corrected to 300 (in red chalk)

This work belongs to a large group of independent drawings produced by Seurat as finished works of art rather than preparatory studies for paintings. The subject has been variously described as a woman reading, a woman sketching, or simply a young woman in a studio, and the date has been variously put at ca. 1884 (DH 601), ca. 1887 (Russell, 1965, pl. 145), and 1887–1888 (Herbert, 1962, pl. 117). These differences of opinion, given the evidence, are not readily adjudicated. Nor are they differences that, if settled, would significantly alter our understanding and appreciation of the drawing. It is more pertinent to ask how Seurat succeeded so well in placing and establishing a female figure—clothed in the curvilinear costume and elaborate headdress of the period—in a convincingly realized interior space, and how, at the same time, he succeeded in giving its form a decorative quality—the figure almost describes an arabesque—that, without apparent contradiction, compresses that interior space.

In large part the answer lies in Seurat's drawing technique, in his management of subtle contrasts of dark and light values. The technique is best studied in a detail (fig. 1). The distinctive results

Figure 1.
Detail, *Woman Seated by an Easel*, reproduced actual size.

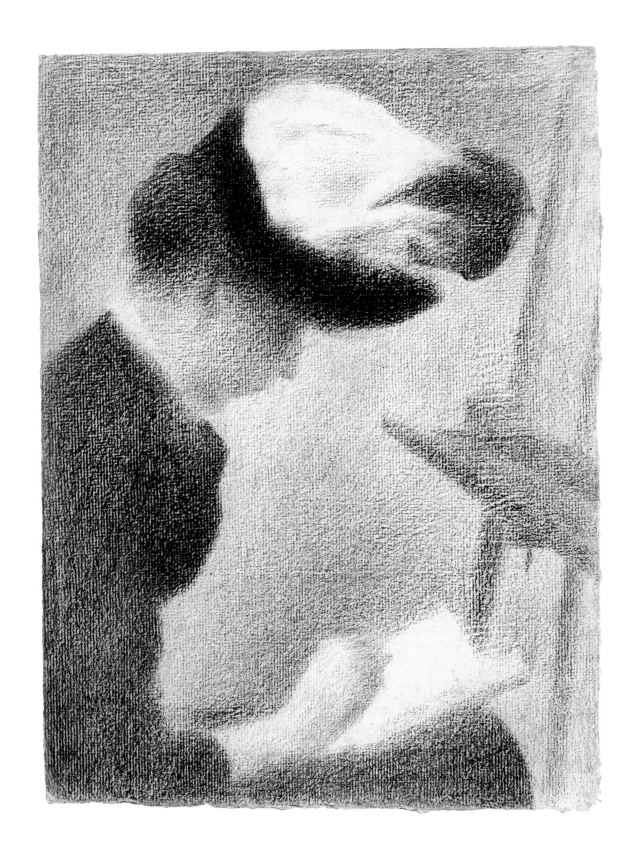

depend on the use of black chalk, probably a type of nongreasy conté crayon, in combination with heavily textured paper. In all but a few of the mature drawings, Seurat employed conté crayon on Michallet paper (Herbert, 1962, pp. 46–47). No matter how lightly applied, the conté crayon leaves a mark that adheres to the toothed surface of the paper while permitting the white of the depressions to show through. Unlike the academic practice of the time, there is no erasure and no stumping. While the manipulation of black-and-white contrast is less pronounced in *Woman Seated by an Easel* than in many of Seurat's drawings, it is replaced by a wider range of middle grays. This narrower tonal range seems to heighten the drawing's translucency.

The drawing was owned by Félix Fénéon, Seurat's greatest critic, before entering the collection of Mrs. Cornelius J. Sullivan, one of the founders of The Museum of Modern Art, New York. She lent it to the museum's first loan exhibition in 1929 (New York, 1929, no. 70). When the Sullivan collection was sold at auction in 1937, the drawing was bought by Maurice Wertheim for $5,700, the highest price fetched by any work of art in the sale (Lynes, 1973, p. 149).

Provenance: In the artist's studio at his death (Inventaire posthume, Dessin no. 300); Francis Vielé-Griffon; Félix Fénéon; Mrs. Cornelius J. Sullivan, by 1929; Maurice Wertheim (Sullivan sale, New York, American Art Association and Anderson Galleries, 30 April 1937, no. 202).

Bibliography: Paris, 1928, no. 164; New York, 1929, no. 70; Seligman, 1946, no. 46; Frankfurter, 1946, p. 64, repr. p. 31; Cambridge, 1946, p. 66, repr. p. 67; San Francisco, 1947, no. 147; New York, 1948C, no. 58; Berger, 1949, no. 48; Quebec, 1949, no. 28, pp. 73–74; Raleigh, 1960, p. 60, repr. p. 61; DH 601; Herbert, 1962, pl. 117, pp. 134–156; Houston, 1962, pl. 28, pp. 62–63; Russell, 1965, pl. 145; Courthion, 1968, repr. p. 61; Augusta, 1972A, no. 34; Minervino, 1972, no. D158; Lynes, 1973, p. 149; Tokyo, 1979, no. 71. Bequest—Collection of Maurice Wertheim, Class of 1906, 1951.70

Henri de Toulouse-Lautrec

Albi 1864–Château Malromé 1901

15. *The Black Countess*, 1881

Oil on artist's board, 32.3 x 40.1 cm.
(12¾ x 15¾ in.)
Signed and dated in brown paint, lower
left: HTL (in monogram) 1881

The Black Countess, for all its wit and sophistication, is juvenilia.
Lautrec was seventeen when he painted it in Nice during a vacation
in the early months of 1881. By that time he had already suffered
the crippling injuries that left him stunted and, by enforcing long
periods of immobilization, including several months in Nice the pre-
vious year, led him to devote increasing amounts of time to sketching
and painting.

With characteristic mordancy,.Lautrec in 1880 commented on
deficiencies in his own painting of the time. "You will think," he
wrote from Nice to a friend, "that my menu is very diversified, but it
isn't; the only choice [of painting subjects] lies between horses and
sailors. I succeed better with horses. As for landscapes, I am quite
incapable of doing any, even as backgrounds: my trees look like spin-
ach and my sea looks like anything you want to call it. The Mediter-
ranean is the devil to paint, just because it is so beautiful" (Joyant,
1926, I, pp. 43–44; trans. in Cambridge, 1946, p. 20).

The Black Countess largely confirms Lautrec's assessment of his
own strengths and weaknesses. He does, as he says, succeed better with
horses, and he does run into difficulty with landscape. The palm tree,
instead of delineating the space behind the horse, seems to sprout
from its back, and the "beautiful" Mediterranean is lifeless. However,
his ability to paint horses, more generally to depict animal motion, is
convincing. Lautrec had lived surrounded by horses from birth, and
they appear in a large proportion of his early sketches and paintings
(Dortu, 1971, vols. II and V). No less important for his development
were the interests of his father, Comte Alphonse de Toulouse-Lautrec,
a hunter and horseman who was not only an amateur draftsman of
hunting scenes (Toulouse-Lautrec, 1969, ills. 11, 12, 14) but who
also engaged René Princeteau, a painter of sporting pictures, in 1879
to be Lautrec's first art teacher (Chicago, 1979, p. 63).

The wit in *The Black Countess*, which verges on caricature,
derives from the juxtaposition of the countess with her coachman, who

Figure 1.
Henri de Toulouse-Lautrec. *The
Promenade des Anglais, Nice*, water-
color and graphite, 1881. Art Institute
of Chicago. Gift of Mrs. Gilbert W.
Chapman in memory of Charles B.
Goodspeed.

looks like a fallen mannequin, and from the contrast of this pair with
the vividly drawn horse and dog in front of them. The identity of the
countess is not known, but her face is without question black and not
concealed, as sometimes thought, by a dark veil. Moreover, micro-
scopic examination of the countess's face reveals no pinkish under-
layers of paint. Other technical information indicates that Lautrec
originally painted the countess's right arm extended, either to grasp a
whip, an umbrella, or the horse's reins, but then painted it out and
settled on the present composition. A related watercolor shows the
driver of a two-horse carriage with the reins draped over a raised
mount attached to the front of it (fig. 1).

Provenance: Comtesse Alphonse de Toulouse-Lautrec, the artist's mother,
Malromé; M. G. Séré de Rivières, the artist's cousin; Knoedler, New York, to
Maurice Wertheim, November 1937.

Bibliography: Joyant, 1926, I, pp. 52 and 254; Toulouse, 1932, no. 2; New
York, 1937, no. 2; Lassaigne, 1939, p. 39; Jewell, 1944, repr. p. 125; Frank-
furter, 1946, p. 64, repr. p. 30; Cambridge, 1946, p. 20, repr. p. 21; New
York, 1948C, no. 25; Quebec, 1949, no. 9, pp. 25–26; Dortu, 1952, p. 5;
Lassaigne, 1953, p. 22; Raleigh, 1960, p. 54, repr. p. 55; Houston, 1962,
pl. 20, pp. 50–51; Caproni and Sugana, 1969, no. 65; Dortu, 1971, P99;
Augusta, 1972A, no. 36; Coolidge, 1975, repr. p. 6; Friesinger, 1985, p. 39.
Bequest—Collection of Maurice Wertheim, Class of 1906, 1951.64

Henri de Toulouse-Lautrec

Albi 1864–Château Malromé 1901

5. *The Hangover* or *The Drinker*, 1887–1889

Oil and black crayon (or chalk) on canvas, 47.1 x 55.5 cm. (18½ x 21⅞ in.)
Signed in black paint, lower right: HTLautrec (initials in monogram)

The original title of this painting, *The Hangover* (in French *Gueule de Bois*), corresponds to a popular song written by Lautrec's friend, the chansonnier Aristide Bruant. Bruant owned the Montmartre cabaret Le Mirliton—frequented by Lautrec from the time of its opening in 1885—where he performed his songs. Bruant hung a number of Lautrec's paintings in the cabaret (Joyant, 1926, I, p. 98), among them several of solitary women: *Rosa the Red*, *Waiting at Grenelle*, *At the Bastille*, and *The Hangover* (Dortu, 1971, P305, P307–308, P340). These titles, taken from Bruant's compositions, were apparently given to the paintings by Bruant himself. While the imagery of the paintings does not specifically allude to the songs (there is no evidence they were composed with the songs in mind), it evokes something of the anomie and disillusionment found in the ballads (for examples of the lyrics, see Caproni and Sugana, 1969, nos. 210, 211, 213).

The subject of a woman drinking alone appears frequently in Lautrec's work of the second half of the 1880s. In several of these paintings the figure is placed in an ambiguous setting that may be read as the interior of a café or the artist's own studio. As if deliberately to add to the uncertainty of place, Lautrec kept a round-topped café table in his studio at which he often posed models. The setting in *The Hangover*, however, is not in doubt; with its two round-topped tables set near a pillar and its absence of studio references, it can be read only as the interior of a café. But like Degas's *Singer with a Glove* (see cat. 3), and particularly his *Absinthe Drinker* (ca. 1876, Louvre), to which it is indebted, *The Hangover* was certainly not painted in a café. Lautrec used as a model Suzanne Valadon, his mistress from 1886 to 1888, who appears in other Lautrec paintings of the time (Gauzi, 1954, pp. 130–136). She wears the plain white shirt popular among working-class women of the district. Therefore, there can be no mistaking her—as there would have been no mistaking her in Lautrec's time—for a prostitute (Toronto, 1981, p. 340).

The painting is composed of loosely hatched strokes of transparent paint, diluted with turpentine, thinly brushed over an "underdrawing" in black crayon or chalk. The "underdrawing" is, in fact, an integral part of the overall composition, clearly visible, and lending emphasis to the contours and details (see Appendix C). In early 1889 *Le Courrier Français*, a local journal of the Montmartre quarter, commissioned from Lautrec a drawing after the painting (fig. 1). The drawing follows the main outlines of the original painting in all particulars and bore its title when published in the issue of 21 April 1889. That date is the *terminus ad quem* for the painting's completion. However, the painting closely resembles other portraits dating from 1887 (Dortu, 1971, P276–280). Most particularly it resembles Lautrec's *Portrait of Vincent van Gogh* from late 1887 (fig. 2). It has been argued that the similarities of style, pose, and setting of the two

Figure 1.
Henri de Toulouse-Lautrec. *Drawing after "The Hangover" or "The Drinker,"* india ink, blue and black crayon, ca. March 1889. Musée Toulouse-Lautrec, Albi.

Figure 2.
Henri de Toulouse-Lautrec. *Portrait of Vincent van Gogh*, pastel on cardboard, ca. early 1887. Rijksmuseum Vincent van Gogh, Amsterdam.

paintings are so pronounced that they should be viewed as companion pieces (ibid., p. 340). The arguments are persuasive, raising the likelihood that *The Hangover* was completed only some months after the *Portrait of Vincent van Gogh*. But it had not been completed when van Gogh departed for Arles in February, for in April he asked his brother in a letter: "Has Lautrec finished his picture of the woman leaning on her elbows on a little table in a café?" (VG 470).

A preparatory pastel study for *The Hangover* is in the collection of the Musée d'Albi (Dortu, 1971, P339).

Provenance: [Aristide Bruant?]; Maurice Masson, Paris; Masson sale, Paris, Hôtel Drouot, 22 June 1911, no. 40; Stephen Bourgeois, New York, to Sir William Van Horne, Montreal, 1911; Maurice Wertheim (Van Horne sale, New York, Parke-Bernet, 24 January 1946, no. 6).

Bibliography: New York, 1913, no. 1061; Coquiot, 1913, repr. p. 145; Brook, 1923, p. 142; Joyant, 1926, I, pp. 98, 267, repr. p. 87; Jedlicka, 1929, repr. p. 109; Montreal, 1933, no. 148; Schaub-Koch, 1935, p. 178; Mack, 1938, p. 293; Lassaigne, 1939, p. 14, repr. p. 76; Toronto, 1944, no. 79; Van Horne, 1946, p. 10; Frankfurter, 1946, p. 64, repr. p. 30; Cambridge, pp. 34–37, repr. p. 35; New York, 1948C, no. 26; Quebec, 1949, no. 15, pp. 42–44; New York, 1950, no. 15; Frankfurter, 1951, repr. p. 100; Hourdain and Adhémar, 1952, repr. p. 26; Lassaigne, 1953, p. 36, repr. p. 26; VG 470; Perruchot, 1958, p. 137; Raleigh, 1960, p. 56, repr. p. 57; Houston, 1962, pl. 21, pp. 52–53; Huisman and Dortu, 1964, pp. 59 and 253; Caproni and Sugana, 1969, no. 227a; Dortu, 1971, P340; Augusta, 1972A, no. 37; Toronto, 1981, pp. 319, 340. Bequest—Collection of Maurice Wertheim, Class of 1906, 1951.63

Paul Cézanne

Aix-en-Provence 1839–1906

17. *Still Life with Commode*, ca. 1885

Oil on canvas, 65.1 x 80.8 cm.
(25⅝ x 31¾ in.)

Cézanne habitually organized his still lifes around a few favored objects. Many of the elements in this taut, compressed painting—the intensely colored apples, the green Provençal olive jar, the Oriental ginger pot, the tablecloth, the pieces of cheap china—reappear in Cézanne's other still lifes. However, it was exceptional for him to paint more than one version of the same, or almost the same, arrangement. Only two instances are known. The first occurred in the mid-1870s (V 186–188), and the second, comprising *Still Life with Commode* and the slightly larger canvas of the same title in the Neue Staatsgalerie in Munich (fig. 1), in the mid-1880s.

Few of Cézanne's paintings are more finished and magisterial than these two still lifes. It is debatable which came first, the Wertheim or the Munich painting; possibly both were worked on together over a period of time. Certainly the thick buildup of paint on the Wertheim canvas, which is especially visible where the darks of the commode meet the lights of the ginger pot and the tablecloth, suggests it may have been executed over a period of several months. Of the two, it is the more densely compacted and closed: the area of wallpaper at the left is cropped and its pattern simplified; the crest of the tablecloth rises up more boldly, higher than the ginger pot; and the spaces between the vessels are tighter.

The composition of *Still Life with Commode* is arranged so that the straight lines of the table and commode enclose the curving forms of the objects inside. But the eye is drawn to the center for the additional reason that the colors are most intense there, the discretely formed red and yellow brushstrokes of the apples standing out against the darker masses of the table and commode. In the painting, there are subtle rhymings of shape. The round knobs of the commode subtly

Figure 1.
Paul Cézanne. *Still Life with Commode,* oil on canvas, ca. 1885. Bayerischen Staatsgemäldesammlungen, Munich.

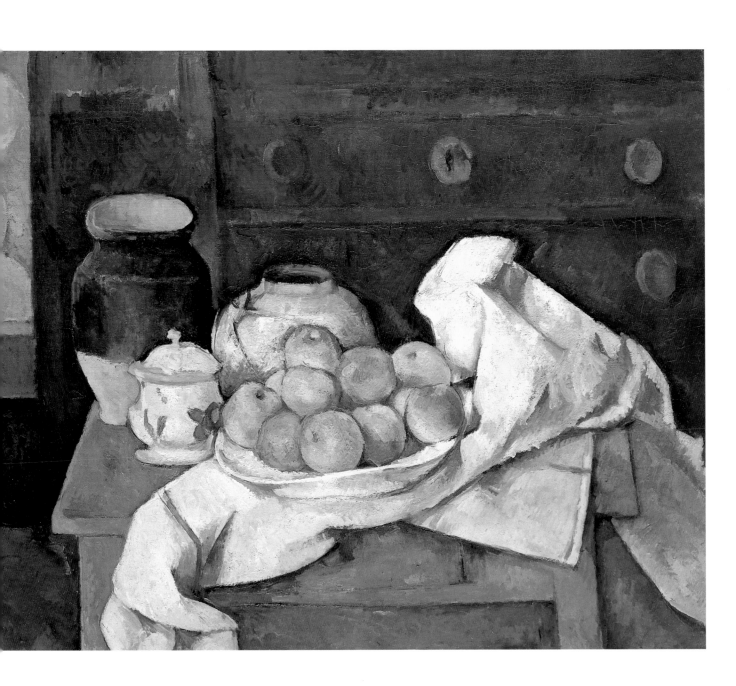

echo the spherical apples, and the scalloped pattern of the wallpaper corresponds to the jagged borders of the tablecloth. While the visual rhymings contribute to the balance and symmetry of the composition, they also contribute—by helping to collapse the foreground into the background—to the painting's spatial flattening and ambiguity. Exactly where in space, for example, is the left side of the commode in relation to the front plane of the commode or to the papered wall beside it?

These formal characteristics seem to corroborate Maurice Denis's description of Cézanne in 1907 as the "Poussin of Impressionism" (Denis, 1907, p. 57). However, Denis also recognized that to stamp Cézanne's work too firmly with a classicist label would be to misrepresent it. *Still Life with Commode* is a case in point. What is one to make of the willful distortions in it or its calculated awkwardness? In the most perceptive account of the painting thus far, Meyer Schapiro concludes that it is precisely the introduction of disharmony that gives the painting its peculiar force. "In this stable rectangular composition," Schapiro writes, "the tablecloth is a powerful contrast and an element of disorder; we are surprised by its complexity, its alien character among the compact objects of single axis on the table, although it is assimilated to these through its colors and the tilting of the distorted platter. It is like a mountain, a rocky creviced mass, or like some human figure, twisting and turning, with an inner balance of directions. Each bend, fold, and tone is strategically considered in relation to neighboring shapes and colors. Without this fantastic body of cloth, the picture would be tame and empty. . . ." (Schapiro, 1952, p. 60).

Provenance: Ambroise Vollard, Paris; Thannhauser, Munich; Paul Cassirer, Berlin; S. Fischer, Berlin, by 1918; R.P.A. (private collection), Paris, by 1939; Paul Rosenberg, Paris, to Maurice Wertheim, by 1939.

Bibliography: Vollard, 1914, p. 146, pl. 48; Meier-Graefe, 1918, pl. 171; Berlin, 1918, no. 32; Bernard, 1926, p. 149; Rotterdam, 1933, no. 2; V 497; Paris and London, 1939, no. 8; New York, 1942B, no. 10; Frankfurter, 1946, p. 64, repr. p. 29; Cambridge, 1946, p. 22, repr. p. 23; Adlow, 1946B, p. 6; New York, 1947B, no. 25; New York, 1948C, no. 5; Quebec, 1949, no. 11, pp. 30–32; New York, 1950, no. 10; Coolidge, 1951, repr. p. 757; Schapiro, 1952, p. 60, repr. p. 61; Raleigh, 1960, p. 6, repr. p. 7; Houston, 1962, pl. 1, pp. 12–13; Orienti, 1970, no. 471; Tokyo, 1972, pl. 29, p. 117; Augusta, 1972A, no. 2; Cologne, 1982, pp. 15–17, 23; Friesinger, 1985, p. 43 (ill.). Bequest—Collection of Maurice Wertheim, Class of 1906, 1951.46

Vincent van Gogh

Grout-Zundert (Holland) 1853–
Auvers-sur-Oise 1890

8. *Three Pairs of Shoes,* 1886–1887

Oil on canvas, 49.2 x 72.2 cm.
(19⅜ x 28½ in.)
Scratched into the paint surface, lower
middle: Vincent; scratched into the paint
surface, upper right: VINCENT

Figure 1.
Vincent van Gogh. *Old Shoes,* oil on
canvas, 1886–1887. Rijksmuseum
Vincent van Gogh, Amsterdam.

Three Pairs of Shoes was painted in Paris, probably in the winter of
1886–1887. Van Gogh had arrived from Holland the previous March
and soon began working from live models and plaster casts in the
studio of Fernand Cormon. At the same time, he began producing still
lifes of flowers and fruit, partly under the influence of Delacroix and
Monticelli. All told, he produced almost a hundred still lifes in Paris
over the course of two years.

 Three Pairs of Shoes, which is marked by high ridges and sharp
crevices of paint, is composed over an earlier flower painting.
Radiographic analysis reveals that the painting below relates closely to
several flower studies dating from the summer or fall of 1886 (F 241,
242, 279). The composition is vertical, with its bottom edge corre-
sponding to the left side of the present painting (Appendix C, fig. 2).
Although van Gogh's paintings of flowers and fruit dominate his
production of still lifes in the Paris years, he also executed a much
debated series of five paintings of boots, among them this painting
(F 255, 331–333, 332a). Except for the present work, all the paintings
in the series depict a single pair of boots. But it has recently been
observed that the Wertheim painting combines three of the pairs from
the other pictures, suggesting that van Gogh may have worked up this
series according to academic procedures—that is, by progressing from
rapid oil sketches and compositional studies to a "final statement"—
as in a series of sunflower paintings of about the same time (New
York, 1984, pp. 36–37). Not only is *Three Pairs of Shoes* the largest in
the group but it is also, with the boots arranged along a strong diag-
onal from bottom left to top right, the most carefully premeditated in
terms of composition. One of the five canvases (F 333, Baltimore
Museum of Art), however, as Ronald Pickvance observes, may have
been "extracted" from the Wertheim painting (ibid., p. 36). It is
painted in contrasting complementary colors of blue and orange of a
higher key, suggesting it was executed after the rest of the series.

 The Wertheim painting lies on the periphery of an extended art-
historical and philosophical controversy. The principal figures in the
debate are the German philosopher Martin Heidegger, the American
art historian Meyer Schapiro, and the French philosopher Jacques
Derrida. In 1935 Heidegger delivered an influential lecture entitled
"The Origin of the Work of Art," which was eventually published
under the same title in 1950 (Heidegger, 1964, pp. 649–701). In the
course of his complex argument about the ways in which art may be
said to disclose "truth," Heidegger referred for purposes of illustration
to a painting of shoes (fig. 1) by van Gogh. He described it as repre-
senting "a pair of peasant shoes and nothing more. And yet—from the
dark opening of the worn insides of the shoes the toilsome tread of
the worker stands forth. In the stiffly solid heaviness of the shoes there
is the accumulated tenacity of her [sic] slow trudge through the
far-spreading and ever-uniform furrows of the field, swept by a raw

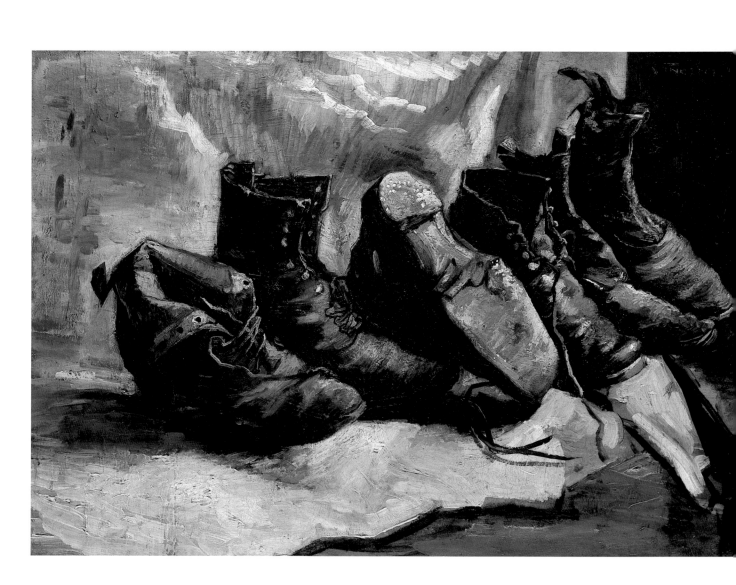

wind. On the leather there lies the dampness and saturation of the soil" (ibid., pp. 662–663).

The ongoing controversy centers on whether Heidegger was correct to read the shoes as peasant shoes and then on whether he was justified in constructing from that supposition an empathetic narrative of peasant life. Derrida argued that on philosophical grounds he was entirely justified (Derrida, 1978, pp. 11–37). Schapiro, however, saw concrete evidence of "the artist's presence" in the shoes rather than any evidence of peasant toil. For him, the series of paintings functioned as self-portraits of a man who had moved from the country to the city, who had shifted the focus of his attention from peasant work to urban work (Schapiro, 1968, pp. 203–209). Bogomila Welsh-Ovcharov accepted as valid both interpretations but pointed out that on the level of historical detail (about which Heidegger was unconcerned) the peasant of the 1880s could have been expected to wear wooden shoes, while the Parisian laborer could have been expected to wear leather boots (Welsh-Ovcharov, 1976, pp. 139–140).

Schapiro also considered it important to identify exactly which painting in the series Heidegger had in mind. Heidegger informed him that he had seen the work in question in an exhibition in 1930 in Holland (ibid., p. 205). Schapiro correctly surmised that Heidegger must have seen *Old Shoes* (Amsterdam, 1930, no. 6). At the same time he must have seen the Wertheim painting, for it was among the paintings by van Gogh also on exhibition in Amsterdam (ibid., no. 20).

Provenance: Vincent W. van Gogh, the artist's nephew, Amsterdam; Johanna van Gogh-Bonger, the artist's sister-in-law, Amsterdam; Sale, Hôtel Drouot, 31 March 1920, no. 62; Joseph Hessel, Paris; Marcel Kapferer, Paris [ca. 1925]; Wildenstein, New York, to Maurice Wertheim, October 1943.

Bibliography: Amsterdam, 1905, no. 72; Berlin, 1914, no. 40; Paris, 1925B, no. 5; Paris, 1927; Amsterdam, 1930, no. 20; Paris, 1937B, no. 132; New York, 1943B, no. 7; Frankfurter, 1946, p. 64, repr. p. 21; Cambridge, 1946, pp. 26–29, repr. p. 27; New York, 1948C, no. 65; Quebec, 1949, no. 13, pp. 35–37; Raleigh, 1960, p. 16, repr. p. 17; Houston, 1962, pl. 5, pp. 20–21; Schapiro, 1968, p. 205; F 332; Augusta, 1972A, no. 38; Welsh-Ovcharov, 1976, p. 139; Derrida, 1978, p. 25 (ill.); Hulsker, 1980, no. 1234; Walker, 1980, p. 16; New York, 1984, p. 36. Bequest—Collection of Maurice Wertheim, Class of 1906, 1951.66

Vincent van Gogh

Grout-Zundert (Holland) 1853–
Auvers-sur-Oise 1890

19. *Self-Portrait Dedicated to Paul Gauguin*, 1888

Oil on canvas, 60.5 x 49.4 cm.
(23¾ x 19½ in.)
Signed and inscribed in red paint, lower
right: Vincent/Arles; inscribed in red
paint, upper left: à mon ami Paul
G[auguin] (signature and inscriptions are
barely legible)

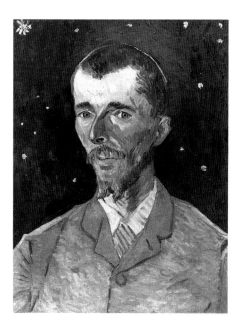

Figure 1.
Vincent van Gogh. *Portrait of Eugène
Boch*, oil on canvas, 1888. Musée
d'Orsay (Jeu de Paume), Paris.

Some painters never write if they can avoid it; others do it so convincingly that their writing becomes an essential complement to their art. Van Gogh stands out among the latter. His letters to friends and to family, especially to his brother, Theo, are the literate testimony of his intentions as a painter. They are also the expression of his hopes for a new contemporary art able to hold its own with the great art of the past.

The *Self-Portrait Dedicated to Paul Gauguin* is the second self-portrait van Gogh did in Arles, where he lived from February 1888 to May 1889. It is one of five painted there, out of some thirty-seven painted during his lifetime (New York, 1984, p. 34). At least twenty-four were done during the previous two years in Paris before he left for the South. Van Gogh's first reference to the painting is in a letter to Theo dated September 17: "The third picture this week is a portrait of myself, *almost colorless*, in ashen tones against a background of pale veronese green" (VG 537; dates and translations of van Gogh's letters follow those of Jirat-Wasiutynski et al., 1984). In order to paint it, he acquired a mirror. But he also deliberately transformed and exaggerated the features he saw reflected back at him, as he explained to Theo in a subsequent letter. "Someday you will also see my self-portrait, which I am sending to Gauguin, because he will keep it, I hope. It is all ashen gray against pale veronese green (no yellow). The clothes are this brown coat with a blue border, but I have exaggerated the brown into purple, and the width of the blue borders. The head is modeled in light colors painted in a thick impasto against the light background with hardly any shadows. Only I have made the eyes *slightly* slanting like the Japanese" (VG 545, early October 1888).

At the heart of van Gogh's concerns in the South was a revival of portraiture as a forceful category in contemporary painting. Through portraiture he hoped to articulate a new iconography of modern life that would restore to art the necessity and vitality he found in the old masters. But he also understood that the old categories of subject matter in painting (as in life) were breaking down and sensed that painting, if it were to find a broad audience, needed to salvage what it could from the past and at the same time explore new means of representation. With this in mind, he pursued portraiture. "We must win the public with the portrait," he wrote to Emile Bernard, "the future, I am sure, lies there" (VG B15, August 1888).

As he had before in Holland, van Gogh began doing "portraits of the people" in a systematic way, choosing for his subjects a uniformed Zouave (F 423 and 424), the postman Roulin and his family (F 432–436, 492–493, and 505–507), the peasant Patience Escalier (F 403 and 444), and Eugène Boch (F 462). The *Portrait of Eugène Boch* (fig. 1), also called *Portrait of a Poet*, was described in a letter to Theo several weeks before it was actually painted. Not only does the description demonstrate van Gogh's ambitions for portraiture but it describes his

Figure 2.
Paul Gauguin. *Self-Portrait: "Les
Misérables,"* oil on canvas, 1888.
Rijksmuseum Vincent van Gogh,
Amsterdam.

strategy for effecting them. "I should like to paint the portrait of an
artist friend who dreams great dreams. . . . So I paint him as he is,
as faithfully as I can, to begin with. But the picture is not yet finished.
To finish it I am now going to be the arbitrary colorist. I exaggerate
the fairness of the hair, I even get to orange tones, chromes and pale
citron-yellow. Behind the head, instead of painting the ordinary wall
of the mean room, I paint infinity, I make a plain background of the
richest, most intense blue that I can contrive, and by this simple
combination of the bright head against the rich blue background, I
get a mysterious effect, like a star in the depths of an azure sky"
(VG 520, mid-August 1888).

The description drives home the symbolic dimension van Gogh
hoped to inject into his portraiture. "I want to paint men or women
with that something of the eternal which the halo used to symbolize,"
he wrote (VG 531, early September 1888). The *Self-Portrait Dedicated
to Paul Gauguin* is best understood in these terms. What it hopes
to convey, as well as *how* it hopes to convey it—by means of exagger-
ated contours, harsh color juxtapositions, and thickly textured brush-
work—makes it a counterpart to the *Portrait of Eugène Boch*. In both
works the artist is conceived as a spiritual figure, a secular saint. "I
have in the first place aimed at the character of a simple bonze wor-
shipping the Eternal Buddha," he explained to Gauguin about his
own image (VG 544a, late September 1888). Thus he not only gave

Figure 3.
Photograph of Vincent van Gogh's
*Self-Portrait Dedicated to Paul Gau-
guin* taken under ultraviolet illumi-
nation.

himself the slightly slanting eyes of a "Japanese" but also arranged
the emerald green brushstrokes behind his head in a circular pattern
suggestive of a "halo." The reference to the bonze, or monk, came
from his recent reading of Pierre Loti's *Madame Chrysanthème*.

At the beginning of October van Gogh inscribed his finished self-
portrait "à mon ami Paul Gauguin," at the top in red, and shipped it
to Pont-Aven, where Gauguin was working with Bernard. Van Gogh
had not definitely decided to send this work until a few days earlier,
when he received in exchange the self-portraits promised him by the
other two artists. He wanted to judge if his measured up. "So now at
last I have a chance to compare my painting with what the comrades
are doing," he informed Theo. "My painting holds its own, I am sure
of that" (VG 545, early October 1888). In van Gogh's tone of voice
there is a slight competitive edge. For some time he had wanted
Gauguin and other artists to join him in a "studio of the South," but
it is clear that he also wanted to be certain his work stood up to theirs.
What he says of Gauguin's self-portrait (fig. 2) applies equally to his
own: "His portrait gives me above all absolutely the impression of
representing a prisoner. Not a shadow of gaiety" (ibid.).

Only Gauguin joined van Gogh in Arles. Though it is sometimes
stated that Gauguin carried van Gogh's self-portrait with him when
he arrived on October 23 (New York, 1984, p. 171), this is not known.
However, it is certain that following the collapse of their relationship,

van Gogh's attack of insanity, and Gauguin's subsequent return north, Gauguin displayed the painting along with other works by van Gogh in his Paris studio (Jirat-Wasiutynski et al., 1984, p. 9). It remained in Gauguin's ownership, shifting locations in Paris but not accompanying him to Tahiti, until he sold it for three hundred francs in 1896 or 1897 (ibid.). In 1919 it entered the collection of the Neue Staatsgalerie in Munich, but not to stay. Denounced by the Nazis along with other examples of modern art as "degenerate," it was sold at auction in Switzerland in 1939 (Roh, 1962, pp. 56–57; see Introduction).

The portrait's movements have some bearing on the question of how the painting sustained the damage visible to the left of van Gogh's neck and shoulder and to the right above his head (fig. 3). Did van Gogh himself, as has sometimes been suggested, intentionally inflict the damage? And, if he did, was he also responsible for removing his dedication to Gauguin and his signature? Recent technical and historical research suggests that van Gogh did not purposefully damage the painting or erase the signature (Jirat-Wasiutynski et al., 1984). Gauguin, on the other hand, was almost certainly responsible, between 1893 and 1895, for the rather clumsy restorations. For this reason, conservators have decided to leave the repairs as they are, to let them stand as a material part of the painting and an integral part of its history.

Provenance: Paul Gauguin, until 1896 or 1897; Ambroise Vollard, Paris [through another dealer]; Paul Cassirer, Berlin, after 1900; Mrs. Hugo von Tschudi, Munich; Neue Staatsgalerie, Munich, 1919; Maurice Wertheim (Nazi sale, Lucerne, Fischer Gallery, 30 June 1939, no. 45).

Bibliography: Duquesne-van Gogh, 1911, repr. as frontispiece; Stuttgart, 1924, no. 40; Scherjon and de Gruyter, 1937, no. 90; Frankfurter, 1946, p. 64, repr. cover; Cambridge, 1946, pp. 30–33, repr. p. 31; New York, 1948C, no. 66; Quebec, 1949, no. 14, pp. 38–41; New York, 1949, no. 78A; *Life*, 1949, pp. 26–27, repr. p. 26; Coolidge, 1951, repr. p. 755; Leymarie, 1951, no. 80; Rewald, 1953; VG, III, p. 37 passim.; Raleigh, 1960, pp. 18–20, repr. p. 19; Roh, 1962, pp. 57, 233–234; Houston, 1962, pl. 6, pp. 22–24; Erpel, 1964, no. 35; F 476; Roskill, 1970, pp. 129, 241, pls. VII and 102; Augusta, 1972A, no. 39; Pollock and Orton, 1978, pl. 40, p. 52; Hulsker, 1980, no. 1581; Toronto, 1981, fig. 32, pp. 49, 184; Hammacher, 1982, p. 176 (ill.); New York, 1984, no. 99; Jirat-Wasiutynski et al., 1984; Friesinger, 1985, pp. 42 (ill.), 43. Bequest—Collection of Maurice Wertheim, Class of 1906, 1951.65

Paul Gauguin

Paris 1848–Hiva Oa (Marquesas Islands)
1903

20. *Poèmes Barbares*, 1896

Oil on canvas, 64.6 x 48 cm.
(25⅜ x 18⅞ in.)
Inscribed, signed, and dated in black paint,
upper left: Poẽmes BarBares/ P Gauguin
96

Poèmes Barbares takes its title from a collection of poems exhibiting a fascination for the exotic by Leconte de Lisle (published in 1872). The painting was executed in Tahiti in 1896, the year following Gauguin's second and final voyage to French Polynesia. Before leaving France, he exchanged letters with August Strindberg. He wanted the writer to promote an auction of his work and used Strindberg's letter declining the invitation as a preface to the sales catalogue. "Who is he, then?" Strindberg wrote. "He is Gauguin, the savage who hates an inconvenient civilization, something of a Titan who, jealous of his Creator, in his lost moments makes his own little creature—a child who takes apart his toys to make others, who renounces and defies, who prefers to see the sky red rather than blue with the crowd" (Gauguin sale, Paris, Hôtel Drouot, 18 February 1895).

In *Poèmes Barbares* Gauguin is the maker, in a literal sense, of "his own little creature." Fashioned in the form of an imaginary idol, it squats in the lower left corner of the painting with its knees drawn up, holding in its right hand a golden orb radiating shafts of light. It has been suggested that the figure represents Ta'aroa, the principal deity in Tahitian mythology and creator of its universe, and that Gauguin depicts it in the process of making the heavens (Zink, 1978, pp. 18–19). Gauguin was certainly familiar with the symbolism of the Maori religion—primarily from the early nineteenth-century writings of J. A. Moerenhout, which he read in 1892 (ibid., p. 18)—even though by the time he arrived the religion had atrophied and largely fallen into disuse. But it is less clear what the fire-eyed idol has in common with the contemplative angel in the painting. And it becomes even less clear on recognizing that the "angel" combines Christian wings, a Tahitian physiognomy, and a mudra-like Buddhist gesture.

It was this blend of disparate, exotic elements that upset Camille Pissarro about an earlier painting in which Gauguin depicted an angel, *The Vision after the Sermon (Jacob Wrestling with the Angel)* (1889, fig. 1). Executed in Brittany seven years before the Wertheim painting, it was a manifesto of artistic primitivism. "I do not criticize Gauguin for having painted a rose background," wrote Pissarro, "nor do I object to the two struggling fighters and the Breton peasants in the foreground. What I dislike is that he copped these elements from the Japanese, the Byzantine painters and others. I criticize him for not applying his synthesis to our modern philosophy which is absolutely social, anti-authoritarian and anti-mystical" (Pissarro, 1972, 20 April 1891). Pissarro, in other words, faulted Gauguin much less for his use of broad, flat areas of color, and for his means of outlining figures in bold contour, than for his primitivizing antinaturalism.

Kirk Varnedoe has recently written on Gauguin's complicated position as "the *primitif* of modernist primitivism, its original, seminal figure" (Varnedoe, 1984, pp. 179). He views Gauguin's eclecticism as having been central to his primitivist enterprise and understands it as

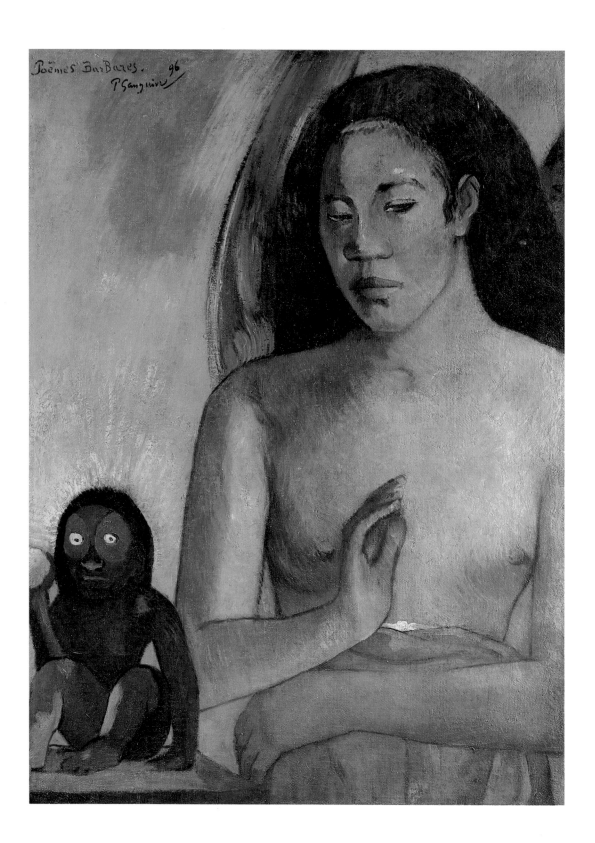

Figure 1.
Paul Gauguin. *The Vision after the Sermon (Jacob Wrestling with the Angel)*, oil on canvas, 1888. National Gallery of Scotland, Edinburgh.

having issued logically from European suppositions and attitudes of mind about cultural syncretism (ibid., pp. 179–209). According to Varnedoe, Gauguin did not intend his hybrid imagery to be worked through literally by viewers (as much recent scholarship attempts to do), any more than he intended it to be dismissed as incomprehensible fiction. By the same token, Varnedoe emphasizes, Gauguin intended his simplifications of form and color to register his synthetic aims.

Provenance: Anonymous collection (Sale, Paris, Hôtel Drouot, 16 June 1906, no. 30); Dr. Alfred Wolff, Munich, by 1912; Sir Michael Sadler, England, by 1924; A. Conger Goodyear, Buffalo and New York, by 1929; Maurice Wertheim, through Wildenstein, New York, April 1937.

Bibliography: Cologne, 1912, no. 167; Burger, 1913, I, p. 82 and II, pl. 31; Gauguin, 1919, 14 February 1897; Morice, 1919, repr. facing p. 176; London, 1924, no. 59; New York, 1929, no. 47; Alexandre, 1930, p. 182, repr. p. 167; Wilenski, 1931, p. 289; New York, 1936C, no. 34; Cambridge, 1936, no. 33; Cleveland, 1936, no. 280; Toledo, 1936, no. 6; Gauguin, 1937, repr. facing p. 217; Rewald, 1938, repr. p. 117; Brooklyn, 1938; Jewell, 1944, repr. p. 162; New York, 1946B, no. 31; Frankfurter, 1946, p. 64; Cambridge, 1946, pp. 38–41, repr. p. 39; New York, 1948C, no. 16; Quebec, 1949, no. 16, pp. 45–47; Van Dorski, 1950, no. 328; Dorival, 1951, p. 118; Huyghe, 1959, repr. p. 82; Raleigh, 1960, p. 14, repr. p. 15; Field, 1961, pp. 145–146; Houston, 1962, pp. 18–19; Wildenstein, 1964, no. 547; Sugana, 1972, no. 373; Augusta, 1972A, no. 10; Zink, 1978, pp. 18–21. Bequest—Collection of Maurice Wertheim, Class of 1906, 1951.49

Camille Pissarro

St. Thomas (West Indies) 1830–Paris 1903

21. *Mardi Gras on the Boulevards*, 1897

Oil on canvas, 64.9 x 80.1 cm.
(25⅝ x 31½ in.)
Signed and dated in blue-black paint,
lower left: C. Pissarro 97

"On Shrove Tuesday," Pissarro wrote to his son Lucien, "I painted the boulevards with the crowd and the march of the Boeuf-Gras, with affects of sun on the serpentines and the trees, and the crowd in shadow" (Pissarro, 1972, 5 March 1897). The Wertheim canvas is one of a trio of paintings (PV 995–997) that Pissarro did of the Mardi Gras parade in 1897, which that year fell on March 2. The other two paintings are now in the Armand Hammer Collection, Los Angeles, and in the Kunstmuseum Winterthur, Switzerland.

Before the 1890s, Pissarro painted few scenes of modern Paris. The city's vistas, its street life, and spectacles, attracted him much less than they did his colleagues. Instead he focused on landscape, concentrating primarily on agrarian and peasant life and, in some instances, on industrial incursions into the countryside. Beginning in 1893, however, just at the moment his work achieved the commercial success that had eluded him during most of his career, he chose to tackle the city. In the decade before his death in 1903, he produced over one hundred paintings of Paris.

Writing to Lucien from Paris in February 1897, Pissarro reported that his dealer Durand-Ruel had been "very pleased" with some scenes he had painted of the rue Saint-Lazare. "A series of paintings of the boulevards seems to him a good idea," reported Pissarro, "and it will be interesting to overcome the difficulties. I engaged a large room at the Grand Hôtel de Russie, 1 rue Drouot, from which I can see the whole sweep of the boulevards. . ." (Pissarro, 1972, 8 February 1897). From the elevated windows of his hotel room Pissarro painted, with Durand-Ruel's encouragement, a total of fifteen views of the boulevard des Italiens and the boulevard Montmartre (PV 986–1000), the street represented in *Mardi Gras on the Boulevards*. In each, the street is represented receding from the picture plane on a

Figure 1.
Camille Pissarro. *The Versailles Road at Louveciennes*, oil on canvas, 1870. Sterling and Francine Clark Art Institute, Williamstown, Mass.

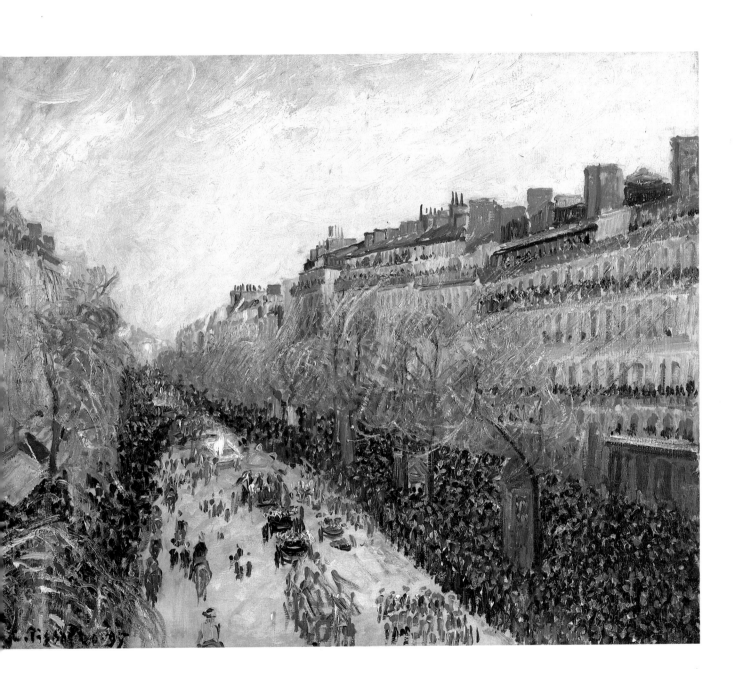

slight diagonal. But the conditions of light and weather, ranging from sun and rain to day and night, are always different. It is almost as if Pissarro decided to treat the boulevards as a category of landscape and to take as a model his own landscapes of an earlier period (for example, his series in 1870 of the Versailles Road at Louveciennes; fig. 1).

In terms of subject matter, the Mardi Gras paintings are indebted to paintings by Manet and Monet. Both artists had painted festivals in 1878 showing the streets of Paris decked out with flags (RW 270 and W 469). However, they showed the streets of the older quarters, whereas Pissarro chose to paint the wider boulevards of Paris. The 1897 Mardi Gras parade that wound its way beneath Pissarro's window was a carefully orchestrated public event. In former times it had sometimes led to disorder in the streets, and following the Commune of 1870–1871, it had been suppressed. It was not officially sanctioned again until the 1890s. In its revived state Mardi Gras was a tamer affair that emphasized the throwing of confetti and streamers, inventions of *la belle époque*, and a parade with floats (Robson, 1930).

It is the latter spectacle that Pissarro presents to us. Offsetting the gray tones of the buildings and the sky are the livelier hues of the streamers. The Wertheim picture is less densely and fully worked than the other two in the series and, for John Rewald, "seems to be the happiest of the three paintings" (Cambridge, 1946, p. 42). However, Ralph T. Coe finds it deficient, along with certain other paintings by Pissarro from this period, because of its "penchant for purely casual effects" (Coe, 1954, pp. 105–106).

Provenance: Mme. Camille Pissarro, the artist's wife; Lucien Pissarro, the artist's son, London; Maurice Wertheim, by 1943.

Bibliography: Paris, 1904, no. 101; Paris, 1914, no. 31; London, 1920, no. 86; Manson, 1920, repr. facing p. 83; Paris, 1921, no. 6; Paris, 1930, no. 91; PV 996; Frost, 1943, p. 21; New York, 1943–1944, no. 20; New York, 1944B, no. 6; New York, 1945A, no. 35; Frankfurter, 1946, p. 64; Cambridge, 1946, pp. 42–45, repr. p. 43; Quebec, 1949, no. 17, pp. 48–50; Coe, 1954, p. 107; Raleigh, 1960, p. 40, repr. p. 41; Houston, 1962, pl. 16, pp. 42–43; Augusta, 1972A, no. 28; Shikes and Harper, 1980, p. 297, repr. p. 296; London, 1981, p. 141; Washington, 1982–1983, p. 258. Bequest—Collection of Maurice Wertheim, Class of 1906, 1951.58

Pablo Picasso

Málaga, Spain 1881–Mougins 1973

2. *Young Girl Wearing a Large Hat* (recto), 1901

Oil on canvas, 72.6 x 49 cm.
(28⅝ x 19¼ in.)
Signed in dark blue paint, upper left:
Picasso (underlined)
Inscribed in red paint, lower right:
S.L. 891.27

3. *Woman with a Chignon* (verso), 1901

Oil on canvas, 72.6 x 49 cm.
(28⅝ x 19¼ in.)
Signed in dark blue paint, upper left:
Picasso (underlined)

Picasso's *Young Girl Wearing a Large Hat* and *Woman with a Chignon* are the recto and verso of a double-sided canvas. The two paintings are divergent in style and subject, even though executed only months apart (Z, I, 76 and 96; D&B, V.69 and VI.23). The portrait, *Young Girl*, was painted during the first half of 1901 and *Woman with a Chignon* during the second half of the same year. Indeed, *Young Girl* may have been exhibited in June (before the verso was executed) in the first exhibition of Picasso's work in Paris, at the Vollard gallery on rue Laffitte. The Vollard gallery was not large, so a number of paintings were exhibited in folders (Fabre, 1981, p. 246). Among the catalogue entries was one bearing the general title "Portraits" (no. 62)—an indication that several portraits, including *Young Girl*, may have been gathered together for viewing in a single folder (ibid., p. 257). Gustave Coquiot, in the preface to the exhibition catalogue, referred to some of Picasso's paintings as being representations of young girls and children who were "solemn-faced, wearing their Sunday-best, smug and stiffly overdressed, like wonderful and extraordinary Sun Kings, crowned by heavy wigs and frills" (quoted in Fabre, 1981, p. 514). We may question whether the figure represented in *Young Girl* seems to fit Coquiot's imperial metaphor, but we cannot doubt that she is "solemn-faced" and "stiffly overdressed."

The Vollard exhibition was a critical and financial success, but *Young Girl* (assuming it was exhibited) was not sold. The painting was returned to Picasso and therefore available for him to work on again— to paint the verso and make the canvas, so to speak, Janus-faced. At the time of the exhibition, the pace and changeability of Picasso's stylistic development elicited some critical comment. "One can tell the source of each of his paintings, and there is too much variety," complained François Charles (quoted in D&B, p. 333). "One easily distinguishes many a probable influence," observed Félicien Fagus of the works on exhibit, "Delacroix, Manet (everything points to him, whose painting is a little Spanish), Monet, van Gogh, Pissarro, Toulouse-Lautrec, Degas, Forain, Rops perhaps. . . . Each influence is transitory, set free as soon as caught: one sees that Picasso's haste has not given him time to forge a personal style; his personality is in this haste, this youthful, impetuous spontaneity. . ." (ibid., p. 333).

Picasso's personality was in his haste (in part, at least), and the "transitory" influence that he "set free" after painting *Young Girl*, but before painting *Woman with a Chignon*, was that of Impressionism. In *Young Girl* the palette is high-keyed, the impasto is thick, and the brushstrokes are broken and vivid. Even the subject matter, though tinged with a kind of precocious malaise, is ostensibly Impressionist. In *Woman with a Chignon*, however, an attitude of *fin-de-siècle* malaise has taken over entirely. It is registered in the somber palette of gray-blue and dusky yellow, the figure's hooded eyes and bitter mouth, and the static attenuations in the contours of limbs and

Figure 1.
Pablo Picasso. *Woman at the Theatre* (recto), oil on canvas, 1901. Collection of Charles Im Obersteg, Geneva.

Figure 2.
Pablo Picasso. *Absinthe Drinker* (verso), oil on canvas, 1901. Private Collection, Switzerland.

body. Though the theme of a solitary woman in a café recalls Degas and Lautrec (see cat. 16), the formal language—the black outlines, the flatly textured quality of the paint surface—is more reminiscent of Gauguin (see cat. 20). And that language is completely at odds with the formal syntax of *Young Girl*.

Picasso painted another double-sided canvas in 1901, and its two halves parallel the stylistic polarities of the Wertheim canvas. *Woman at the Theater* (fig. 1), which is unfinished, was executed close in time to *Young Girl*, and the *Absinthe Drinker* (fig. 2) close in time to *Woman with a Chignon*. The rectos of both canvases present themselves as portraits, despite the unspecific titles they now go by. In the versos, however, the facial features of the respective figures have been simplified and hardened so that they bear little imprint of individual personality. In place of characterization, Picasso offers stylized masks.

Coquiot stated in his preface that Picasso was an insatiable painter of modern life and predicted that in the future he would "offer us everything else that he has not been able to attain up to now" (quoted in Fabre, 1981, p. 514). Coquiot was right, but in ways he could not have foreseen. He wrote: "We can see at once that P. R. Picasso wants to see everything and say everything. All too often an artist attracted by just two or three aspects of our times is described as portraying Modern Life, but P. R. Picasso deserves this description more than anybody else. From our own time he has taken prostitutes, country scenes, street scenes, interiors, workers and so on, and we can be sure that tomorrow he will offer us everything else that he has not been able to attain up to now because of his extreme youth" (ibid., p. 514).

Provenance: Ambroise Vollard; Carroll Galleries, New York, to John Quinn, New York, 1915; Quinn Estate, 1924–1926; Paul Rosenberg, Paris, 1926; Dr. and Mrs. Harry Bakwin, New York; Maurice Wertheim, by December 1936.

Bibliography: [Paris, 1901, no. 62]; New York, 1921, no. 79 (*Young Girl* only); Quinn, 1926, p. 13, repr. p. 100 (*Woman* only); Z, I, 76, 96; Hartford, 1934, nos. 6, 7; New York, 1936A, nos. 7, 8; Frankfurter, 1946, p. 63 (*Woman* only); Cambridge, 1946, pp. 46–49, reprs. pp. 47, 49; Quebec, 1949, nos. 18, 19, pp. 51–54; Cirici-Pellicer, 1950, p. 112 (*Woman* only); Coolidge, 1951, repr. p. 756 (*Woman* only); Vallentin, 1957, p. 52 (*Young Girl* only); Raleigh, 1960, pp. 32–35, reprs. pp. 33, 35; Houston, 1962, pls. 12, 13, pp. 34–37; D&B, V.69 and VI.23; Reid, 1968, p. 207; Finkelstein, 1970, p. 37 (*Woman* only); Augusta, 1972A, nos. 23, 24; Washington, 1978, fig. 11, pp. 32–34, p. 176; Fabre, 1981, p. 257, nos. 633, 671. Bequest—Collection of Maurice Wertheim, Class of 1906, 1951.55.2 and 1951.55.1

Pablo Picasso

Málaga, Spain 1881–Mougins 1973

24. *Mother and Child,* 1901

Oil on canvas, 112.3 x 97.5 cm.
(44¼ x 38⅜ in.)
Signed in dark brown paint, upper right:
Picasso (underlined); signed in black
paint, lower left: Picasso (very faint)

Like the double-sided *Young Girl Wearing a Large Hat/Woman with a Chignon* (cats. 22 and 23), *Mother and Child* is a twice-used canvas. The present painting of the seated mother holding her child is super-imposed on a portrait of Max Jacob (Deknatel, 1976, pp. 37–42), the poet and early companion of Picasso in Paris. The information that Picasso had executed a portrait of Jacob was first made known in 1927 in an article by Jacob on Picasso (Jacob, 1927, p. 37). It was corrobo-rated in the 1950s by Picasso himself, who added that he remembered having painted a *"maternité"* over the portrait (Vallentin, 1957, p. 57). The existence of the portrait under the Wertheim *Mother and Child* was finally confirmed in the 1970s, when radiographic analysis of the painting was undertaken in the Fogg's conservation laboratories (Deknatel, 1976, p. 37). X-ray photographs of the canvas (Appendix C, fig. 3, shows a detail) reveal a figure seated among an assortment of books, an image that squares fully with Jacob's memory of the paint-ing (Jacob, 1927, p. 37).

According to Jacob, the portrait was done in June 1901—the month when the Vollard exhibition opened (see cats. 22 and 23). Jacob had expressed admiration for Picasso's work to Pedro Mañach, a dealer-agent and one of the promoters of the exhibition, and Mañach had arranged for Picasso and Jacob to meet. "I went to see them, Mañach and Picasso," wrote Jacob. "Picasso spoke no more French than I did Spanish, but we looked at each other and shook hands enthusiastically. . . . They came the following morning to my place, and Picasso painted a huge canvas, which has since been lost or covered over, my portrait seated on the floor among my books and in front of a large fire" (ibid., p. 37).

Jacob was correct in remembering the canvas as "huge" (it is one of Picasso's largest from 1901) and correct in surmising that it might have been covered over. But he seems not to have known how speedily his image was obliterated, for *Mother and Child* was executed only a few months after the portrait was completed, close in time to *Woman with a Chignon* (cat. 23). It is therefore among the earliest paintings of Picasso's Blue Period. Compared with *Woman with a Chignon*, the color is severely curtailed to a range of blues, and the paint is mark-edly looser and less dry in handling. Picasso did not scrape down the portrait of Jacob before beginning the new painting, thus giving extra weight and density to the surface texture of the canvas. If the painting is viewed in a raking light, one can still make out the raised contours of Jacob's head, just to the left of the bowed head of the mother.

The figure of the mother in the successor painting is represented huddled under a blanket, her eyes closed, clasping a child. Her bare feet and right hand—unnaturally, even grotesquely, attenuated—protrude from the blanket, and on her head she wears a formless shawl. There are few visual clues in the painting about precisely what setting mother and child occupy: the room is represented without

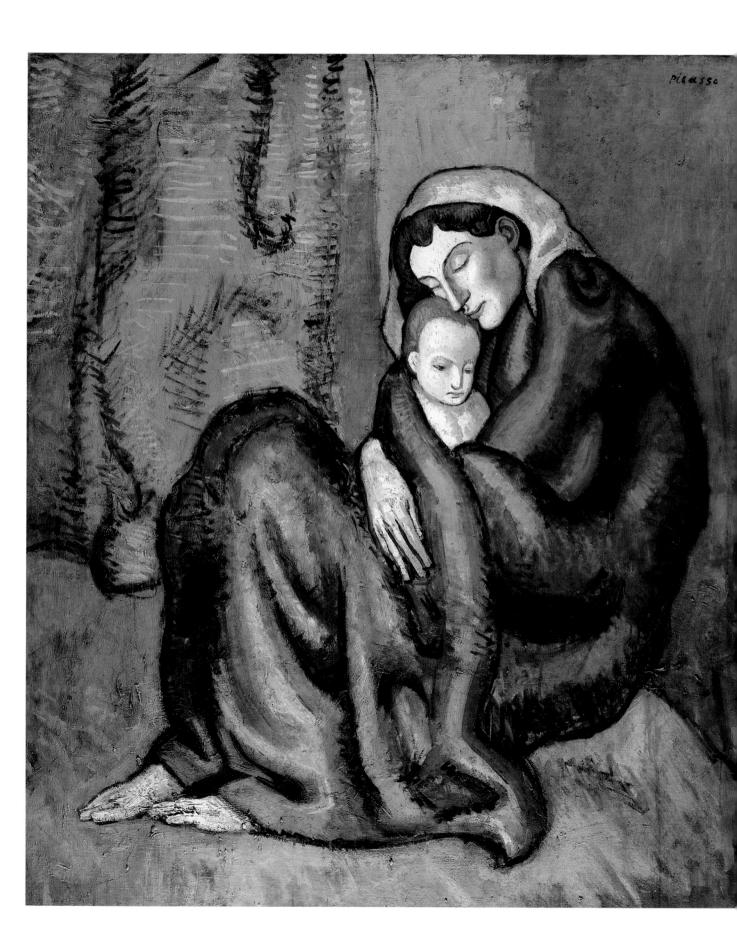

Figure 1.
Pablo Picasso. *Mother and Baby in Front of a Bowl of Flowers*, oil on cardboard, 1901. Private Collection, Paris.

furniture (the woman sits on the floor, her back against the wall), and the background is sectioned off by a curtain falling to the floor. Without doubt the painting presents an image of destitution and poverty, and in this respect it differs markedly from most of Picasso's earlier mother-and-child paintings, which were executed before the summer of 1901. Among the works completed prior to the Vollard exhibition is *Mother and Baby in Front of a Bowl of Flowers* (fig. 1), a maternity cast in strong values and set in an interior filled with flowers. It is an open celebration of motherhood—a treatment of the subject that contrasts sharply with the ambivalent attitude toward maternity registered by Picasso in the Wertheim painting.

Michael Leja has investigated this transformation in Picasso's mother-and-child paintings of 1901–1902 (Leja, 1985, pp. 66–81). His starting point is a group of paintings of prostitutes, initiated at about the time of the Vollard exhibition by a visit to Saint-Lazare, a hospital-prison in Paris for prostitutes with venereal disease (ibid., p. 66). Leja asks why Picasso should have chosen to arrange a visit to Saint-Lazare. While conceding that personal factors may have played a part in his decision—the suicide of his friend Casagemas, an interest in French Symbolism influenced by Jacob, the possible contraction of venereal disease himself—Leja considers it most likely that Picasso's curiosity was spurred by the wide public controversy at the time about prostitution and government regulation (or nonregulation) of it, a controversy in which Saint-Lazare figured prominently (ibid., pp. 67–69). Newspapers ran features about prostitution, venereal disease, and Saint-Lazare; pamphlets detailed the symptoms of syphilis, and novels dramatized the causes and consequences. In addition, it is worth recalling (see cats. 22 and 23) that Coquiot had just singled out Picasso as a

Figure 2.
Pablo Picasso. *Inmates at Saint-Lazare,*
oil, 1901. Formerly in the Thyssen-
Bornemisza Collection, Lugano.

painter with an appetite for modern life (Fabre, 1981, p. 514). What could signify his commitment to modernity more than an interest in Saint-Lazare, one of the major topics of the day?

The inmates of Saint-Lazare were required to wear white Phrygian bonnets, the legislated garb for venereal patients. In some paintings Picasso represents the inmates in this headgear, but paradoxically (or so it would seem), he also represents them accompanied by children (fig. 2). This apparent contradiction is explained by the fact—shocking to some visitors at the time—that children commonly accompanied their mothers to Saint-Lazare. Jules Hoche, a journalist writing in March 1901 about the appalling conditions in the prison, encountered a two-year-old child who had been incarcerated there since the age of six months (cited in Leja, 1985, p. 69).

In a number of maternities from the second half of 1901 and 1902, such as *Mother and Child by the Sea* (1902, D&B VII.20), a painting in which the stylized facial expressions of the figures closely resemble those of the Wertheim painting, the Phrygian bonnets worn by the women are replaced by shawls or flowing hoods. By means of this substitution, Picasso removes any overt reference to prostitution and venereal disease. However, he does not remove or alter the prevailing psychological mood established by the Saint-Lazare paintings. This mood stems from a perception of motherhood, Leja argues, that is "primarily pessimistic, emphasizing its hardships and pressures for lower-class women. Even those works which portray a mother consoled or gratified by her child are equivocal; celebration of their relationship is tempered by foreboding" (ibid., p. 72). This description fits *Mother and Child*. The *maternité* represented in the painting may or may not refer to something Picasso witnessed at Saint-Lazare, but the artist's decision to invest the theme with pathos, to depict it accompanied by poverty, was conditioned by his experience of the prison.

Provenance: Ambroise Vollard, Paris; Carroll Galleries, New York, to John Quinn, New York, 1915; Quinn Estate, 1924–1926; Paul Rosenberg, Paris, 1926; Baron Shigetaro Fukushima, Paris; Maurice Wertheim, by January 1937.

Bibliography: New York, 1926 (as *The Sad Mother*); Quinn, 1926, pp. 12 (ill.), 88 (as *The Sad Mother*); Jacob, 1927, p. 37; Z, I, 115; D'Ors, 1930, pl. 3; Hartford, 1934, no. 8; Estrada, 1936, p. 43; *Art News*, 1937, repr. cover; New York, 1939, no. 17; Barr, 1946, pp. 22, 25; Frankfurter, 1946, p. 63, repr. p. 65; Cambridge, 1946, p. 50, repr. p. 51; New York, 1947A, no. 7; Quebec, 1949, no. 20, pp. 55–57; Cirici-Pellicer, 1950, p. 158, no. 121; Boeck and Sabartès, 1955, pp. 123, 458 (ill.), 488; Vallentin, 1957, pp. 57, 449; Raleigh, 1960, p. 36, repr. p. 37; Blunt and Pool, 1962, pp. 70–71; Houston, 1962, pl. 14, pp. 38–39; D&B, pp. 54, 112, VI.30; Reid, 1968, pp. 207–208, 655; Finkelstein, 1970, pp. 29–30, 33–34, 36, 46, 52, 54; Leymarie, 1971, pp. 10–11; Augusta, 1972A, no. 25; Deknatel, 1976, pp. 37–42, repr. p. 39; Washington, 1978, pp. 32, 176; Fabre, 1981, no. 703; Friesinger, 1985, p. 43 (ill.). Bequest—Collection of Maurice Wertheim, Class of 1906, 1951.57

Pablo Picasso

Málaga, Spain 1881–Mougins 1973

25. *The Blind Man,* 1903

Watercolor on cream wove paper mounted on canvas, 53.9 x 35.8 cm. (23⅜ x 14⅛ in.) Signed in blue watercolor, lower right: Picasso 19[03] (the last two digits of the date are illegible)

The Blind Man was painted in Barcelona in 1903. At least four drawings are related to the painting (illustrated in Fabre, 1981, nos. 913–915, 917). All represent the same sightless, etiolated figure—chest indented and limbs elongated—and all depict the man seated, his head slightly raised. The drawing most resembling the painting, at least in terms of the disposition of the head and shoulders, is the so-called *Blind Man Singing* (no. 915) from a book of studies used by Picasso to develop the compositions of several paintings. The sketchbook was filled in October 1903 (Fabre, 1981, p. 352).

The Blind Man was not painted in gouache, as is sometimes supposed (Z, I, 172). Nor was it painted in several different hues, as the eye might suspect. The medium is watercolor with no thickening agent, and the color is exclusively Prussian blue. There is not even evidence of a graphite underdrawing. However, there should be no mistaking the care and attention paid by Picasso to the execution of the painting. The fastidiousness manifests itself in the precision of draftsmanship in the hands and feet and in the exacting folds and creases in the clothing. Because of the poor condition of the watercolor, one might almost believe that the paper itself is creased. The highlights in the painting have been achieved by lifting off previously washed-in color, and the darks, almost iridescent in places, by repeated applications of blue washes.

The indigent figure represented in *The Blind Man* is reused by Picasso, with alterations, in *The Blind Man's Meal* (fig. 1). The pos-

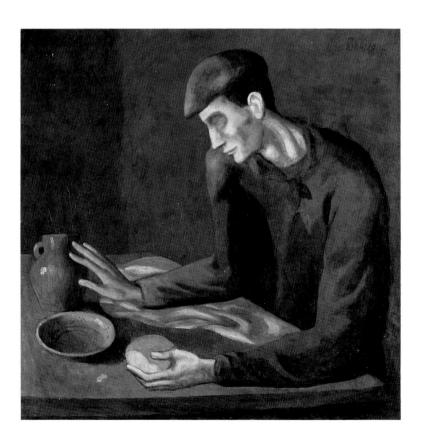

Figure 1.
Pablo Picasso. *The Blind Man's Meal,* oil on canvas, 1903. Metropolitan Museum of Art, New York. Gift of Mr. and Mrs. Ira Haupt, 1950.

tures of both figures are marked by "the elongations, the insistent pathos, the cramped postures or affected gestures" that are character-istic of Picasso's work in late 1903 and 1904 (Barr, 1946, pp. 28–29). The attenuations are reminiscent of El Greco, an affinity of form and purpose that led Alfred H. Barr, Jr., to label these Blue Period works as "Mannerist" (ibid., p. 29).

The Blind Man, bought by Wertheim in May 1936, is reported to have been the first purchase of modern European art to enter the collection (Frankfurter, 1946, p. 31). It was quickly followed by the acquisition of four more works by Picasso—the other three entries in this catalogue and *Nude on a Red Background* (1906, D&B XVI.8), which Wertheim subsequently sold (see Introduction).

Provenance: D. H. Kahnweiler, Paris; [B. Shüler, Bochum]; Galerie Pierre, Paris, by 1930; René Gimpel, Paris, to the Toledo Museum of Art, Ohio, 1930; Toledo Museum of Art to Edouard Jonas, Paris and New York, 1936; Valentine Gallery, New York, to Maurice Wertheim, May 1936.

Bibliography: Hildebrandt, 1913, p. 377; Raynal, 1921, pl. 11; Documents, 1930, p. 303; Z, I, 172; Merli, 1942, p. 42; Frankfurter, 1946, p. 31, repr. p. 31; Cambridge, 1946, p. 52, repr. p. 53; Quebec, 1949, no. 21, pp. 58–59; Raleigh, 1960, p. 38, repr. p. 39; Houston, 1962, pl. 15, pp. 40–41; D&B IX.31; Augusta, 1972A, no. 26; Fabre, 1981, no. 916, pp. 352–353, 358. Bequest—Collection of Maurice Wertheim, Class of 1906, 1951.56

Pablo Picasso

Málaga, Spain 1881–Mougins 1973

26. *Mother and Daughter*, 1904

Blue, red, yellow, and black crayon on cream wove paper, 36.8 x 29.6 cm. (14½ x 11⅝ in.)
Signed in graphite pencil, lower left: Picasso (underlined)
Inscribed on the verso in black crayon, lower right: DT 12

Figure 1.
Pablo Picasso. *Woman Ironing*, oil on canvas, 1904. Solomon R. Guggenheim Museum, New York. Gift of Justin K. Thannhauser, 1972.

Even the attentive viewer may be deceived by the deployment of color in Picasso's outline drawing, traditionally called *Mother and Daughter*. The cause for deception relates to the color juxtaposition of the blue crayon on the yellow paper. The contrast was not calculated by Picasso—at least not in its present intensity—for the paper was white when he executed the drawing. Time and the cheapness of the paper are responsible for its change from white to yellow (see Appendix C).

Mother and Daughter is dated by consensus to the second half of 1904 (Z, I, 239; D&B D.XI.19). By then, Picasso had arrived in Paris for the fourth time, as it turned out to settle permanently. In the summer of 1904 he formed a liaison with a woman named Madeleine, who is thought to have been the model for *Woman Ironing* (fig. 1), one of the last "blue" works, and for a number of drawings and gouaches adumbrating the theme of the Family of Harlequin, which preoccupied Picasso in 1905 (New York, 1980, p. 56). Among the drawings is *Mother and Daughter*. The woman's posture, with her bowed head and neck and right shoulder stretched in the form of a crescent, is comparable to that of the figure in *Woman Ironing*. Like *The Blind Man* (cat. 25), and other paintings completed in Barcelona before Picasso's departure in the spring of 1904, the drawing falls among those works which Alfred H. Barr, Jr., described as "Mannerist" (Barr, 1946, p. 29).

Provenance: Pierre Matisse Gallery, New York, by 1932; Pierre Matisse Gallery to M. Gutmann, October 1936; Maurice Wertheim, by 1937.

Bibliography: Z, I, 239; Frankfurter, 1946, p. 64; Cambridge, 1946, p. 68, repr. p. 69; Quebec, 1949, no. 30, pp. 77–78; Raleigh, 1960, p. 66, repr. p. 67; Houston, 1962, pl. 27, pp. 60–61; D&B D.XI.19; Augusta, 1972A, no. 27; Cambridge, 1981, pp. 53–54. Bequest—Collection of Maurice Wertheim, Class of 1906, 1951.76

Henri Rousseau

Laval (Mayenne) 1844–Paris 1910

27. *The Banks of the Oise*, ca. 1907

Oil on canvas, 33.1 x 46 cm.
(13 x 18⅛ in.)
Signed in black paint, lower right:
H. Rousseau (underlined)
Inscribed on the back of the stretcher:
"Bords de l'Oise, 1907"

Among the labels that have been applied to Rousseau, often in quotation marks, are naive, childlike, intuitive, instinctive, primitive, Sunday painter, and amateur. "Sunday painter" and "amateur" are terms of dismissal, alluding to Rousseau's lack of formal training and an apparent absence of control over his media. The other labels, however, are less derogatory. In particular, they force the question of whether the consistent qualities found in Rousseau's art come, as is sometimes claimed, from the painter's naiveté or, on the contrary, from his sophistication (Walsh, 1985, p. 9).

The Banks of the Oise belongs to a small group of rural landscapes depicting the Ile de France. Most of the paintings include figures, and most draw on a repertory of stereotyped ingredients—trees, clouds, animals, pasture—that Rousseau rearranged and juxtaposed from painting to painting (DV, pp. 87–88; New York, 1985, no. 40). The Wertheim painting has similarities with three earlier landscapes (DV 10, 13, 225A) and closely resembles a later work (DV 255). Indeed, *Banks of the Oise* seems to have served as a model for the later work (*Meadowland*, fig. 1), which was commissioned from Rousseau by the Italian author and painter Ardengo Soffici. But Soffici was disappointed with the painting when he saw it. "Alas, *quantum mutatus!*" he wrote. "In a field that looked like a green public square stood two animals that could just as well have been steers as cows; they were being tended, but instead of a shepherd there was a gentleman who looked like a *commedia dell'arte* character in a scarlet-red cap. Instead of the strong, age-old oak trees standing out among the woods . . . all I could see was a vegetal black with silvery commas in place of foliage; this tree looked more like a haystack than like the

Figure 1.
Henri Rousseau. *Meadowland*, oil on canvas, 1910. Bridgestone Museum of Art, Tokyo. Ishibashi Foundation.

willow it was supposed to be; it was stuck down in front of a row of poplars lined up like soldiers across the background of the picture . . ." (quoted in Certigny, 1961, p. 439).

In his disappointment, Soffici, who had asked for a version of DV 187, also overlooked Rousseau's control of detail and clarity of color in *Meadowland*. The same characteristics are found in its model: the schematic patterning of the leaves of the willow—Soffici's "silvery commas"—is echoed in the patterning of the leaves of the poplars; the white cap of the cowherd rhymes, deliberately and wittily, with the white markings on the flanks and faces of the cows; and the composition is carefully, almost geometrically, ordered.

The Banks of the Oise has been dated as early as the mid-1890s (Shattuck, 1968, no. 23) and as late as ca. 1910 (DV 240), the year of the artist's death. Rousseau's work, with its peculiarly unchanging technique, is notoriously difficult to date, and Shattuck's estimate of ca. 1895 cannot be discounted. Here it is dated to ca. 1907, partly on the basis of an inscription on the original stretcher—"Bords de l'Oise, 1907"—which is possibly in Rousseau's own hand (though he was known to be inaccurate in dating his own work), and partly on the evidence that it was hanging in Rousseau's studio throughout the year 1908. The artist Max Weber, who met and became friends with Rousseau in Paris in mid-October 1907 (Leonard, 1970, pp. 15–16), remembered the painting when he saw it again at the Paul Rosenberg Gallery, New York, in late 1948. "In our conversation about Rousseau," he wrote to Rosenberg, "I forgot to mention that the painting of the poplars and grazing cows by Rousseau which you were so kind to show to my friend [Marius] de Zayas and me some months since, hung in Rousseau's studio, #2 rue Perrel, Paris, throughout the entire year 1908 on the wall facing him when he was seated at his easel" (FMA, undated letter [early 1949]). The painting, then, was done no later than 1907. However, it remains difficult to establish when the earliest date might have been.

Provenance: M. Huc, Toulouse; Paul Rosenberg, Paris, 1912; Alphonse Kann, St. Germain-en-Laye; Paul Rosenberg, New York, 1947; Paul Rosenberg to Maurice Wertheim, by July 1949.

Bibliography: Zervos, 1927, pl. 68 (confused with DV 255); Quebec, no. 22, pp. 60–62; Shattuck, 1968, no. 4, p. 80; Raleigh, 1960, p. 48, repr. p. 49; Bouret, 1961, no. 142 (confused with DV 255); Vallier, 1961, no. 111; Houston, 1962, pl. 18, pp. 46–47; DV 240, pp. 88, 111, 113; Leonard, 1970, p. 21; Augusta, 1972A, no. 32. Bequest—Collection of Maurice Wertheim, Class of 1906, 1951.67

Henri Matisse

Le Cateau-Cambrésis 1869–Nice 1954

8. *Geraniums*, 1895

Oil on canvas, 61 x 50.2 cm.
(24 x 19¾ in.)
Signed in red paint, lower right: Henri
Matisse

Geraniums was painted in 1915. In the development of Matisse's art, Alfred H. Barr, Jr., has argued, 1915 was a year in which the artist's paintings—relatively few in number and marked by a peculiar and uneasy kind of abstraction—were informed by "a sense of serious and sometimes uncertain experiment" (Barr, 1951, p. 187).

In most respects, this still life fits Barr's general description. At least three kinds of floral pattern are represented in the painting and against all odds are made to cohere pictorially. The botanical profusion is spread throughout: in the arabesque patterns of the wallpaper above the table, in the decorative blue and white designs on the ceramic plate, and in the pot of geraniums itself. A fourth bit of flora, if that is what it is, lies on the surface of the ocher-colored table—a solitary patch of blue surrounded by white. It hardly matters whether this patch represents a fallen blossom from the plant, its color altered from cadmium red to Prussian blue in the course of its descent, or whether it represents a petal that has unaccountably slipped off the tilted Persian plate. What does matter is that we are persuaded that it belongs there; that is, we are persuaded by the image as a whole, by the relations of its parts, by its sheer artifice, by Matisse's manipulation and control of paint and canvas.

Before applying his colors, Matisse first outlined the composition

Figure 1.
Henri Matisse. *Vase with Geraniums*, crayon, 1915. Musée Matisse, Nice-Cimiez.

in black. The drawing is particularly visible in the snaking tendrils of the patterned wallpaper and in the organic patterning of the plate. Also clearly visible—inside the elliptical contours of the plate—is the off-white ground that Matisse selected to work on. It is significant that after settling on the composition he seems not to have deviated from it. Nor does he seem to have changed his mind and altered, as he so often did in his work (see cat. 29), his initial distribution of colors. In short, *Geraniums*, for all its verve and wit, has the look of having materialized almost without effort.

However, this appearance of ease may be illusory. A drawing from the same year as the painting, and of a directly related subject (fig. 1), carries evidence of the uncertainty and experimentation referred to by Barr. In the drawing, which focuses on the structuring of a Cubist-inflected space, the various stages of Matisse's analysis are marked by erasures and revisions. It is likely that in preparing to paint *Geraniums* Matisse first took the composition through a similar series of revisions. The taut, curvilinear forms of the painting, the heavily repainted ocher tabletop, the fibrillating tendrils that animate its upper register have undergone more twists and turns than can readily be seen in the finished product.

Provenance: Private collection, Paris (said to have been bought directly from the artist between 1916 and 1918); Valentine Gallery, New York, to Maurice Wertheim, 1936–1937.

Bibliography: New York, 1936B, no. 7; *Arts and Decoration*, 1937, repr. p. 17; Frankfurter, 1946, p. 64; Cambridge, 1946, p. 54, repr. p. 55; Quebec, no. 24, pp. 65–66; Raleigh, 1960, p. 24, repr. p. 25; Houston, 1962, pl. 9, pp. 28–29; Augusta, 1972A, no. 14. Bequest—Collection of Maurice Wertheim, Class of 1906, 1951.52

Henri Matisse

Le Cateau-Cambrésis 1869–Nice 1954

29. *Still Life with Apples*, 1916

Oil on wood panel, 32.9 x 41.1 cm.
(13 x 16¼ in.)
Signed in black paint, lower right: Henri
Matisse

Still Life with Apples is an austere painting without the decorative incident that characterizes *Geraniums* (1915, cat. 28). The surface of the wall behind the table is represented as a single tone of unbroken gray. The plate at the center of the composition, tilted toward us at the same precarious angle as the ceramic plate in the earlier still life, is plain and unembellished. And the two apples sitting on the plate seem to be uningratiatingly hard.

The painting is constructed by means of a geometry of strong outlines. Matisse's emphasis is on sharp right angles, straight lines, and uninterrupted ovals—as in the half-filled glass of water whose elliptical mouth rhymes with the circumference of the plate below. Matisse's deployment of color complements the stark forms. Against predominantly cool grays and dark blues, which were heavily reworked before the final colors were arrived at (see Appendix C), the apples are painted in gaudy hues of red and green. In intensity they are almost phosphorescent.

The result is a composition that seems tense and unstable. These are qualities that characterize a high number of Matisse's paintings from 1916, which are among the most remarkable of his career. On 1 June 1916 he wrote of his work to Hans Purrmann, who had just purchased *Goldfish and Sculpture* (1911, Museum of Modern Art). "As I told you I have worked a great deal. I have finished a canvas the sketch of which is on the back [*The Window*, Detroit Institute of Arts]. I have also taken up again a five-meter-wide painting showing bathing women [*Bathers by a River*, Art Institute of Chicago]. As for other events concerning me: the painting which I gave to the blind has been bought by Kelekian, and the canvas showing a Spanish glass water jug in which is dipped a branch of ivy, by Alph[onse] Kann. . . . The still life with oranges which you asked me to reserve for you is finished. These are the important things in my life. I can't say that it is not a struggle. . ." (Barr, 1951, p. 181).

Although *Still Life with Apples* is small in scale compared with the paintings mentioned in the letter, it, too, reflects something of the struggle referred to by Matisse. The struggle, it would seem, was to find a way of lending weight and solidity to represented things— to the hard rectangularity of a table, to the round density of an apple —while still owning up to the artificiality of painting's procedures. In finding a solution to the problem, Matisse sometimes, as in this still life, produced a strikingly discordant image.

Provenance: Paul Guillaume, Paris; Maurice Wertheim, 1936–1937.

Bibliography: Paris, 1929; George, 1929, pp. 78–79, repr. p. 79; *Cahiers d'Art*, 1931, fig. 59; Paris, 1931, no. 31; Scheiwiller, 1933, pl. 8; Paris, 1935; Escholier, 1937, p. 60; New York, 1943A; Frankfurter, 1946, p. 64, repr. p. 29; Cambridge, 1946, p. 56, repr. p. 57; Quebec, 1949, no. 25, pp. 67–68; Raleigh, 1960, p. 22, repr. p. 23; Houston, 1962, pl. 8, pp. 26–27; Augusta, 1972A, no. 15; Carrà, 1982, no. 214. Bequest—Collection of Maurice Wertheim, Class of 1906, 1951.51

Henri Matisse

Le Cateau-Cambrésis 1869–Nice 1954

30–33. *Mlle. Roudenko (Dancer of the Ballets Russes)*, 1939

Pen and black ink on white wove paper,
48 x 31.5 cm. (18⅞ x 12⅜ in.)
Signed and dated in graphite, lower right:
Henri Matisse/juill. 39

34. *Nude Leaning on Her Left Elbow,* ca. 1935–1939

Pen and black ink on white wove paper,
48 x 31.5 cm. (18⅞ x 12⅜ in.)
Inscriptions in graphite, left to right
across top: 33; Barb; ph

The quartet of drawings of Mlle. Roudenko, executed in July 1939, was first exhibited in 1948 at the large Matisse retrospective organized by the Philadelphia Museum of Art (Philadelphia, 1948, nos. 154–157). The retrospective drew heavy crowds and considerable attention from the press, in part because Matisse himself collaborated in its preparation. He not only selected many of the works for the exhibition (including all the drawings) but also contributed a long letter and an essay to the accompanying catalogue.

Matisse's written contributions, particularly the letter (addressed to Henry Clifford, curator of the exhibition), must have struck some readers of the catalogue as curious. The letter expressed anxiety about how younger artists in America would respond to work in the exhibition, voicing an uneasiness that they would interpret "the apparent facility and negligence" in the drawings as not apparent but real—and that they would take Matisse's example as an excuse for dispensing with the apprenticeship necessary to eventual accomplishment (ibid., pp. 15–16). The essay, entitled "Exactitude is not Truth," touched on the same theme but attempted to answer potential criticisms with a personal case study. From among the drawings selected for the exhibition, Matisse chose to discuss a group of four self-portraits (fig. 1). This group, executed only three months after the Roudenko quartet, is identical to it in concept, technique, and style. What Matisse has to say about the self-portraits is directly relevant to what he would have us understand about the Wertheim sheets.

"These drawings seem to me," began Matisse, "to sum up observations that I have been making for many years on the characteristics of a drawing, characteristics that do not depend on the exact copying of natural forms, nor on the patient assembling of exact details, but on the profound feeling of the artist before the objects which he has chosen. . . . The four drawings in question are of the same subject, yet the calligraphy of each one of them shows a seeming liberty of line, of contour, and of the volume expressed. . . . The elements, if they are not always indicated in the same way, are still always wedded in each drawing with the same feeling—the way in which the nose is rooted in the face—the ear screwed into the skull—the lower jaw hung. . . . It is thus evident that the anatomical, organic inexactitude in these drawings has not harmed the expression of the intimate character and inherent truth of the personality, but on the contrary has helped to clarify it" (ibid., pp. 33–34).

The apologia concludes with the observation that the results have nothing to do with "chance." In other words—notwithstanding the speed at which the line drawings were executed, the shifting and the summary appearance of facial features, the air of spontaneity—the end results were almost premeditated. Matisse had stated in 1939 that it was his practice to make numerous charcoal studies before working in pen and ink (Matisse, 1907–1954, pp. 81–82). The purpose, so

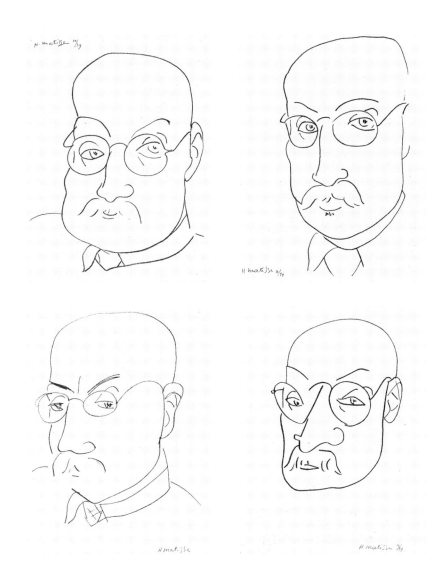

he said, was to permit him to establish a rapport with his model;
then he could proceed with the line drawings. A charcoal study of
Mlle. Roudenko, dated June 1939, indicates that this was his procedure
before starting on the Roudenko drawings (Goode, 1939, p. 35).

Luba Roudenko, who was born to Russian parents in Bulgaria,
was a dancer with the Ballets Russes de Monte Carlo. It is probable that
Matisse met her during the course of his work on the set and costumes
for Léonide Massine's ballet *Rouge et Noir*, which was first performed
in Monte Carlo in May 1939 and later in Paris. Matisse stayed in Paris
through July at the Hôtel Lutetia, so the drawings must have been
executed there. It is interesting, though not entirely relevant, that
after the war Luba Roudenko immigrated to the United States,
where she became a New York fashion designer (Sheppard, n.d.).

In 1976 the four Roudenko portraits were removed from their
frames for the first time since being bought by Wertheim directly

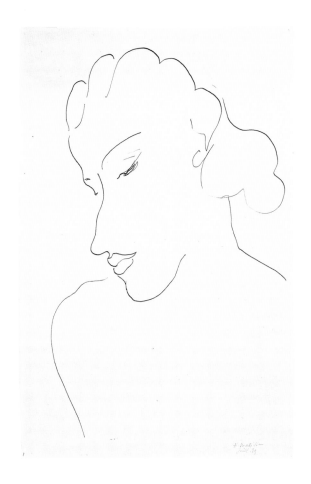

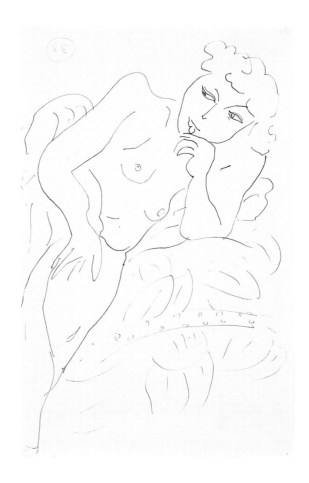

from Matisse in 1948 (FMA, letter from Matisse to Wertheim,
4 August 1948). A fifth drawing, a study of a reclining nude, previ-
ously unknown and unpublished, was discovered attached to the back
of cat. 33. An extra blank sheet was also found glued to the verso of
cat. 32. The other two drawings, made on thicker paper, had no
backing sheets. Apparently Matisse preferred the heavier support for
his line drawings and therefore attached backing sheets to the thinner
paper to make it sturdier.

The subject of the recovered drawing relates to a series done
between 1935 and 1937, in which Matisse explored the theme of a
model reclining in the studio against a decorative background. The
technique of the drawing—a thin, flowing, unshaded black line work-
ing against a broad expanse of white paper—is the same as that
employed in the Roudenko portraits.

Provenance: In the artist's possession until 1948; Matisse, through the
Pierre Matisse Gallery, New York, to Maurice Wertheim, 1948.

Bibliography (all references are to cats. 30–33 only): Philadelphia, 1948,
nos. 154–157; Quebec, 1949, nos. 31, 31a–31c, pp. 79–80; Mongan, 1958,
pl. viii, p. 204; Raleigh, 1960, p. 64, repr. p. 65; Houston, 1962, pls. 23–26,
pp. 58–59; Sheppard, n.d.; Augusta, 1972A, nos. 16–19. Bequest—Collection
of Maurice Wertheim, Class of 1906, 1951.72, 1951.73A, 1951.73B (*Nude
Leaning on Her Left Elbow*), 1951.74, 1951.75

125

Pierre Bonnard

Fontenaye-aux-Roses 1867–Le Cannet
1947

35. *Interior with Still Life of Fruit*, 1923

Oil on canvas, 43.5 x 65 cm.
(17⅛ x 25⅝ in.)
Signed in ocher paint, bottom right:
Bonnard

It is unclear in this painting what kind of container holds the assorted oranges, apples, grapes, and figs depicted by Bonnard. It could be a basket or a porcelain bowl. It is also unclear what the four rectangular forms running along the top edge of the composition represent. Other paintings by Bonnard would suggest they are windows, but they could just as easily be a row of pictures within the picture. Nor, on a broader level, can the painting be clearly categorized either as a "still life" or as an "interior." The still-life arrangement of fruit, spoon, eggs, and plate (cropped by the framing edge) is unquestionably the focus of the composition; its foreground placement and high-keyed colors make it so. However, the painting also hints at a deep interior space stretching behind the white tabletop. Through the dark-blue gloom, one can just distinguish the back of a seated figure (the head turned to the right in profile) and another table or bureau surmounted by a green vase.

On the occasion of Bonnard's first one-man exhibition in the United States, at the Bignou Gallery in New York in 1947, Clement Greenberg commented on Bonnard's high renown "among those who profess to know and like painting for painting's sheer sake" (Greenberg, 1947, p. 53). Greenberg observed that Bonnard owed his rising reputation in America principally to work produced since 1915—that is, to work in which the emphasis, more than in the earlier paintings, was on the culinary pleasures of his medium. "It is precisely this concentration on his stuff," continued Greenberg, "on juice and matter, that seems to have led Bonnard to paint more and more abstractly; the greater the attention to pigment and brushstroke the less becomes the concern with the original idea of the subject in nature" (ibid.). The Wertheim canvas, executed in 1923, conforms to this description. The attention is concentrated on texture and color, while the objects represented have about them a casual and incidental air.

Interior with Still Life of Fruit was Wertheim's last purchase for the collection. He acquired it in March 1950, two years after the large and critically successful Bonnard retrospective at The Museum of Modern Art, New York (New York, 1948A). The exhibition included twenty-two works from the 1920s, the majority of them still lifes and interiors. The Wertheim painting was not included in the retrospective, but it was shown in 1946 in Paris at a special exhibition of works that had been seized by the Nazis during the Occupation and returned to the original owners following the war (Paris, 1946, no. 51).

Provenance: Bonnard to Bernheim-Jeune, Paris, 1923; Henri Canonne; Paul Rosenberg, Paris, by 1939; seized by the Nazis during the Occupation, recovered at the Liberation; Paul Rosenberg, New York, to Maurice Wertheim, March 1950.

Bibliography: Amsterdam, 1939, no. 10; Paris, 1946, no. 51; Raleigh, 1960, p. 4, repr. p. 5; Houston, 1962, p. 11; Augusta, 1972A, no. 1; Dauberville, 1973, III, no. 1203. Bequest—Collection of Maurice Wertheim, Class of 1906, 1951.69

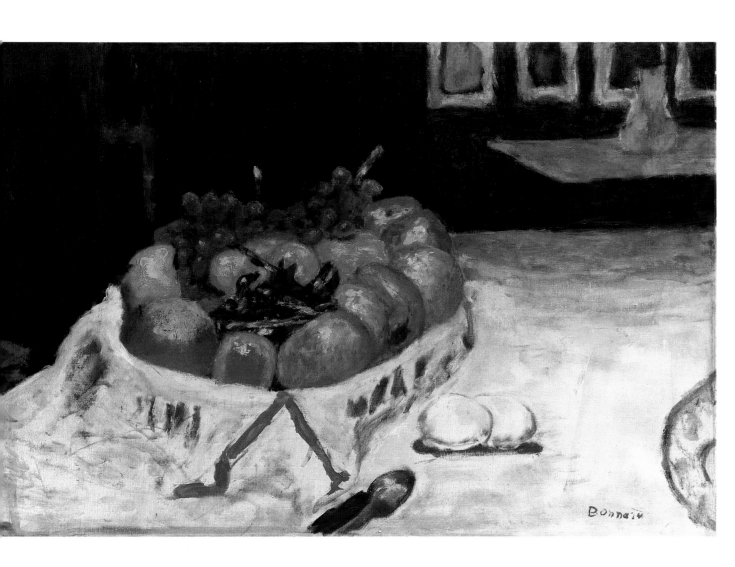

Raoul Dufy

Le Havre 1877–Forcalquier 1953

36. *Race Track at Deauville, the Start,* 1929

Oil on canvas, 65.5 x 81.5 cm.
(25¾ x 32⅛ in.)
Signed and dated in green paint, lower
center: Raoul Dufy 1929

The most perceptive published account of *Race Track at Deauville, the Start,* written by Frederick S. Wight, appeared as a catalogue entry for the first exhibition of the Wertheim collection at the Fogg Art Museum in 1946 (Cambridge, 1946, p. 62). Writing in the present tense (for in 1946 Dufy was alive and still at work), Wight contended that Dufy, for all his ability and skill as a painter, was like a modern-day "showman in paint"—a showman content to go where his audience went and to paint what his audience liked. Moreover, Wight charged that Dufy had failed to escape the leisured tastes of his audience and instead had catered to them. Wight's entry is worth reprinting here:

> *The race course has long fascinated Dufy. His material is all here: the crowd, the general activity, the animated subject matter to go with the animated color. The scene is composed of colored planes which create the space of the theatre, where colored light itself is used to establish the planes of the wings. Over this abstract design, broad and horizontal, flows a perpendicular arabesque of notations so close to handwriting that it is positively journalistic. . . .*
>
> *Dufy is a decorative painter at once mundane and romantic. His touch is light, his color transparent . . . and he is aware of the patterns of textiles—possibly conscious that he is decorating a piece of cloth. As in this picture he frequently makes use of a flag. Often the whole canvas has been treated as a flag and divided into zones of color. The figures exist under one zone or another as though it were a climatic change or a political shading which had swept across them. . . . [Dufy] is the man who puts on the show, manipulates the scenery, who insists that it never rains. It is really very simple: Dufy is a showman in paint. He goes where most people want to go and likes whatever most people like* (ibid.).

The Deauville track, which Dufy frequently visited, was constructed as a financial speculation in 1864 by the Duc de Morny

Figure 1.
Eugène Boudin. *The Races at Deauville,* graphite and watercolor, 1866.
Mr. and Mrs. Paul Mellon, Upperville, Virginia.

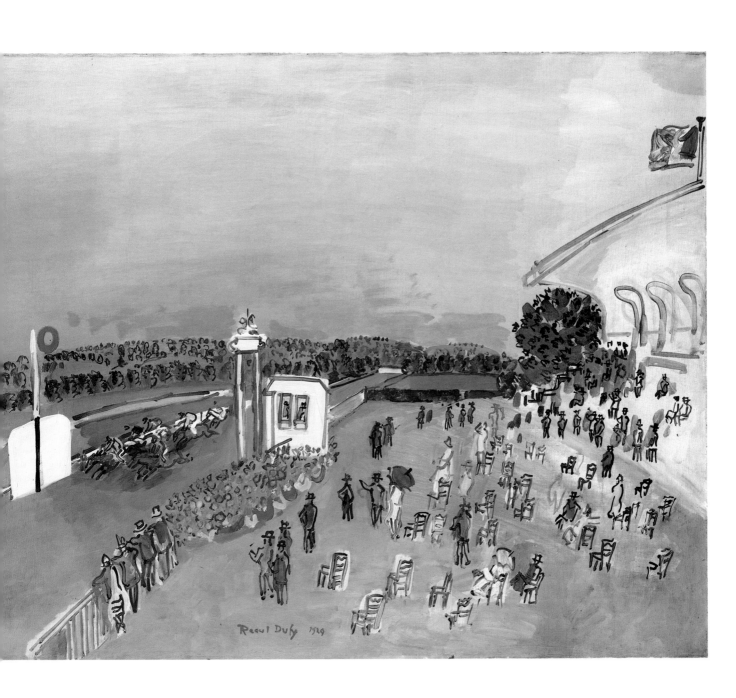

(Washington, 1983, p. 142). In a short time it became a huge success, quickly attracting the wealthy of France and England and, following them, artists. In 1866 Eugène Boudin painted *The Races at Deauville* (fig. 1), a sheet of sketches representing elegantly turned-out spectators and glistening horses. Boudin's emphasis, like Dufy's sixty years later, is on the festive side of the occasion, the sparkling day (during which "it never rains"), and its decorative aspect. Between 1923 and 1936 Dufy returned time and again to the theme of the race track. At least thirteen of his canvases take the hippodrome at Deauville as a subject, seven from the vantage point represented in the Wertheim painting (Laffaille, 1972–1976, nos. 1287–1293).

Provenance: Pierre Matisse Gallery, New York, to Maurice Wertheim, 1938.

Bibliography: Berr de Turique, 1930, p. 110; New York, 1940A; Frankfurter, 1946, p. 64; Cambridge, 1946, p. 62, repr. p. 63; Quebec, 1949, no. 26, pp. 69–70; Canaday, 1959, pp. 408–409, repr. p. 409; Raleigh, 1960, p. 12, repr. p. 13; Houston, 1962, pl. 3, pp. 16–17; Augusta, 1972A, no. 9; Laffaille, 1972–1976, no. 1293. Bequest—Collection of Maurice Wertheim, Class of 1906, 1951.48

Edgar Degas

Paris 1834–1917

7. *Horse Trotting, the Feet Not Touching the Ground,*
ca. 1881–1890

Bronze, 22.9 x 27.2 cm. (9 x 10¾ in.)
Signed, proper left front of top of base:
Degas
Numbered, proper right rear of top of
base: 49/B
Stamped, proper right rear of top of base:
CIRE/PERDUE/A A HEBRARD

8. *Grande Arabesque, Third Time,*
ca. 1885–1890

Bronze, 40.2 x 55.4 cm. (15⅞ x 21¾ in.)
Signed, proper right side of top of base:
Degas
Numbered, proper rear of top of base:
16/D
Stamped, proper rear of top of base:
CIRE/PERDUE/A A HEBRARD

"No animal is closer to a *première danseuse*, wrote Paul Valéry in his book on Degas, "than a perfectly balanced thoroughbred" (Valéry, 1938, pp. 69–70). It has often been remarked that the two themes—racehorse and dancer—were closely associated in Degas's mind. They were as dominant in his sculpture as in his drawing and painting. They were also given a prominent place in his poetry and seemed to overlap in significance; one sonnet in a series of eight devoted principally to dancers and the dance is entitled "Thoroughbred" (Reff, 1978). Approximately half of Degas's known sculptures represent dancers, and racehorses account for a high proportion of the remainder. These subjects figured in the spectacle of modern life as Degas saw it. They also offered the possibility of dealing with figures in motion.

Degas's sculptures are difficult to date with precision. It is likely that *Horse Trotting* and *Grande Arabesque* were modeled during the 1880s—that is, after Degas had seen Eadweard Muybridge's serial photographs of the phases of movement in a horse's trot and gallop (Millard, 1976, pp. 21–25). One frame from a sequence of a horse trotting, published in *Le Globe* in 1881, shows the horse airborne with all four feet off the ground in much the same attitude as that used by Degas in the Wertheim sculpture (Rewald, 1944, p. 22). But the convincing illusionism of the sculpture is only partially dependent on Muybridge's photograph. Its real sense of thrust and movement depends for sculptural effect, as it must, on Degas's attention to the massing of volumes and the interaction of solids and voids.

Neither Degas's original wax model for *Horse Trotting* nor his plasticene model for *Grande Arabesque* (both in the collection of Mr. and Mrs. Paul Mellon since 1955) was exhibited or cast in Degas's own lifetime (Millard, 1976, pp. 27–39). Indeed, with the single exception of *Little Dancer, Fourteen Years Old*, which was shown at the Impressionist exhibition of 1881, none of the sculpture was exhibited or cast. After Degas's death in 1917, about one hundred and fifty sculptures in various stages of disintegration and preservation were discovered in his atelier (Rewald, 1944, p. 14). Of these, seventy-three were cast in bronze in sets of twenty-three—or perhaps more, as no exact records were kept (Failing, 1979, pp. 38–41)—by the Paris foundry of A. A. Hebrard. Each sculpture was assigned a number from 1 to 73, and each cast of the twenty sets intended for sale was assigned a letter from A to T (Millard, 1976, pp. 32–33).

Provenance (37): Maurice Wertheim, by 1944.
(38): Justin Thannhauser, New York, to Maurice Wertheim, April 1945.

Bibliography: Rewald, 1944, nos. XI and XL; Rewald, 1944, *Art News*, pp. 21–22, repr. p. 22 [no. 38]; Frankfurter, 1946, p. 64, repr. p. 30 [no. 37]; Cambridge, 1946, p. 70, repr. p. 71; Rewald, 1957, pp. 142, 149, figs. 13, 20–21; Raleigh, 1960, p. 70, reprs. p. 71; Houston, 1962, pl. 29, pp. 64–65; Beaulieu, 1969, pp. 374–375; Augusta, 1972A, nos. 5, 6; Dallas, 1974, fig. 12 [no. 38]; Coolidge, 1975, repr. p. 5 [no. 38]; Millard, 1976, pp. 23–24, 99–100, figs. 62, 91; London, 1976, nos. 5, 8. Bequest—Collection of Maurice Wertheim, Class of 1906, 1951.79 and 1951.78

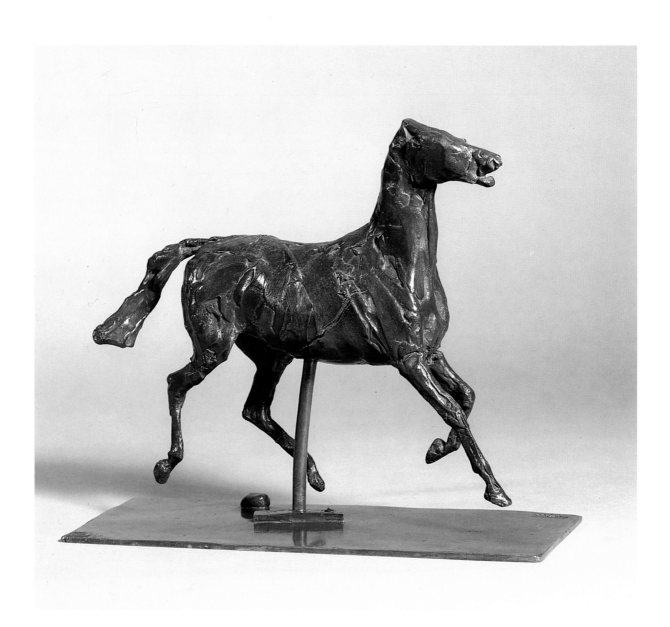

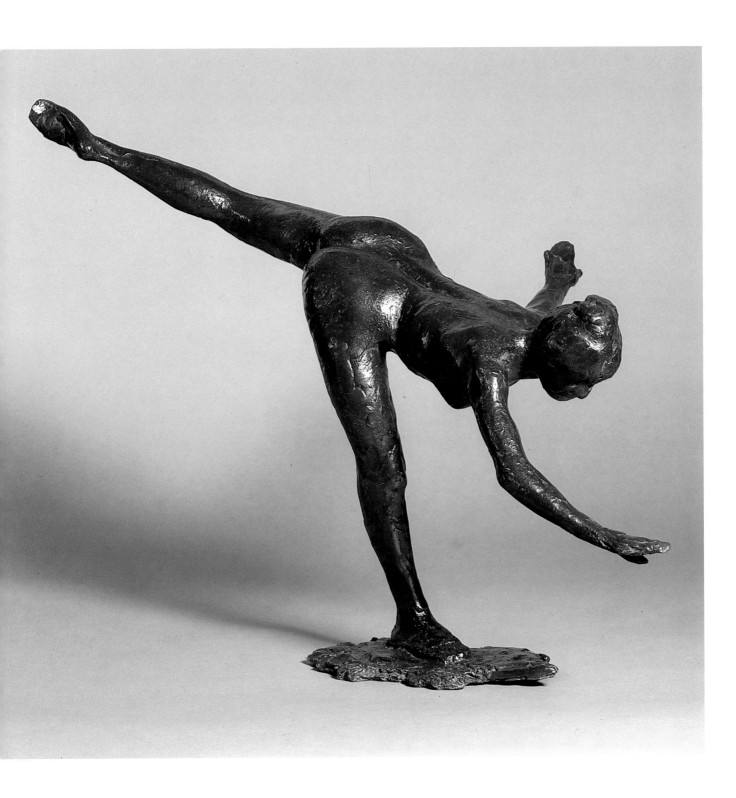

Aristide Maillol

Banyuls-sur-Mer 1861–1944

39. *Head of a Woman,* ca. 1898–1905

Plaster, with painted patina of red, brown, and purple washes, 32.9 x 26.7 cm. (13 x 10½ in.)

"The portrait and the statue are, for me, completely opposite things," Maillol stated (Cladel, 1937, p. 132). "I don't make portraits," he continued, somewhat misleadingly (see cat. 40), "I make heads in which I try to give an impression of the whole. A head interests me when I can bring the architecture out in it." In *Head of a Woman* it is the architectural unity, as Maillol would have it, that asserts itself. The features of the head are without idiosyncrasy—nothing about them suggests a particular individual. On the contrary, the face is generalized and symmetrical, while the hair and kerchief are modeled after examples of Greco-Roman sculpture. In short, the sculpture is a manifestation of early twentieth-century classicism. Moreover, it was intended to be seen as such, for Maillol was associated in the 1890s with the circle around Gauguin and the Nabis, in particular, Maurice Denis, who was a spokesman for a renewed classicism in contemporary art. Not coincidentally, Denis was the author in 1905 of an important article on Maillol (see Slatkin, 1982, pp. 2—3).

Bronze casts of this sculpture are in the Phillips Collection, Washington, D.C., the Los Angeles County Museum of Art, and other public and private collections. However, the relationship of the Wertheim cast, which is in plaster painted with red, brown, and purple washes in imitation of bronze, to the bronze casts is unclear. The plaster seems too clean to have served in the foundry as a master model (though the simulated patina hides much of the evidence that would be needed to determine this with certainty). Instead, the highly visible cast lines indicate that the plaster was made either from a piece mold or, alternatively, from a previous model. The latter seems most likely as the back of the cast shows bubbling, which often occurs on plasters made from gelatin molds.

Two dates for *Head of a Woman* have been proposed. In 1964 Waldemar George dated it to 1905 (George, 1964, p. 148, pl. 150), and in 1975 Linda Konheim dated it to 1898 (New York, 1975, no. 22). However, neither author cited firm evidence for the date offered. Therefore, until more evidence is produced, it seems appropriate to date this cast to 1898–1905.

The Wertheim version was almost certainly in the collection of A. Conger Goodyear before 1929, the year he became the first president of The Museum of Modern Art, New York (Lynes, 1973, p. 10). By that time, Goodyear owned a sizable collection of sculptures by Maillol and Emile-Antoine Bourdelle, as well as a strong collection of Impressionist paintings. *Poèmes Barbares* by Gauguin (cat. 20) and *Gabrielle in a Red Dress* by Renoir (cat. 10), both owned by Goodyear, were subsequently bought by Wertheim.

Provenance: A. Conger Goodyear, New York; Maurice Wertheim (sale, New York, Parke-Bernet, 11 May 1944, no. 75).

Bibliography: Denis, 1925, pl. 26; New York, 1944A, no. 75; Buffalo, 1945, pp. 85, 105; Frankfurter, 1946, p. 64; Cambridge, 1946, p. 74, repr. p. 75; George, 1964, pl. 150, p. 54; New York, 1975, no. 22. Bequest—Collection of Maurice Wertheim, Class of 1906, 1951.81

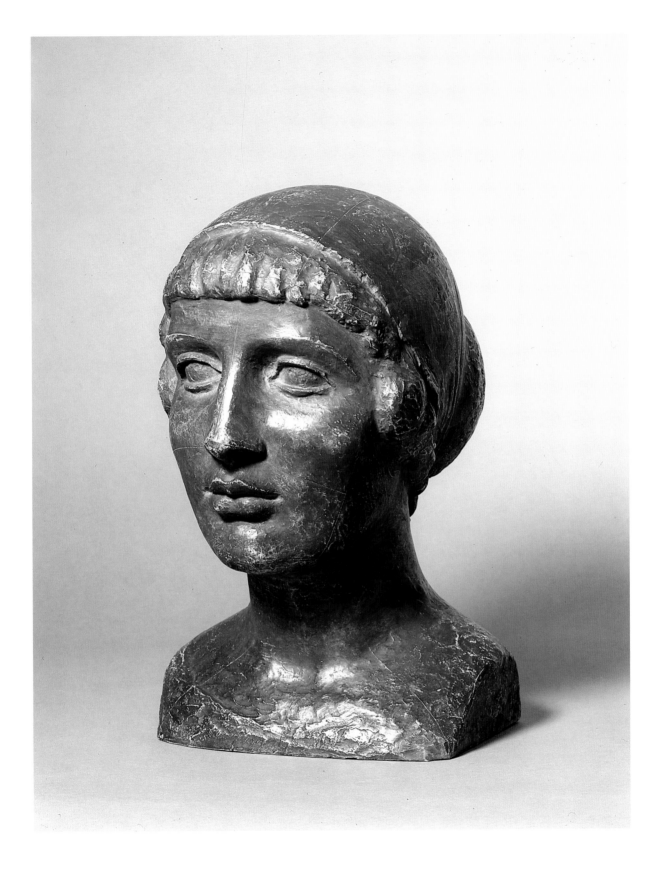

Aristide Maillol

Banyuls-sur-Mer 1861–1944

40. *Bust of Renoir*, 1906

Bronze, 41 x 28.2 cm. (16⅛ x 11⅛ in.)
No cast number
Signed with monogram, proper left side
of base: M in oval

Maillol's *Bust of Renoir* is among the few portraits executed by the artist. It is also among his few psychologically penetrating works. Renoir had been stricken by rheumatoid arthritis in 1888, and after 1902 his health deteriorated seriously. Maillol represents Renoir without making any attempt to mend the sagging features of his subject's once-paralyzed face and without straightening his bent shoulders and emaciated neck. Rather, he built and structured the bust around Renoir's skeletal cheekbones and jutting nose and gave to the surface of the sculpture a worked cragginess. The finished bronze persuasively evokes the broken physiognomy of Renoir in 1906.

Maillol found the sculpture difficult to execute. He informed his biographer, Henri Frère, that it had given him "a tremendous amount of trouble. It was an impossible face. It was all sick and deformed. There was nothing in it; there was only the nose. When I got there and saw him, I was perplexed. He had no mouth, he had drooping lips. It was awful. I had seen an old portrait and thought he had a fine beard. But he had shaved off his beard. Oh, did I have trouble!" (Frère, 1956, p. 238).

We cannot doubt that Maillol experienced difficulty making the bust, for it stands in sharp contrast to the work for which he is best known—his classical heads and monumental torsos (see cats. 39 and 41). The reason he undertook the portrait, it seems, was because it had been commissioned by Ambroise Vollard, Maillol's dealer as well

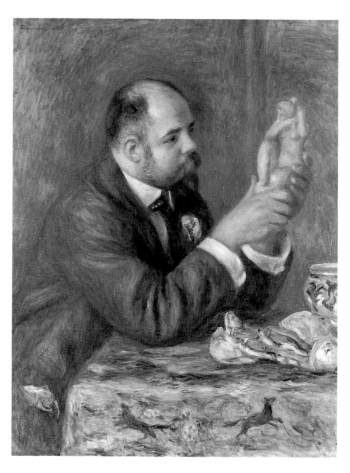

Figure 1.
Pierre-Auguste Renoir. *Portrait of Ambroise Vollard*, oil on canvas, 1908.
Courtauld Institute Galleries, London.
Samuel Courtauld Collection.
Catalogue of the Sculptures

as one of Renoir's dealers (ibid., p. 237). It is worth observing that only a short while later Vollard arranged to have his own portrait painted by Renoir (1908, fig. 1), and that in this commissioned work he chose to have himself pictured contemplating a small statue by Maillol (the *Crouching Woman* of 1900). By this pictorial conceit, Vollard associated himself with both artists, while at the same time associating the artists with each other. In fact, Vollard's association of Renoir and Maillol was not forced, for the artists did share a common aesthetic preference for classically monumental art. Moreover, when Renoir began to undertake large sculptural projects in 1913, his results were indebted to the example of Maillol.

The bust was modeled at Renoir's house at Essoyes in Burgundy. Over the years there has been some difference of opinion about whether Maillol executed it in 1906, 1907, or 1908. Georges Rivière in his book on Renoir states that the bust was completed in 1908 (Rivière, 1921, pp. 247–248), while John Rewald gives the date as 1907 (Rewald, 1939, p. 167). However, it was surely done in 1906. Barbara Ehrlich White has recently found in a letter from Renoir to Vollard, dated 12 September of that year, this curt reference to the sculpture: "My bust is going splendidly" (White, 1984, p. 235). This was presumably written just before the sculpture collapsed because of too much moisture in the clay (Maillol's explanation; Frère, 1956, p. 237) or because of a faulty armature (Jean Renoir's explanation; Renoir, 1962, p. 323). Both observers state that Maillol immediately set to work remodeling the portrait to the form in which it now exists.

Casts of the bust are in the collections of several American museums, including the Art Institute of Chicago, The Metropolitan Museum of Art, New York, and The Museum of Modern Art, New York.

Provenance: Maurice Wertheim, by 1939.

Bibliography: Rivière, 1921, pp. 247–248; Rewald, 1939, pl. 146, p. 16, 167; New York, 1941A, no. 89; Frankfurter, 1946, p. 64; Cambridge, 1946, p. 72, repr. p. 73; Frère, 1956, pp. 78, 237–238; Raleigh, 1960, p. 72, repr. p. 73; Houston, 1962, pl. 32, pp. 68–69; Renoir, 1962, p. 323; George, 1964, pl. 147, p. 223; Augusta, 1972A, no. 12; Coolidge, 1975, repr. p. 5; New York, 1975, no. 60, p. 131; Slatkin, 1982, pp. 41, 91; White, 1984, p. 235; London, 1985, p. 275. Bequest—Collection of Maurice Wertheim, Class of 1906, 1951.80

Aristide Maillol

Banyuls-sur-Mer 1861–1944

41. *Ile de France*, 1925

Bronze, 166.8 x 57.5 cm. (65¾ x 22¾ in.)
Signed with monogram, proper right rear
of top of base: M in oval
Numbered, proper right rear of top of
base: 3/6
Incised, proper right rear of side of base:
Alexis Rudier./Fondeur. Paris

This life-size bronze of a standing nude, to which Maillol gave the title *Ile de France*, was completed in 1925. The bronze represents the final stage of a sculpture project which he began in 1910 (George, 1964, pp. 223–224). The first step in its evolution was a bronze torso with neither arms nor head. This work, so we are told, originated from Maillol's desire to represent a nude bather wading in shallow water (ibid.; illustrated in Buffalo, 1945, p. 80). The subject and form is reminiscent of Renoir's *Large Bathers* (see cat. 9). The second step, executed about ten years later, is the same torso but with the arms truncated at their sockets and the legs extending an additional eleven centimeters beneath the knees (illustrated in New York, 1975, no. 82). The penultimate step, completed between 1921 and 1925, takes the form of a marble of the full-length figure, now in the collection of the Musée National d'Art Moderne, Paris. (There are also several drawings of the figure from this time; New York, 1975, nos. 127 and 129). Finally, an edition of six bronzes of the *Ile de France* was cast in Paris by the founder Alexis Rudier.

From the first torso to the final bronze, the project engaged

Figure 1.
Photograph of the front hall of Maurice Wertheim's townhouse, 43 East 70th Street, New York.

Maillol's attention for fifteen years. It therefore comes as no great surprise to learn that the pose of this canonical nude figure is traceable even further back in Maillol's work to the 1890s (Slatkin, 1982, p. 89). There is a precise correspondence between the pose in the *Ile de France* and the pose of a nude bather in a Maillol painting dating from 1896–1897 (*Two Bathers*, Petit Palais, Paris; illustrated in Slatkin, 1982, no. 17). In both works the figure is represented in the same arrested posture—the heel of the back foot raised, the shoulders arched, the head erect, the arms extended behind the body. According to Wendy Slatkin, the repertoire of forms employed by Maillol in his monumental sculptures of the 1910s, 1920s, and 1930s rests mainly on the paintings and tapestries he produced before 1905 (ibid., pp. 87–90). Using a vocabulary of figure types that he had invented while working in close contact with the Nabis, he continued during the remainder of his life to refine their subtle geometries.

The geometries of the large works are characterized by simplified, rounded forms. Their smoothly modeled surfaces catch and hold the flow of light—as shown in the photograph of the *Ile de France* installed in the front hall of Wertheim's townhouse, 43 East 70th Street, New York (fig. 1). This cast (no. 3), according to Wertheim's scrapbook, had never been exhibited before he acquired it in 1949. However, he had been searching for a cast for some time previously. In 1948, when he learned that an American private collector had found and acquired one in Europe through the dealer Curt Valentin, he persuaded the collector to let him install it in his townhouse temporarily—and then made a strenuous bid to purchase it (correspondence, FMA). Wertheim's offer was declined, but a short while later he acquired the cast now in the Fogg.

Provenance: Maurice Wertheim, by 1949.

Bibliography: Dreyfus, 1926–1927, p. 85; Cladel, 1937, pl. 31, pp. 114–115; Rewald, 1939, pp. 66–67; Payro, 1942, p. 37; Buffalo, 1945, pp. 80–81; Bouvier, 1945, pp. 67, 124–125; New York, 1950, no. 1; Camo, 1950, pp. 54–55, 68, 82; Linnenkamp, 1957, no. 15; Raleigh, 1960, p. 74, repr. p. 75; George, 1964, pp. 40, 48, 57, 223–224; Slatkin, 1982, pp. 80, 89. Bequest—Collection of Maurice Wertheim, Class of 1906, 1951.82

Charles Despiau

Mont-de-Marsan 1874–Paris 1946

42. *Portrait of Mme. Henri de Waroquier,* 1927

Bronze, 39.7 x 27.3 cm. (15⅝ x 10¾ in.)
Signed, proper left rear: C. Despiau
Numbered, proper left rear: 2/6
Stamped, proper left rear, beneath
signature: CIRE/C. VALSUANI/PERDUE

43. *Seated Man, Statue for a Monument to Mayrisch,* ca. 1930

Bronze, 76.8 x 53.9 cm. (30¼ x 21¼ in.)
Signed, proper left rear: C. Despiau
Incised, proper left rear of top of base:
original
Stamped, proper right rear: CIRE/C.
VALSUANI/PERDUE

Despiau worked for Rodin as a stone carver from 1907 to 1914. However, he is best known and understood as a modeler, especially of portrait busts. The bust of Suzanne de Waroquier, wife of the Parisian painter and sculptor Henri de Waroquier, forms part of a sequence of portraits that Despiau executed of artists and their wives. Among those he represented are Mme. Line Aman-Jean, Mme. André Derain, Mme. Othon Friesz, and Dunoyer de Segonzac (Paris, 1974). The differences in detail from one portrait to the next are subtle and discreet—sufficient to distinguish traits of personality but not so marked as to threaten classical unities of structure.

The original plaster of the *Portrait of Mme. Henri de Waroquier* was given in 1961 by Mme. Despiau to the Musée National d'Art Moderne, Paris. Cast no. 5 of the edition of bronzes, formerly in the collection of The Museum of Modern Art, New York (gift of Frank Crowninshield, 1943), is now in a New York private collection. The Wertheim bronze is no. 2 of the six casts.

Despiau's modeling procedure was painstaking and deliberate. In contrast to Rodin's broad, aggressive technique, he built up his forms touch by touch with minute accretions of clay. This slow, additive process can be read in the delicately roughened surfaces of his finished works—in the head of Mme. Waroquier, as well as in *Seated Man, Statue for a Monument to Mayrisch.* The latter work, which is less than life-size, represents an intermediate step in the development of a larger-than-life-size statue of the identical subject. The large seated figure was commissioned shortly after the death of the Luxembourg industrialist Emile Mayrisch (1862–1928) and is installed in his tomb at Colpach, designed by Auguste Perret. Despiau began the project in 1929 with a series of drawings from the nude model (fig. 1; Paris, 1974, nos. 116–118). Following these, he undertook the Wertheim version of the sculpture in order to determine the figure's exact pose and proportions. It was presumably completed by the following year, for Léon Deshairs reported seeing the commissioned sculpture in progress in Despiau's studio in 1930 (Deshairs, 1930, pp. 71–72). The final work, classicizing in its reticence and its powerful symmetry, was completed in 1932 (Fierens, 1933, pp. 10–12).

Provenance (42 and 43): Maurice Wertheim, by 1939.

Bibliography (42): *Creative Art*, 1928, pp. XLI–XLII; Rindge, 1930, pp. 14 (ill.), 16, 44; Deshairs, p. 82; Jewell, 1944, pl. 163; Frankfurter, 1946, p. 64; Cambridge, 1946, p. 76, repr. p. 77; Adlow, 1946A; Raleigh, 1960, p. 76, repr. p. 77; Houston, 1962, pl. 31, pp. 66–67; Augusta, 1972A, no. 8; Paris, 1974, no. 58. Bequest—Collection of Maurice Wertheim, Class of 1906, 1951.83
Bibliography (43): Martinie, 1929, p. 388; Deshairs, 1930, pp. 71–72; Fierens, 1933, pp. 10–12; Alazard, 1939, pp. 113–114; Frankfurter, 1946, p. 64; Raleigh, 1960, p. 78, repr. p. 79; Houston, 1962, p. 66; Augusta, 1972A, no. 7. Bequest—Collection of Maurice Wertheim, Class of 1906, 1951.84

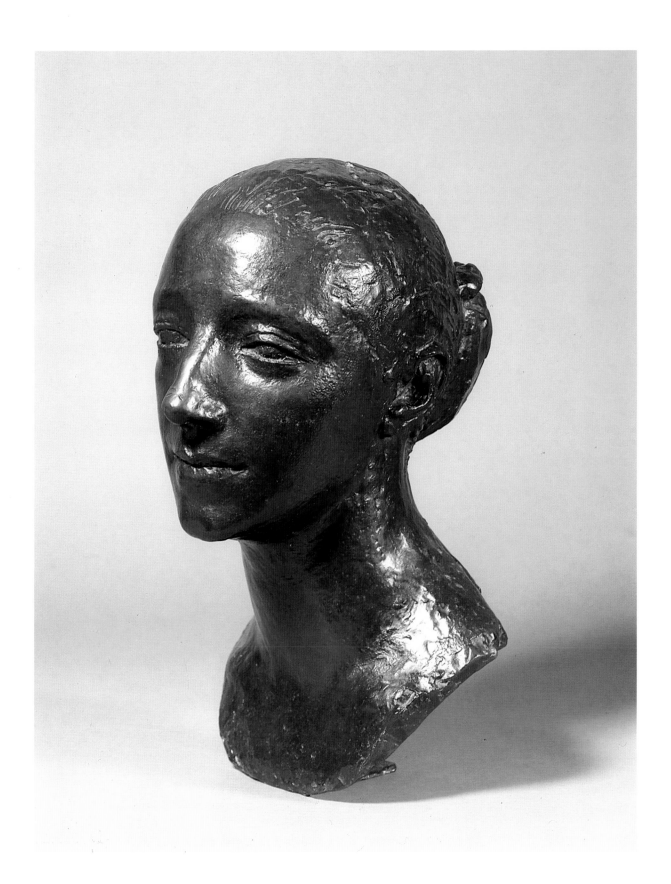

Figure 1.
Charles Despiau. *Study for "A Monument to Mayrisch,"* pen and ink, 1929. Musée Despiau-Wlérick, Mont-de-Marsan.

Appendix A

Chronology of Acquisitions by Maurice Wertheim

May 1936	Picasso, *The Blind Man*, 1903 (cat. 25)
By December 1936	Picasso, *Young Girl Wearing a Large Hat* (recto), *Woman with a Chignon* (verso), 1901 (cats. 22 & 23)
1936–1937	Matisse, *Geraniums*, 1915 (cat. 28)
1936–1937	Matisse, *Still Life with Apples*, 1916 (cat. 29)
By 1937	Picasso, *Mother and Daughter*, 1904 (cat. 26)
By January 1937	Picasso, *Mother and Child*, 1901 (cat. 24)
April 1937	Gauguin, *Poèmes Barbares*, 1896 (cat. 20)
April 1937	Seurat, *Woman Seated by an Easel*, ca. 1884–1888 (cat. 14)
November 1937	Toulouse-Lautrec, *The Black Countess*, 1881 (cat. 15)
1938	Dufy, *Race Track at Deauville, the Start*, 1929 (cat. 36)
By 1939	Cézanne, *Still Life with Commode*, ca. 1885 (cat. 17)
By 1939	Despiau, *Portrait of Mme. Henri de Waroquier*, 1927 (cat. 42)
By 1939	Despiau, *Seated Man, Statue for a Monument to Mayrisch*, ca. 1930 (cat. 43)
By 1939	Maillol, *Bust of Renoir*, 1906 (cat. 40)
June 1939	Van Gogh, *Self-Portrait Dedicated to Paul Gauguin*, 1888 (cat. 19)
March 1940	Seurat, *Vase of Flowers*, ca. 1879–1881 (cat. 12)
1942	Degas, *The Rehearsal*, ca. 1873–1878 (cat. 2)
By 1943	Pissarro, *Mardi Gras on the Boulevards*, 1897 (cat. 21)
June 1943	Monet, *Red Boats, Argenteuil*, 1875 (cat. 4)
October 1943	Van Gogh, *Three Pairs of Shoes*, 1886–1887 (cat. 18)
December 1943	Renoir, *Gabrielle in a Red Dress*, 1908 (cat. 10)
By 1944	Degas, *Horse Trotting, the Feet Not Touching the Ground*, ca. 1881–1890 (cat. 37)
April 1944	Seurat, *Seated Figures, Study for "A Sunday Afternoon on the Island of the Grande Jatte,"* 1884–1885 (cat. 13)
May 1944	Maillol, *Head of a Woman*, ca. 1898–1905 (cat. 39)
April 1945	Degas, *Grande Arabesque, Third Time*, ca. 1885–1890 (cat. 38)
June 1945	Monet, *The Gare Saint-Lazare; Arrival of a Train*, 1877 (cat. 5)
January 1946	Toulouse-Lautrec, *The Hangover* or *The Drinker*, 1887–1889 (cat. 16)
By June 1946	Guys, *A Lady of Fashion*, ca. 1860 (cat. 1)
November 1946	Renoir, *Seated Bather*, ca. 1883–1884 (cat. 8)
December 1946	Renoir, *Self-Portrait at Thirty-Five*, 1876 (cat. 7)
March 1947	Renoir, *Two Nude Women, Study for the "Large Bathers,"* ca. 1886–1887 (cat. 9)

1948	Matisse, *Mlle. Roudenko (Dancer of the Ballets Russes)*, 1939 (cats. 30–33)
1948	Matisse, *Nude Leaning on Her Left Elbow*, ca. 1935–1939 (cat. 34)
May 1949	Degas, *Singer with a Glove*, ca. 1878 (cat. 3)
By July 1949	Manet, *Skating*, 1877 (cat. 11)
By July 1949	Rousseau, *The Banks of the Oise*, ca. 1907 (cat. 27)
By 1949	Maillol, *Ile de France*, 1925 (cat. 41)
March 1950	Bonnard, *Interior with Still Life of Fruit*, 1923 (cat. 35)
1955*	Monet, *Madame Paul*, 1882 (cat. 6)

*Acquired for the collection after Wertheim's death, at the suggestion of Cecile Wertheim, through the Wertheim Fund, Inc.

Appendix B

Exhibitions of the Maurice Wertheim Collection, 1946–198

Cambridge, 1946 *French Painting Since 1870: Lent by Maurice Wertheim, Class of 1906.* Cambridge, Mass.: Fogg Art Museum, June 1–September 7, 1946.*

Québec, 1949 *La Peinture française depuis 1870.* Québec: Musée de la Province de Québec, July 12–August 7, 1949.*

New York, 1952 *The Wertheim Collection of Paintings.* New York: Metropolitan Museum of Art, July 1–September 14, 1952.

Washington, 1953 *The Maurice Wertheim Collection.* Washington, D.C.: National Gallery of Art, July 1–September 13, 1953.

Philadelphia, 1957 *The Maurice Wertheim Collection.* Philadelphia: Philadelphia Museum of Art, June 15–September 15, 1957.

Minneapolis, 1958 *The Maurice Wertheim Collection.* Minneapolis, Minn.: Minneapolis Institute of Arts, June 11–August 31, 1958.

Raleigh, 1960 *The Maurice Wertheim Collection: Modern French Art, Monet to Picasso.* Raleigh, N.C.: North Carolina Museum of Art, June 17–September 4, 1960.*

Houston, 1962 *The Maurice Wertheim Collection: Manet to Picasso.* Houston: Houston Museum of Fine Arts, June 13–September 2, 1962.*

Baltimore, 1963 *19th- and 20th-Century Masters from the Maurice Wertheim Collection.* Baltimore: Baltimore Museum of Art, June 20–September 1, 1963.

Manchester, 1965 *The Maurice Wertheim Collection.* Manchester, N.H.: Currier Gallery of Art, June 5–September 4, 1965.

Providence, 1968 *The Wertheim Collection.* Providence, R.I.: Rhode Island School of Design, June–September, 1968.

Montgomery, 1971 *The Maurice Wertheim Collection of Impressionist and Post-Impressionist Paintings and Drawings.* Montgomery, Ala.: Montgomery Museum of Fine Arts, June 20–September 5, 1971.

Augusta, 1972 *The Maurice Wertheim Collection.* Augusta, Me.: Maine State Museum, June 11– September 4, 1972.*

New York, 1985 *Manet to Matisse: The Maurice Wertheim Collection.* New York: IBM Gallery of Science and Art, April 9–May 25, 1985.

*Exhibitions accompanied by a catalogue.

Appendix C

Technical Information on the Collection

Paintings: Teri Hensick, Kate Olivier (with contributions by Sandy Easterbrook and Carolyn Tomkiewicz)

Drawings: Marjorie B. Cohn, Pia de Santis

1.

Guys
A Lady of Fashion,
ca. 1860

Materials/Techniques: The drawing was executed on a warm white wove paper. Guys first placed the figure on the page with a few summary lines of graphite. Pen and ink were then used to delineate the image and washes used to define the shallow space in which the woman poses and to add volume to her billowy hoop skirt. The edges of the washes are easily discernible and exist as curving lines of particulate matter, indicating that the coloring material was not evenly incorporated in its dilutant. These factors suggest that Guys used very dilute washes. In some areas the fibers were roughed up during the drawing's execution; color particles cling to the roughened surfaces, creating dark spots in otherwise light-toned areas. On the verso, there are areas of brown discoloration corresponding to those design elements executed in iron gall ink. This acidic ink is black when first made but turns brown over time.

Condition: A layer of adhesive on the verso indicates that the drawing was previously mounted. There are deep creases along the right edge of the drawing. At some point it was cut horizontally on the right edge near the lower corner.

2.

Degas
The Rehearsal,
ca. 1873–1878

Materials/Techniques: The support is a fine, plain weave canvas (thread count: 20 threads per cm.). The ground is off-white in color. The edges of the painting are covered with brown paper tape, hardly visible because it has been incorporated into the painting and is covered with original paint. The tape must have been part of Degas's original mounting system, perhaps on a drawing board. X-rays show stretch scalloping only along the bottom edge, suggesting that when the ground was applied the canvas was supported on a larger stretcher. Degas must have cut the canvas from this larger format and mounted it to a temporary support using tape. X-rays reveal that the overall composition was well worked out before painting began. Infrared examination, however, shows several pentimenti in the figures themselves. The position of the violinist's right leg was originally farther forward. The planted feet of the central ballerina and the second ballerina from the left have been shifted. The central ballerina has been reworked, as is evidenced by a second 5-by-5-cm. grid pattern visible only with infrared. Finally, an indiscernible pentimento, possibly a figure, can be seen below and to the right of the central ballerina.

Condition: In 1976 a discolored natural resin varnish was removed and the painting revarnished. At a previous time the painting was lined (with glue/paste) and its tacking margins trimmed. *The Rehearsal* is in very good condition, with very little inpainting.

149

3.

Degas

Singer with a Glove,
ca. 1878

Materials/Techniques: This mixed-media work was executed on primed canvas. Pigment analysis indicates that pastels were used in all areas except the red and green stripes appearing at the left of the composition; these must have been executed in dry pigments ground in a medium of oil paints leached of their oil since they do not contain the clays and other additives usually found in pastels. Highlights aside, Degas's use of the pastel was not conventional. In most areas the crayons used were wet, and under magnification the picture surface appears hard and granular rather than soft and particulate. Media analyses carried out in 1985 suggest that Degas used casein to temper the pulverized pastels, but the data have yet to be confirmed. Some loss of the background near the thumb of the gloved hand reveals a pentimento. It should also be noted that the pink bodice was executed over layers of blue and red (revealed by sampling).

Condition: The painting support is dry and brittle, and flaking, although not now active, has occurred in the past. Otherwise the picture is in good condition. Sampling did not reveal any fading of the colors.

4.

Monet

Red Boats, Argenteuil,
1875

Materials/Techniques: The painting is executed on a twill canvas (thread count: warp 24 threads per cm.; weft 36 threads per cm.). The canvas is pre-primed with a light beige ground. In some areas, especially the water and the large red boat, the paint has been applied in pure unmixed colors. These blend optically at a distance but at close range are seen as clearly separate. Under infrared illumination two pentimenti are visible. In the family of ducks in the left foreground the position of the lower right duck has been changed and a sixth duck, farther to the right, has been painted out. Also visible with infrared illumination are the faint outlines of a rowing boat, immediately beneath the gray sailboat on the right side of the painting. No underdrawing could be detected. The signature, in the lower left corner, is painted in dark blue paint with specks of vermilion.

Condition: There are no conservation records prior to 1984. The painting has been wax lined and stapled onto a Bearce expansion stretcher. The original tacking margins remain intact. The painting is in good condition, with no damage or retouching.

5.

Monet

*The Gare Saint-Lazare;
Arrival of a Train,*
1877

Materials/Techniques: The support consists of a twill canvas (thread count: warp 22 threads per cm.; weft 27 threads per cm.). The canvas was pre-primed with a light beige-colored ground. The paint layer is dense, with slight impasto and a fairly pronounced age crackle. There is no underdrawing visible under infrared illumination. However, under infrared it is possible to determine that Monet repainted and raised the engine and the chimney of the smoking locomotive on the right side of the painting. Circular marks on all four sides impressed into the wet paint must have been caused by the corks used to separate a stack of paintings.

Condition: The paint layer is in good condition, with no retouching. In 1955 the painting was wax lined and stapled onto a Bearce spring stretcher. The previous nail holes indicate that the original stretcher was somewhat smaller and that the painting was stretched at a slightly different angle. It was also cleaned and revarnished at this time.

6.

Monet

Madame Paul,
1882

Materials/Techniques: The painting is executed on a very fine, plain weave canvas (thread count: 30 by 34 threads per cm.). The canvas was cut from a larger piece of commercially preprimed canvas. The colorman's stamp on the reverse reads, "H. Pieille + E. Troisgros, Rue de Laval. Paris, couleurs, toiles

et panneaux." The five-membered, mortise-and-tenon-joined stretcher is original. The priming, visible throughout, is a light gray color. There is no underdrawing visible under infrared illumination. There are nine customs stamps on the reverse of the canvas and stretcher.

Condition: The painting is in excellent condition. It has never been lined or restretched. It was surface cleaned in 1972 and again in 1985. There is a thin, slightly yellowed varnish film, particularly visible in the white impasto areas.

7.
Renoir
Self-Portrait at Thirty-Five,
1876

Materials/Techniques: The painting is executed on a finely woven, plain weave canvas (thread count: 32 threads per cm.). The canvas has a white, preprimed ground that is clearly visible, especially at the upper left and right and lower right edges. The paint is very thinly applied, allowing a major change in the position of the right arm to be seen. Under infrared examination, the bent arm, from elbow to hand, seems to have been rubbed out with a cloth and lightly painted over to appear as part of the coat.

Condition: Although there are no conservation records for this painting prior to 1984, the painting has obviously been glue lined. There is a stamp, "Douane centrale Paris," on the back of the lining canvas, suggesting that the painting was lined in Europe before coming to America. The original tacking margins have been cut. However, remnants of the tacking margins show the original dimensions of the painting to have been 71.7 by 55.7 centimeters. It is now stretched on a slightly larger stretcher. The paint layer is in very good condition, with minor inpainting around the edges.

8.
Renoir
Seated Bather,
ca. 1883–1884

Materials/Techniques: The support consists of a fine, plain weave canvas (thread count: 24 threads per cm.). The ground, which contains lead white pigment, is off-white in color; it is visible where the white drapery meets the left edge of the painting. Also visible in a few areas (especially in the figure) is red underpainting directly over the ground. Under infrared illumination there is evidence of slight compositional changes: the right proper foot has been displaced three inches, and the braceleted arm has possibly been displaced as well.

Condition: Although there are no conservation treatment records prior to 1959, when surface grime was removed, it is apparent that the painting has been glue lined. The original tacking margins have been cut down. Remnants of them, however, are visible on all four sides, indicating that the painting retains its original dimensions. The paint layer is in good condition, with very minor retouching.

9.
Renoir
*Two Nude Women, Study for
the "Large Bathers,"*
ca. 1886–1887

Materials/Techniques: The drawing was executed in two colors of sanguine on a sheet of wove paper of poor quality, with a groundwood-pulp content. Some chalk strokes have scratched and marked the paper; in these areas, natural red chalk was probably used as it is subject to variation in composition and can contain pockets of grit. White chalk was used for the drapery on the left leg of the bather to the right. Some areas of the composition—the left hand of the right bather, the facial features of both figures, and the foliage in the background—suggest that Renoir initially executed the drawing in careful, delicate lines but went back over it to emphasize the contours. Stumping was combined with a judicious use of bare paper to give the bathers' bodies the appearance of smooth, sculpted surfaces. Renoir used the broad side of the chalk to define coarser textures such as hair. At some point, the lower left corner of the drawing was cut out, a new piece of paper added, and the left arm of the recumbent bather extended. The texture of the paper,

the color of the chalk, and the quality of the line suggest that this alteration was made by Renoir, although this section has aged differently from the rest of the sheet, becoming less discolored.

Condition: The drawing has suffered from the artist's choice of a wood-pulp paper support. The paper is not only susceptible to harmful, acid-producing materials in the environment but to unstable components of the pulp, lignins and hemicelluloses, which were not removed during the paper's manufacture. Vertical and horizontal tears occurred as a result of the paper's increasing fragility as it aged. At some point the drawing was mounted to a secondary support of equally poor quality, and the potential for tearing and deterioration was increased by the stretching of this secondary support onto a wooden stretcher. Tears occurred at three of the corners and were subsequently mended with paper and covered with chalk to hide the staining caused by the adhesive used. In 1955, after the drawing had come to the Fogg, it was removed from its secondary support, bathed, mended, and mounted to a new silk support. The drawing is currently in good condition.

10.

Renoir
Gabrielle in a Red Dress,
1908

Materials/Techniques: The support is a medium, plain weave canvas (thread count: 21 threads per cm.). It is preprimed with a thinly applied off-white ground. The five-membered, mortise-and-tenon-joined stretcher appears to be original. Although the canvas has been restretched, the additional holes in the tacking margin match those in the stretcher, helping to confirm its authenticity. Infrared examination reveals no pentimenti or underdrawing. It appears that the initial composition was laid out in a thin wash of color. Portions of the background and dress consist only of this wash. The flesh tones and highlights are built up more thickly. Shadows in these areas have been achieved by allowing the thin wash to show through and adding darks on top. The signature in the lower right is abraded. N.B. The signature cannot definitely be seen as a stamp.

Condition: The painting has been lined, although there is no documentation of the treatment. The original tacking margins are present. The painting has a very slightly yellowed natural resin varnish and no notable retouching. It is in good condition.

11.

Manet
Skating,
1877

Figure 1.
X-ray photograph of Edouard Manet's *Skating*.

Materials/Techniques: The support is a fine, plain weave linen (thread count: 23 by 26 threads per cm.). The thinly applied ground is yellowish white, consisting mainly of lead white with a trace of calcium carbonate. The ground is exposed in several areas. Infrared examination reveals no discernible underdrawing, though Manet's extensive use of grays and black would obscure a sketch containing carbon. Paint application ranges from thin washes to multiple layers and some impasto. Major compositional changes can be seen in the X-rays (fig. 1). Brushstrokes with relatively high impasto and lead white content that do not correspond to the final image are present beneath the bodice and proper right arm of the central figure. The position of this arm has been straightened; it formerly crossed the figure's torso and sported a puffed, short sleeve. The hastily painted child in the foreground is definitely a later addition to the composition. One interpretation of the X-rays suggests that the child was formerly more prominently positioned in the work, with its head located at the waist of the central figure.

Condition: The painting has been lined (with glue/paste), and its original tacking margins have been cut. There is no record of when and where this was done. Very little inpainting is present, and the overall condition of the painting is very good. Ultraviolet examination indicates the presence of a natural resin varnish that is slightly yellowed. A technical analysis, including pigment identification, was undertaken in 1984.

12.

Seurat

Vase of Flowers,
ca. 1879–1881

Materials/Techniques: The support is a plain weave canvas (thread count: 22/24 threads per cm.). The ground, visible on all four sides, is a warm beige color. The use of diagonal, crisscrossing brushstrokes, especially in the underlayer, is visible in a raking light in many areas. Their presence, especially in the vase and table, gives the painting a distinct texture. Infrared illumination reveals one pentimento: a flower appears to be painted out in the top left of the vase.

Condition: The painting has been lined, and its original tacking margins have been trimmed. The present stretcher is approximately one centimeter larger in both directions than the original would have been. No record of when and where this was carried out exists. Some flattening of the impasto has occurred. A slightly yellowed, natural resin varnish coats the painting. The paint layer appears to be in fairly good condition, with minor inpainting.

13.

Seurat

Seated Figures, Study for "A Sunday Afternoon on the Island of the Grande Jatte,"
1884–1885

Materials/Techniques: The support consists of a wood panel without a ground. The wood appears to be sealed with a resinous substance enhancing its warm orange tone. Seurat has exploited this warm color, allowing it to shine through in several areas. This is particularly noticeable in the upper left corner along the far riverbank. The brushstrokes are short and multidirectional, often of juxtaposed complementary or unmixed colors. No pentimenti or underdrawing is visible under infrared illumination.

Condition: The panel has been cradled with mahogany. The back and edges are veneered to imitate a mahogany panel (endgrain is used for the vertical edges and longitudinally cut wood for the horizontal edges). It is impossible to determine the wood type or thickness of the original panel without removing a section of this veneer. The edges of the painting have been carefully retouched to disguise the veneered additions. There are no records of when and where this treatment was carried out. The paint layer is in good condition, with one inpainted dent along the bottom right. Several other dents or scrapes are covered with original paint and must have existed in the panel prior to painting.

14.

Seurat

Woman Seated by an Easel,
ca. 1884–1888

Materials/Techniques: Seurat has chosen his usual drawing materials for this study: soft black chalk and richly textured Michallet paper. The full sheet was torn in quarters, leaving rough edges at the top and left; the right and bottom edges retain the feathering irregularities of the deckle edge of the handmade paper. Careful inspection reveals the trace of a linear underdrawing, especially around the head and bodice of the figure. The design was then filled in with overall tone and diagonal hatchings, laid on at varying angles from upper right to lower left. Only in the head and hands, where the artist sought to represent the fine texture of flesh, has the chalk been rubbed into the paper.

Condition: The drawing is in excellent condition, with no significant accidental smudging of the fragile chalk surface. The paper, however, is somewhat darkened.

15.

Toulouse-Lautrec

The Black Countess,
1881

Materials/Techniques: The painting is executed on artist's board composed mainly of softwood fibers, which has been glued onto chipboard. Pinholes along the edges (especially the top) indicate that Lautrec tacked the board to a firmer support while painting. He chose a lead white ground and executed his sketch in a black, carbon-based medium. Several compositional changes are evident under infrared illumination. The positions of the figures have been reworked, and the countess seems to have originally held a whip,

umbrella, or the horse's reins. The scalloped lines in the sky cannot be accounted for but suggest further pentimenti.

Condition: The painting is in fair condition. The corners are dog-eared, the trees abraded. More disturbing is a spotty discoloration (mold?) found throughout the sky and in a few areas in the lower left foreground. There are no records of when the painting was mounted on chipboard. In 1973 the surface was cleaned. In 1985 a mahogany cradle was removed from the rear of the chipboard. The obverse was cleaned of surface grime and varnish; it was then revarnished and lightly inpainted to tone down the discolored spots and reduce the abraded appearance of the trees. A technical analysis (including pigment identification) was undertaken at the time of treatment in 1985.

16.

Toulouse-Lautrec
The Hangover or *The Drinker*,
1887–1889

Materials/Techniques: This work is executed on preprimed, plain weave canvas (thread count: about 14 threads per cm.). The lead white ground plays a major role in the chromatic composition because it is so visible. Original pencil marks define the perimeter of the composition on all four sides. The initial drawing is done in black crayon or chalk; it cannot correctly be termed "underdrawing," as the strokes are not hidden by the paint in all cases but rather used in conjunction with it as a dark tone. Infrared illumination shows the full extent of the black drawing. The composition was thoroughly sketched out before painting; some of the lines were executed with the length of the crayon and are modulated from thick to thin. Pentimenti—also visible with the naked eye—are found in the areas around the bottle, the table at upper left, and the pillar in the background. The paint itself is thin and transparent, having been leached of much of its oil binder by the artist and then diluted with turpentine.

Condition: The condition of the painting is very good, apart from a discolored natural resin varnish. It has been lined and restretched on a new stretcher with the warning: "Caution—this painting has been waxed." The original tacking margins are still present on all four sides. No restoration records are extant. A technical examination (including pigment analysis) was undertaken in 1985.

17.

Cézanne
Still Life with Commode,
ca. 1885

Materials/Techniques: The support consists of a plain weave canvas (thread count: 13 threads per cm.) with an off-white ground. The paint is fairly thickly layered except in a few areas (e.g., the Provençal olive jar on the left). There is extensive early drying crackle, especially in the browns of the commode. Under infrared the green olive jar has visible underdrawing, and a straw handle on the ginger pot can be clearly seen.

Condition: The painting has been triple lined with glue adhesives and the original tacking margins removed. The paint layer appears somewhat moated and crushed. In 1959 the painting was cleaned and revarnished, and in 1985 it was cleaned again. The paint layer is in fairly good condition, with very little retouching.

18.

Van Gogh
Three Pairs of Shoes,
1886–1887

Materials/Techniques: The support is a medium, plain weave canvas (thread count: 13/14 threads per cm.). The first application of ground, which is white, can be detected only in small areas of loss along the edge of the painting. Over this first ground a vase of flowers was painted. This can be seen in the X-rays (fig. 2), with the painting beneath oriented vertically, its bottom to the left of the present composition. In raking light the flowers are noticeable beneath the right half of *Shoes*. A second, white ground layer

Figure 2.
X-ray photograph of Vincent van Gogh's *Three Pairs of Shoes.*

19.

Van Gogh

Self-Portrait Dedicated to Paul Gauguin,

1888

20.

Gauguin

Poèmes Barbares,

1896

covers this entire composition. It shows through the wide early drying cracks of the final composition and in the signature, "Vincent," which is scratched into the upper right corner of the painting. A second signature is also scratched into a black brushstroke at the bottom center edge of the painting. The paint is thickly applied, and individual brushstrokes measure up to 1.5 cm. in width.

Condition: The discolored varnish was reduced in 1985. There are no previous conservation records. The painting has been glue lined and its original tacking margins removed. Ultraviolet examination indicates areas of loss and inpainting in the shoes and background. No underdrawing was detected under infrared examination. The paint layer is in very good condition (although there is evidence of some flattening of the impasto, due, no doubt, to lining).

Materials/Techniques: The support is a plain weave linen (thread count: 11 by 16 threads per cm.). The ground layer is thin and white in color (identified as lead: Cambridge, 1984, pp. 30–31). It is unclear whether or not the canvas was commercially preprimed. There is some indication of a pencil line marking the perimeter of the painting. The paint layer is fairly thick and built up in a series of layers, with no underdrawing visible. X-rays emphasize van Gogh's characteristic brushwork: the strokes turned in concentric circles around the head and modeling the face. There is a considerable amount of impasto, which has been somewhat flattened and impressed with canvas weave. (This may have been caused by stacking or rolling the canvas.)

Condition: There are no conservation records prior to 1980, when the painting was cleaned. However, the canvas has been glue lined and the original tacking margins removed. There is strong evidence that Gauguin himself restored the painting in Paris in 1893–1895. (For further information on this restoration, see Cambridge, 1984.) At some time it appears to have been attached to a smaller stretcher, causing damage around the edges. Obvious, crudely overpainted losses occur above and slightly to the right of van Gogh's head and above his right proper shoulder. This latter damage extends through the neck and chin as a thin slit. The inscription, "à mon ami Paul Gauguin," is heavily abraded. The controversy concerning these damages is also detailed in the above-mentioned publication, together with a full technical examination, including pigment analysis.

Materials/Techniques: The support consists of a fairly coarse, plain weave canvas (thread count: 9 by 10 threads per cm.). The paint layer is built up over a white ground and is quite thick overall. In some areas the underlayers are in striking contrast to the surface colors, i.e., bright vermilion under the blue/black hair and emerald green under the brown idol. The small, mostly vertical (and in some cases only superficial) losses of paint that occur throughout may have been caused by a previous rolling of the canvas. Some of the paint covering the damages has been very freely applied. The painting may have been retouched by Gauguin himself. There is a small pentimento in the proper right hand, which is visible with the naked eye. No underdrawing can be detected under infrared illumination.

Condition: There are no conservation records prior to 1985. The painting has been glue lined, and the original tacking margins have been cut and covered with paper tape. Most of the losses occur in the figure and hair on the right side of the painting. In 1985 considerable surface grime and an extremely discolored natural resin varnish were removed. The painting was inpainted and revarnished.

21.

Pissarro

Mardi Gras on the Boulevards,
1897

Materials/Techniques: The support consists of a very fine, plain weave canvas (thread count: 29 by 34 threads per cm.). The ground is light gray, easily visible in the boulevard and buildings, where it is used as a middle tone. Two layers of paint are discernible. One, a fairly dense covering layer, blocks in the sky and major architectural features. The figures, trees, and confetti are painted in a thicker impasto, often with several unmixed colors in a single, short brushstroke. There is no detectable underdrawing or underpainting (even under infrared illumination).

Condition: The painting has been lined (glue/paste), and its original tacking margins have been cut off completely. There are no records of when and where this work was done. The present stretcher is slightly larger than the original stretcher would have been. The paint layer is in very good condition, with no notable retouching.

22.

Picasso

*Young Girl Wearing
a Large Hat,*
1901

Materials/Techniques: This work is the recto of *Woman with a Chignon.* The painting is executed on a medium, plain weave canvas (thread count: 14 threads per cm.). The canvas is tacked to a strainer, which also serves as the rabbet for *Woman with a Chignon.* The original tacking margins have been flattened out and covered with gold-colored paint. Creases along the edges indicate that the painting was conventionally stretched at some point in its history. Stretch scalloping is present only along the bottom edge. The canvas is preprimed with an off-white ground. The paint layer ranges from thin washes in the underlayer to very high impasto in the brightest whites.

Condition: The original tacking margins have been trimmed slightly. They are in poor condition, perforated with numerous tack holes from previous stretchings. However, the painting itself is in good condition; it has never been lined, and the presence of a layer of paint on the verso has greatly minimized drying crackle. It is possible that *Young Girl* was, at some point, covered over with a layer of paint (which was subsequently removed). Evidence for this is the black pigment (carbon black) that is scattered over the work, trapped in the interstices of the impasto and canvas weave. There are no records of this (or any other) treatment. The painting is varnished in patches. Ultraviolet examination reveals very little inpainting. A fine scratch through the face and nose of the sitter has not been retouched.

23.

Picasso

Woman with a Chignon,
1901

Materials/Techniques: The painting is executed on the reverse of the medium, plain weave canvas used for *Young Girl Wearing a Large Hat.* The characteristics of the canvas are noted in the previous entry. Unlike the recto, however, *Woman with a Chignon* has no ground; it is painted directly onto the reverse of the preprimed canvas. The ground on the recto acts as an antiabsorbent barrier. The paint layer, where it is thinnest (especially in the dark outlines of the arms and head), has soaked into the canvas, revealing its texture. In other sections, such as the flesh tones, which are more thickly painted, the canvas structure is hidden. Unpainted tacking margins suggest that Picasso restretched *Young Girl* face down onto the same stretcher to paint *Woman with a Chignon.* Infrared illumination reveals pentimenti in the lower right corner; the outlines of the sitter's waist and left proper arm have been revised several times. This is somewhat apparent in normal light; three positions of the line defining the left proper hip are visible.

Condition: The painting is in very good condition, with no inpainting.

24.

Picasso

Mother and Child,

1901

Figure 3.
X-ray photograph of a detail of
Pablo Picasso's *Mother and Child.*

25.

Picasso

The Blind Man,

1903

26.

Picasso

Mother and Daughter,

1904

Materials/Techniques: The support is a preprimed, plain weave canvas (thread count: 15 threads per cm.). The off-white ground is thinly and evenly applied. It tested positively for lead in 1969. X-rays and infrared examination reveal a portrait, documented to be of Max Jacob, beneath the present composition (see fig. 3). Jacob's head is easily visible in raking light just to the left of the mother's head. Picasso's signature on this first composition, though faint, can be seen in the light blue area below the drapery on the left. The large drips of very liquid paint in the lower left and right belong to the earlier composition, indicating its speedy execution and possibly unfinished state. Due to the thickness of the paint layer of *Mother and Child*, the X-rays are difficult to read. It appears, however, that Max Jacob was seated on the floor with books piled on the right. Picasso's signature on the *maternité* composition in the upper right is in a dark brown paint and is slightly abraded.

Condition: The painting was examined and X-rayed in 1969, and the varnish was partially removed in 1985. There are no conservation records prior to this. The painting has been glue lined. Its original tacking margins are intact but have been cut down somewhat. The present stretcher is slightly larger than the original stretcher would have been. The lower left corner has been overglazed to minimize the drips showing through from the composition underneath. Paint loss is minor, and the paint layer is in excellent condition.

Materials/Techniques: Picasso executed this wash painting on a cardboard of very poor quality, whose color has darkened over the years and turned a somewhat reddish hue. Thus the present greenish aspect of the midtone washes is in fact a falsification of the original cooler and purer blue in which the artist painted the entire image. Despite the fine linear detail in several areas, notably the hands and feet of the figure, Picasso seems to have worked up the design entirely with a brush, applying layer after layer of wash, some dilute and some, locally, more concentrated. Soft highlights, such as the lips and bony structure of the head, may have been recovered by blotting or erasure.

Condition: Darkening of the sheet, noted above, has lowered the overall tone of the image and altered the color harmony; the surface has been abraded and scratched. At some time the board was mounted on canvas on a strainer. It is not possible to determine whether this mounting was done prior to the execution of the work or at a later time.

Materials/Techniques: Picasso has drawn with colored crayons on paper of very poor quality; the irregular upper edge of the sheet indicates that it may have been torn out of an inexpensive sketchpad. The entire design was first established in blue crayons, and then the outline of the girl's head was filled in and her profile accented with red and yellow crayons and the woman's with black. A final touch of blue across the woman's eyebrows indicates that Picasso continued to work with all four pigments as he completed the drawing. He has signed the sheet in graphite pencil; this perhaps indicates that he tore it out and sold it or gave it away at a later date.

Condition: The sheet has substantially darkened from its original tone, lessening the contrast of the figures, especially in the delicately shaded areas of pale blue hatchings that fill in their bodies. When the drawing entered the Fogg Collection, it was laid down on a heavy cardboard of poor quality; it has been removed. A former wood-pulp mat has stained the edges; there are traces of foxing in the torso of the woman.

27.

Rousseau

The Banks of the Oise,
ca. 1907

Materials/Techniques: The support is a fine, "simple cord" canvas (thread count: warp 13 threads per cm.; weft 20 threads per cm.). The canvas is stretched on its original strainer, which is inscribed "Bords de l'Oise, 1907." The thinly applied, off-white ground can be seen through the reverse of the loosely woven canvas. It covers the tacking edges, indicating the use of a preprimed canvas. The paint layer is evenly applied in a thin but pasty consistency with a low impasto in the lights. There is no apparent use of glazing. Infrared examination does not reveal an underdrawing or any obvious pentimenti.

Condition: The painting is in excellent condition. It has never been lined. The edges have been taped, but the original tacking margins are intact. Records document a varnish removal, minor inpainting, and revarnishing in 1977.

28.

Matisse

Geraniums,
1915

Materials/Techniques: The painting is executed on a plain weave canvas (thread count: 22 threads per cm.). The stretcher is original and consists of five members with mitered mortise-and-tenon joins. The painting has never been restretched. The canvas is preprimed in an off-white color. In some areas (e.g., the plate, around the outlines of the geranium, and in the background flower design) it is left uncovered. The paint layer varies in thickness from areas that barely cover the ground to a fairly thick buildup around the geranium blooms. The design appears to have been sketched in with strokes of thinly applied black paint. This can be seen more clearly under infrared illumination, which also shows a change of outline in the flower beneath the plate.

Condition: The painting is in very good condition. It has never been lined, and the inpainting is limited to the ocher-colored table, where a frame caused a slight ridge in the paint before it was completely dry. A customs stamp on the reverse of the canvas has produced a round impression on the front and slight cracking (in the upper right corner). Fine drying cracks in the blue background and wider ones in the ocher foreground reveal the off-white ground beneath. In 1959 the painting was surface cleaned and revarnished.

29.

Matisse

Still Life with Apples,
1916

Materials/Techniques: The painting is executed on a thin mahogany panel that is approximately 0.5 cm. thick. The left and right edges have been beveled to a thickness of about 0.2 cm. A thin white ground is visible where the still wet paint was pushed up by the frame. Pentimenti in the design, as well as the colors, are revealed by the wide drying cracks in the background and by viewing the painting in raking light. The gray background appears to have been painted over a somewhat sporadic, thin layer of black, which is over a thicker layer of reddish brown, while the blue table appears to have been painted over a dark, grayish blue color. This latter color is visible in the drying cracks in the gray background above the blue table. It extends about 3.5 cm. on the left, tapering to about 1.5 cm. on the right, indicating that the preliminary table was at a slightly different angle. Slight changes in the outlines of the plate, apples, and glass are visible in raking light. The paint layer is fairly smooth, apart from a few scattered lumps (in the ground) and some slight rounded impasto in the plate, glass, and apple on the right. Under infrared illumination additional brushstrokes outlining the contours of the apples are visible.

Condition: The painting is covered with a thick layer of natural resin varnish. This was partially removed in 1985. There are no records of prior treatment. Thin strips of wood have been nailed into the top and bottom edges of the panel.

30–33.

Matisse

Mlle. Roudenko (Dancer of the Ballets Russes),

1939

34.

Matisse

Nude Leaning on Her Left Elbow,

ca. 1935–1939

35.

Bonnard

Interior with Still Life of Fruit,

1923

36.

Dufy

Race Track at Deauville, the Start,

1929

Materials/Techniques: The drawings were executed on warm white wove paper with the use of a pointed, double-nibbed pen and India ink. To vary textural effects in the compositions, as with the plant below the figure in cat. 34, Matisse exploited the broken, faint line obtainable when the pen is permitted to run almost dry. The same technique was also used to enliven the line describing the left eyelid of the figure in cat. 30. Matisse's choice of a smooth, heavily sized paper to work on was well suited to his use of pen and ink in these drawings.

Condition: Cats. 30 and 33 were mounted onto sheets of paper similar to the primary drawing supports. When they came to the Fogg, however, the secondary support of cat. 33 carried the drawing of the reclining nude woman leaning on her left elbow. In 1977 an enzyme treatment was used to separate the secondary supports from the drawings. Cat. 31 exhibited foxing-type adhesive, which was reduced during a wet treatment. All drawings have thumbtack holes in the corners or edges. The top, left, and bottom edges of cats. 30–32 have been cut.

Materials/Techniques: The canvas is of a fine plain weave (thread count: 22 by 24 threads per cm.). A cream-colored ground reaches the cut edges (the tacking margins have been removed) on all sides except for the right. This side is also the only one with marked scalloping. It appears as if a preliminary sketch was made with thin washes of color and that the edges were then taped and the painting completed. An underdrawing in thin purple magenta paint is also visible throughout the painting and even more apparent under infrared illumination. There are numerous nail holes on the front of the painting around the edges. These were made after the thinly applied undersketch had been executed and may be the result of the artist's having tacked the painting onto a drawing board. Under ultraviolet illumination, areas with white fluoresce a pale lime green, indicating the use of the pigment zinc white.

Condition: There are no conservation records prior to 1985. The painting has been glue lined and the edges cut and taped. The present taping corresponds almost exactly to the above-mentioned taping (presumably by the artist). The paint layer is in good condition, with only minor retouching (visible under ultraviolet illumination) around the edges.

Materials/Techniques: The support consists of a medium, plain weave canvas (thread count: 14 by 10 threads per cm.). The stretcher, which appears to be original, has mortise-and-tenon joins and five members. The ground is an off-white color and covers the tacking margins on all sides except the top. The paint layer is generally even, apart from some areas of impasto that include the trees, riders, and the spectator with green parasol. In the right fore- and middle ground the paint has been applied in thin washes, revealing the ground beneath. Infrared illumination reveals a few changes in the composition. Most notable is a figure, which was painted out, above and slightly to the left of the signature. The painting is unvarnished.

Condition: The painting has never been lined. Its tacking margins have been glued to the stretcher, and the tack holes appear to have been reused. The paint layer is in fairly good condition but is slightly uneven (due possibly to the sensitivity of some of the colors to mild solvents and water). The surface is spattered with an insoluble, clear substance, especially in the upper right corner. There is feather cracking, especially in the sky, which has partially been caused by stresses related to the stretcher. The painting was surface cleaned in 1972.

Bibliography

Primary Sources

AAA	Archives of American Art. Smithsonian Institution, Washington, D.C.
CA	Cone Archives. Baltimore Museum of Art, Baltimore, Md.
FMA	Fogg Art Museum Archives. Harvard University, Cambridge, Mass. (Contains the Wertheim Scrapbook and extensive correspondence and information relating to the Wertheim Collection)
HL	Houghton Library. Harvard University, Cambridge, Mass. (Manuscripts Division)
HTC	Harvard Theatre Collection. Cambridge, Mass. (George Pierce Baker Correspondence)
HUA	Harvard University Archives. Cambridge, Mass. (Especially the Harvard College Class Reports)
SL	Schlesinger Library. Harvard University, Cambridge, Mass. (Freda Kirchwey Papers)
WFP	Wertheim Family Papers (Several locations)

Secondary Sources

Adlow, 1946A	Adlow, D. "*Mme. Henri de Waroquier; A Portrait by Charles Despiau.*" *Christian Science Monitor* (12 July 1946).
Adlow, 1946B	"*Nature Morte à la Commode*; A Painting by Paul Cézanne." *Christian Science Monitor* (16 July 1946).
Alazard, 1939	Alazard, J. "L'Art de Charles Despiau." *Gazette des Beaux-Arts*, XXI (Feb. 1939).
Alexandre, 1930	Alexandre, A. *Paul Gauguin.* Paris, 1930.
Alexandre, 1933	————. "La Collection E.L." *La Renaissance*, XVI (Oct.–Nov. 1933).
Amsterdam, 1905	*Vincent van Gogh.* Amsterdam: Stedelijk Museum, 1905.
Amsterdam, 1930	*Vincent van Gogh en zijn Tijdgenooten.* Amsterdam: Stedelijk Museum, 1930.
Amsterdam, 1939	*Parisje Schilders.* Amsterdam: Stedelijk Museum, 1939.
Art News, 1937	Front cover, *Art News*, XXXV (3 April 1937).
Art News, 1943	"Advertising Supplement." *Art News*, XLII (1–14 Dec. 1943).
Art News, 1946	"20 Van Horne Paintings Bring $221,500." *Art News*, XLIV (Feb. 1946).
Arts and Decoration, 1937	"Outstanding Modern Painters in Decoration." *Arts and Decoration*, XLV (Jan. 1937).

Auckland, 1985 — *Claude Monet: painter of light.* Auckland, N.Z.: Auckland City Art Gallery, 1985.

Augusta, 1972A — *The Maurice Wertheim Collection.* Augusta: Maine State Museum, 1972.

Augusta, 1972B — "Maurice Wertheim Art Collection to be Featured Exhibit." *Musings About the Maine State Museum,* III (1972).

Baden-Baden, 1978 — *Maillol.* Baden-Baden: Kunsthalle Baden-Baden, 1978.

Barnes and de Mazia, 1935 — Barnes, A. C., and V. de Mazia. *The Art of Renoir.* New York, 1935.

Barr, 1946 — Barr, A. H., Jr. *Picasso: Fifty Years of His Art.* New York, 1946.

Barr, 1951 — ————. *Matisse: His Art and His Public.* New York: Museum of Modern Art, 1951.

Baudelaire, 1863 — Baudelaire, C. "The Painter of Modern Life" (1863). In *The Painter of Modern Life and Other Essays,* J. Mayne, ed. London, 1964.

Bazire, 1884 — Bazire, E. *Manet.* Paris, 1884.

Beaulieu, 1969 — Beaulieu, M. "Les sculptures de Degas. Essai de chronologie." *La Revue du Louvre,* XIX (1969).

Berger, 1949 — Berger, K. *Französische Meisterzeichnungen von 19. Jahrhundert.* Basel, 1949.

Berlin, 1910 — *Les Manet de la Collection Pellerin.* Berlin: Paul Cassirer Gallery, 1910.

Berlin, 1914 — *Vincent van Gogh.* Berlin: Paul Cassirer Gallery, 1914.

Berlin, 1918 — *Cézanne Ausstellung.* Berlin: Paul Cassirer Gallery, 1918.

Berlin, 1925 — *Impressionisten.* Berlin: Paul Cassirer Gallery, 1925.

Berlin, 1927 — *Renoir.* Berlin: Galerie Flechtheim, 1927.

Berlin, 1969 — *Kleine Museumreise durch Amerika.* Berlin, 1969.

Bernard, 1926 — Bernard, E. *Souvenirs sur Paul Cézanne.* Paris, 1926.

Berne, 1984 — *Der Junge Picasso: Frühwerk und Blaue Periode.* Berne: Kunstmuseum Berne, 1984.

Berr de Turique, 1930 — Berr de Turique, M. *Raoul Dufy.* Paris, 1930.

Besson, 1929 — Besson, G. *Renoir.* Paris, 1929.

Besson, 1949 — ————. *Claude Monet.* Paris, [1949].

Blunt and Pool, 1962 — Blunt, A., and P. Pool. *Picasso: The Formative Years—A Study of His Sources.* New York, 1962.

Boeck and Sabartès, 1955 — Boeck, W., and J. Sabartès. *Picasso.* Stuttgart, 1955.

Boggs, 1978 — Boggs, J. S. "Variations on the Nude." *Apollo,* CVII (May 1978).

Boston, 1905 — *Claude Monet, Master Impressionist.* Boston: Copley Society, 1905.

Boston, 1913 — *Impressionist Paintings.* Boston: Saint Botolph Club, 1913.

Boston, 1935 — *Independent Painters of Nineteenth Century Paris.* Boston: Museum of Fine Arts, 1935.

Boston, 1939 — *Art in New England.* Boston: Museum of Fine Arts, 1939.

Bouret, 1961 — Bouret, J. *Henri Rousseau.* Neuchâtel, 1961.

Bouvier, 1945 — Bouvier, M. *Aristide Maillol.* Lausanne, 1945.

Brame and Reff, 1984 — Brame, P., and T. Reff. *Degas et son oeuvre: A Supplement.* New York and London, 1984.

Brode, 1978 — Brode, N., ed. *Seurat in Perspective.* Englewood Cliffs, N.J., 1978.

Brook, 1923 — Brook, A. "Henri de Toulouse-Lautrec." *The Arts* (Sept. 1923).

Brooklyn, 1938 — *The Complete Graphic Work and a Selection of Paintings by Paul Gauguin.* Brooklyn: Brooklyn Museum, 1938.

Browse, 1949 — Browse, L. *Degas Dancers*. New York [1949].

Brussels, 1935 — *L'Impressionisme*. Brussels: Palais des Beaux-Arts, 1935.

Buenos Aires, 1939 — *La Pintura francesca de David a nuestros días*. Buenos Aires: Museo Nacional de Bellas Artes, 1939.

Buffalo, 1945 — *Aristide Maillol*. Buffalo: Albright–Knox Art Gallery, 1945.

Burger, 1913 — Burger, F. *Cézanne und Hodler*. 2 vols. Munich, 1913.

Cahiers d'Art, 1931 — "Matisse." *Cahiers d'Art*, VI (no. 5–6, 1931).

Cambridge, 1911 — *Loan Exhibition of Paintings and Pastels by H. G. E. Degas*. Cambridge, Mass.: Fogg Art Museum, 1911.

Cambridge, 1919 — *French Art from the Ninth to the Twentieth Century*. Cambridge, Mass.: Fogg Art Museum, 1919.

Cambridge, 1936 — *Paul Gauguin*. Cambridge, Mass.: Fogg Art Museum, 1936.

Cambridge, 1946 — *French Painting Since 1870: Lent by Maurice Wertheim, Class of 1906*. Cambridge, Mass.: Fogg Art Museum, 1946.

Cambridge, 1968 — *Degas Monotypes: Essay, Catalogue & Checklist*. Cambridge, Mass.: Fogg Art Museum, 1968.

Cambridge, 1981 — *Master Drawings by Picasso*. Cambridge, Mass.: Fogg Art Museum, 1981.

Camo, 1950 — Camo, P. *Maillol, mon ami*. Lausanne, 1950.

Canaday, 1959 — Canaday, J. *Mainstreams of Modern Art*. New York, 1959.

Caproni and Sugana, 1969 — Caproni, G., and G. M. Sugana. *L'opera completa di Toulouse-Lautrec*. Milan, 1969.

Carrà, 1982 — Carrà, M. *Tout l'oeuvre peint de Matisse, 1904–1928*. Paris, 1982.

Certigny, 1961 — Certigny, H. *La Vérité sur le Douanier Rousseau*. Paris, 1961.

Chicago, 1979 — *Toulouse-Lautrec: Paintings*. Chicago: Art Institute of Chicago, 1979.

Chicago, 1984 — *Degas in the Art Institute of Chicago*. Chicago: Art Institute of Chicago, 1984.

Cirici-Pellicer, 1950 — Cirici-Pellicer, A. *Picasso avant Picasso*. Geneva, 1950.

Cladel, 1937 — Cladel, J. *Aristide Maillol: sa vie, son oeuvre et ses idées*. Paris, 1937.

Clark, 1977 — Clark, T. J. "The Bar at the Folies-Bergère." In *The Wolf and the Lamb: Popular Culture in France*. Saratoga, Calif., 1977.

Clark, 1984 — ————. *The Painting of Modern Life: Paris in the Art of Manet and His Followers*. New York, 1984.

Cleveland, 1936 — *Twentieth Anniversary Exhibition*. Cleveland: Cleveland Museum of Art, 1936.

Coe, 1954 — Coe, R. T. "Camille Pissarro in Paris: A Study of His Later Development." *Gazette des Beaux-Arts*, XLIII (Feb. 1954).

Cohn and Siegfried, 1980 — Cohn, M. B., and S. L. Siegfried. *Works by J.-A.-D. Ingres in the Collection of the Fogg Art Museum*. Cambridge, Mass., 1980.

Cologne, 1912 — *Exposition Internationale*. Cologne, 1912.

Cologne, 1982 — *Kubismus*. Cologne: Josef Haubrich Kunsthalle, 1982.

Constable, 1964 — Constable, W. G. *Art Collecting in the United States of America*. London, 1964.

Coolidge, 1951 — Coolidge, J. "The Wertheim Collection." *Harvard Alumni Bulletin* (7 July 1951).

Coolidge, 1975 — ————. "Maurice and Cecile Wertheim." *Fogg Art Museum Newsletter* (March 1975).

Coquiot, 1913 Coquiot, G. *Henri de Toulouse-Lautrec*. Paris, 1913.

Coquiot, 1925 ————. *Renoir*. Paris, 1925.

Courthion, 1926 Courthion, P. "L'Art français dans les collections privées en Suisse." *L'Amour de l'Art*, VII (Feb. 1926).

Courthion, 1968 ————. *Georges Seurat*. New York [1968].

Daix and Boudaille (cited as D&B) Daix, P., G. Boudaille, and J. Rosselet. *Picasso: The Blue and Rose Periods, A Catalogue Raisonné of the Paintings, 1900–1906*. Greenwich, Conn., 1966.

Dallas, 1974 *The Degas Bronzes*. Dallas: Dallas Museum of Fine Arts, 1974.

Dauberville, 1973 Dauberville, J. and H. *Bonnard, catalogue raisonné de l'oeuvre peint*. 4 vols. Paris, 1973.

Daulte (cited as D) Daulte, F. *Auguste Renoir, catalogue raisonné de l'oeuvre peint, 1860–1890*. 1 vol. to date. Lausanne, 1971.

Daulte, 1964 ————. "Renoir, son oeuvre regardé sous l'angle d'un album de famille." *Connaissance des Arts*, 154 (Nov. 1964).

De Goncourt, 1874 De Goncourt, J. and E. *Pages from the Goncourt Journal*, Robert Baldick, ed. Oxford, 1962.

De Hauke (cited as DH) De Hauke, C. M. *Seurat et son oeuvre*. 2 vols. Paris, 1961.

Deknatel, 1955 Deknatel, F. B. "*Madame Paul.*" *Fogg Art Museum Annual Report*. Cambridge, Mass., 1954–1955.

Deknatel, 1976 ————. "A Lost Portrait of Max Jacob by Picasso." *Fogg Art Museum Annual Report: 1972–1974*. Cambridge, Mass., 1976.

De Laprade, 1951 De Laprade, J. *Georges Seurat*. Paris [1951].

Denis, 1907 Denis, M. "Cézanne." In *Cézanne in Perspective*, J. Wechsler, ed. Englewood Cliffs, N.J., 1975.

Denis, 1925 ————. *Maillol*. Paris, 1925.

De Régnier, 1923 De Régnier, H. *Renoir, peintre du nu*. Paris, 1923.

Derrida, 1978 Derrida, J. "Restitutions de la verité en peinture." *Macula*, 3/4 (1978).

Deshairs, 1930 Deshairs, L. *C. Despiau*. Paris, 1930.

Detroit, 1927 *Loan Exhibition of Old and Modern Masters*. Detroit: Detroit Institute of Arts, 1927.

Deudon, 1920 "La curiosité, la collection Deudon." *Bulletin de la Vie Artistique* (1 May 1920).

Documents, 1930 *Documents*. Paris (no. 3, 1930).

Dorival, 1951 Dorival, B. "Sources of the Art of Gauguin from Java, Egypt and Ancient Greece." *Burlington Magazine*, XCIII (April 1951).

Dorra and Rewald (cited as DR) Dorra, H., and J. Rewald. *Seurat: L'oeuvre peint, biographie et catalogue critique*. Paris, 1959.

D'Ors, 1930 D'Ors, E. *Pablo Picasso*. Paris, 1930.

Dortu, 1952 Dortu, M. G. *Toulouse-Lautrec*. Paris, 1952.

Dortu, 1971 ————. *Toulouse-Lautrec et son oeuvre*. 6 vols. New York, 1971.

Dreyfus, 1926–1927 Dreyfus, A. "Ein Besuch bei Aristide Maillol." *Kunst und Kunstler*, XXV (1926–1927).

Dubray, 1930 Dubray, J.-P. *Constantin Guys*. Paris, 1930.

Dunlop, 1979 Dunlop, I. *Degas*. New York, 1979.

DuQuesne-van Gogh, 1911 DuQuesne-van Gogh, E. H. *Persönnliche Erinnerungen an Vincent van Gogh*. Munich, 1911.

Duret, 1902 Duret, T. *Histoire d'Edouard Manet et de son oeuvre*. Paris, 1902.

Edinburgh, 1979 *Degas, 1879*. Edinburgh: National Gallery of Scotland, 1979.

Elder, 1935 Elder, M. *L'Atelier de Renoir*. 2 vols. Paris [1935].

Erpel, 1964 Erpel, F. *Van Gogh Self-Portraits*. Oxford, 1964.

Escholier, 1937 Escholier, R. *Henri Matisse*. Paris, 1937.

Estrada, 1936 Estrada, G. *Genio y figura de Picasso*. Mexico, 1936.

Eudel, 1885 Eudel, P. *L'Hôtel Drouot et la curiosité en 1883–1884*. Paris, 1885.

Fabre, 1981 Palau i Fabre, J. *Picasso, The Early Years, 1881–1907*. New York, 1981.

Failing, 1979 Failing, P. "The Degas Bronzes Degas Never Knew." *Art News*, 78 (April 1979).

Faille (cited as F) Faille, J.-B. de la. *The Works of Vincent van Gogh: His Paintings and Drawings*. New York, 1970 (rev. ed., first published in 1928).

Fénéon, 1886 Fénéon, F. "The Impressionists in 1886" (1886). In *Impressionism and Post-Impressionism*. L. Nochlin, ed. Englewood Cliffs, N.J., 1966.

Fezzi, 1972 Fezzi, E. *L'opera completa di Renoir nel periodo impressionista, 1869–1883*. Milan, 1972.

Field, 1961 Field, R. "Plagiare ou créateur?" In *Gauguin*, R. Huyghe et al. Paris, 1961.

Fierens, 1933 Fierens, P. *Sculpture d'aujourd'hui*. Paris, 1933.

Finkelstein, 1970 Finkelstein, S. *Der Junge Picasso*. Dresden, 1970.

Fitzgerald, 1905 Fitzgerald, D. "Claude Monet—Master of Impressionism." *Brush and Pencil*, XV (March 1905).

Flint, 1931 Flint, R. "The Private Collection of Josef Stransky." *Art News Supplement*, XXIX (16 May 1931).

Florisoone, 1938 Florisoone, M. *Renoir*. Paris, 1938.

Fox, 1953 Fox, M. *Pierre-Auguste Renoir*. New York, 1953.

Frankfurter, 1937 Frankfurter, A. M. "Masterpieces of French Art." *Art News*, XXXVI (9 Oct. 1937).

Frankfurter, 1941 ———. "Now the Great French 19th Century in the National Gallery." *Art News*, XL (15–31 December 1941).

Frankfurter, 1946 ———. "Today's Collectors: Modern Milestones." *Art News*, XLV (June 1946).

Freisinger, 1985 [Freisinger, G.] "Second Impressions." *Harvard Magazine*, 87 (May–June 1985).

Frère, 1956 Frère, H. *Conversations de Maillol*. Geneva, 1956.

Frost, 1943 F[rost], R. "They Painted Paris." *Art News*, XLII (15–31 Dec. 1943).

Gauguin, 1919 Gauguin, P[aul]. *Lettres à Daniel de Monfreid*. Paris, 1919.

Gauguin, 1937 Gauguin, P[ola]. *My Father, Paul Gauguin*. New York, 1937.

Gauzi, 1954 Gauzi, F. *Lautrec et son Temps*. Paris, 1954.

Geffroy, 1920A Geffroy, G. "Claude Monet." *L'Art et les Artistes* (Nov. 1920).

Geffroy, 1920B ———. "Renoir, Peintre de la Femme." *L'Art et les Artistes* (April 1920).

Geffroy, 1922 ———. *Claude Monet, sa vie, son temps, son oeuvre*. Paris, 1922.

George, 1929 George, W. *La grande peinture contemporaine à la collection Paul Guillaume*. Paris [1929].

George, 1964 ———. *Aristide Maillol et l'âme de la sculpture*. Neuchâtel, 1964.

Gimpel, 1963 Gimpel, R. *Journal d'un collectionneur*. Paris, 1963.

Glasgow, 1927 *A Century of French Painting*. Glasgow: Lefèvre Galleries, 1927.

Goldwater, 1940 Goldwater, R. "Artists Painted by Themselves." *Art News*, XXXVIII (30 March 1940).

Goode, 1939 Goode, G. *Book of Ballets Classic and Modern*. New York, 1939.

Gordon and Forge, 1983 Gordon, R., and A. Forge. *Monet*. New York, 1983.

Grappe, 1909 Grappe, G. *Claude Monet*. Paris [1909].

Gribbon, 1982 Gribbon, D. A. *Manet: The Development of His Art Between 1868 and 1876*. Ph.D. Thesis (unpubl.). Harvard University, 1982.

Hall, 1945 Hall, C. *Constantin Guys*. London, 1945.

Hamilton, 1954 Hamilton, G. H. *Manet and His Critics*. New Haven, 1954.

Hammacher, 1982 Hammacher, A. M., and R. *Van Gogh: A Documentary Biography*. New York, 1982.

Hanson, 1977 Hanson, A. C. *Manet and the Modern Tradition*. New Haven, 1977.

Harrison et al., 1983 Harrison, C., et al. *Modern Art & Modernism: Manet to Pollock*. 13 vols. Milton Keynes, 1983.

Hartford, 1934 *Pablo Picasso*. Hartford, Conn.: Wadsworth Atheneum, 1934.

Heidegger, 1964 Heidegger, M. "The Origin of the Work of Art." In *Philosophies of Art and Beauty*, A. Hofstadter and R. Kuhns, eds. New York, 1964.

Herbert, 1962 Herbert, R. L. *Seurat's Drawings*. New York, 1962.

Herbert, 1979 —————. "Method and Meaning in Monet." *Art in America*, 67 (Sept. 1979).

Hildebrandt, 1913 Hildebrandt, H. "Die Fruhbilder Picassos." *Kunst und Kunstler*, XI (1913).

Hofmann, 1973 Hofmann, W. *Nana; Mythos und Wirklichkeit*. Cologne, 1973.

Homer, 1964 Homer, W. I. *Seurat and the Science of Painting*. Cambridge, Mass., 1964.

Hoschedé, 1960 Hoschedé, J.-P. *Claude Monet, ce mal connu*. 2 vols. Geneva, 1960.

Hourdain and Adhémar, 1952 Hourdain, F., and J. Adhémar. *Toulouse-Lautrec*. Paris, 1952.

House, 1986 House, J. *Monet: Nature into Art*. New Haven, Conn., 1986.

Houston, 1962 *The Maurice Wertheim Collection: Manet to Picasso*. Houston: Houston Museum of Fine Arts, 1962.

Houston, 1976 *Gustave Caillebotte: A Retrospective Exhibition*. Houston: Houston Museum of Fine Arts, 1976.

Huisman and Dortu, 1964 Huisman, P., and M. G. Dortu. *Lautrec par Lautrec*. Paris, 1964.

Hulsker, 1980 Hulsker, J. *The Complete van Gogh: Paintings, Drawings, Sketches*. New York, 1980.

Hunter, 1958 Hunter, S. *Modern French Painting*. New York, 1958.

Huyghe, 1959 Huyghe, R. *Gauguin*. New York, 1959.

Isaacson, 1978 Isaacson, J. *Observation and Reflection: Claude Monet*. Oxford, 1978.

Jacob, 1927 Jacob, M. "Souvenirs sur Picasso." *Cahiers d'Art*, VI (1927).

Jamot and Wildenstein, 1932 Jamot, P., and G. Wildenstein. *Manet*. 2 vols. Paris, 1932.

Jedlicka, 1929 Jedlicka, G. *Henri de Toulouse-Lautrec*. Berlin, 1929.

Jewell, 1944 Jewell, E. A. *French Impressionists and Their Contemporaries in American Collections*. New York, 1944.

Jirat-Wasiutynski et al., 1984 Jirat-Wasiutynski, V., H. T. Newton, E. Farrell, and R. Newman. *Vincent van Gogh's "Self-Portrait Dedicated to Paul Gauguin": An Historical and Technical Study*. Cambridge, Mass., 1984.

J. L., 1896 J. L. "Exposition d'Oeuvres de Manet chez Durand-Ruel." *La Chronique des Arts et de la Curiosité* (12 Dec. 1896).

Joyant, 1926 Joyant, M. *Henri de Toulouse-Lautrec, 1864–1901.* 2 vols. Paris, 1926.

Kinne, 1954 Kinne, W. P. *George Pierce Baker and the American Theatre.* Cambridge, Mass., 1954.

Laffaille, 1972–1976 Laffaille, M. *Raoul Dufy, catalogue raisonné de l'oeuvre peint.* 4 vols. Geneva, 1972–1976.

Lafond, 1918–1919 Lafond, P. *Degas.* 2 vols. Paris, 1918–1919.

Lassaigne, 1939 Lassaigne, J. *Toulouse-Lautrec.* London, 1939.

Lassaigne, 1953 ————. *Lautrec.* Geneva, 1953.

Leja, 1985 Leja, M. "'Le Vieux Marcheur' and 'Les Deux Risques': Picasso, Prostitution, Venereal Disease and Maternity, 1899–1907." *Art History* (March 1985).

Lemoisne (cited as L) Lemoisne, P.-A. *Degas et son oeuvre.* 4 vols. Paris, 1946–1949.

Leonard, 1970 Leonard, S. E. *Henri Rousseau and Max Weber.* New York, 1970.

Leroy, 1879 Leroy, L. "Fine Arts." *Charivari* (17 April 1879).

Levine, 1975 Levine, S. Z. "Monet's *Gare Saint-Lazare.*" *Fogg Art Museum Newsletter* (June 1975).

Levine, 1976 ————. *Monet and His Critics.* New York, 1976.

Leymarie, 1951 Leymarie, J. *Van Gogh.* Paris, 1951.

Leymarie, 1971 ————. *Picasso: metamorphose et unité.* Geneva, 1971.

Life, 1949 "The van Gogh Mystery Case." *Life* (19 Dec. 1949).

Linnenkamp, 1957 Linnenkamp, R. *Aristide Maillol, Erster Kritischer Katalog zur Grossplastik.* Hamburg, 1957.

London, 1920 *Memorial Exhibition of the Works of Camille Pissarro.* London: Leicester Galleries, 1920.

London, 1924 *Important Pictures by 19th Century French Masters.* London: Leicester Galleries, 1924.

London, 1932 *Exhibition of French Art, 1200–1900.* London: Royal Academy of Arts, 1932.

London, 1936 *Modern French Paintings from Ingres to Matisse.* London: Wildenstein, 1936.

London, 1976 *The Complete Sculptures of Degas.* London: Lefèvre Gallery, 1976.

London, 1980–1981 *Pissarro.* London: Hayward Gallery, 1980–1981.

London, 1985 *Renoir.* London: Hayward Gallery, 1985.

Lynes, 1973 Lynes, R. *Good Old Modern.* New York, 1973.

Mack, 1938 Mack, G. *Toulouse-Lautrec.* New York, 1938.

Manson, 1920 Manson, J. B. "Camille Pissarro." *The Studio*, 79 (15 May 1920).

Martinie, 1929 Martinie, A. H. "Charles Despiau." *Amour de l'Art*, X (Nov. 1929).

Mathey, 1959 Mathey, F. *Les Impressionistes et leur temps.* Paris, 1959.

Matisse, 1973 Matisse, H. *Matisse on Art.* Jack D. Flam, ed. New York, 1973.

McBride, 1937 McBride, H. "The Renoirs in America." *Art News Supplement*, XXXV (1 May 1937).

McCully, 1981 McCully, M. *A Picasso Anthology: Documents, Criticism, Reminiscences.* London, 1981.

McMullen, 1984 McMullen, R. *Degas: His Life, Times and Work.* Boston, 1984.

Meier-Graefe, 1918 Meier-Graefe, J. *Cézanne und sein Kreis.* Munich, 1918.

Meier-Graefe, 1929 — ———. *Renoir*. Leipzig, 1929.

Merli, 1942 — Merli, J. *Picasso: El artista y la obra de nuestra tiempo*. Buenos Aires, 1942.

Millard, 1976 — Millard, C. W. *The Sculptures of Edgar Degas*. Princeton, 1976.

Minervino, 1972 — Minervino, F. *L'Opera completa di Seurat*. Milan, 1972.

Mongan, 1958 — Mongan, A. "The Fogg Art Museum's Collection of Drawings." *Harvard Library Bulletin*, XII (Spring 1958).

Montreal, 1933 — *The Sir William Van Horne Collection*. Montreal: Art Association of Montreal, 1933.

Moreau-Nélaton, 1926 — Moreau-Nélaton, E. *Manet raconté par lui-même*. Paris, 1926.

Naugatuck, 1938 — *The Harris Whittemore Collection*. Naugatuck, Conn.: Tuttle House, 1938.

New York, 1913 — *International Exhibition of Modern Art*. New York: Armory of the 69th Infantry, 1913.

New York, 1914 — *Paintings by Renoir*. New York: Durand-Ruel, 1914.

New York, 1917 — *Paintings by Renoir*. New York: Durand-Ruel, 1917.

New York, 1921 — *Loan Exhibition of Impressionist and Post-Impressionist Paintings*. New York: Metropolitan Museum of Art, 1921.

New York, 1924 — *Paintings by Renoir*. New York: Durand-Ruel, 1924.

New York, 1926 — *Memorial Exhibition of Representative Works Selected from the John Quinn Collection*. New York: Art Center, 1926.

New York, 1929 — *First Loan Exhibition: Cézanne, Gauguin, Seurat, van Gogh*. New York: Museum of Modern Art, 1929.

New York, 1931 — *Renoir and His Tradition*. New York: Museum of Fine Arts, 1931.

New York, 1936 — *Sale of the Collection of Jacob Wertheim*. New York: American Art Association and Anderson Galleries (10 Jan. 1936).

New York, 1936A — *Picasso: "Blue" and "Rose" Periods, 1901–1906*. New York: Jacques Seligmann, 1936.

New York, 1936B — *Twenty Paintings by Henri Matisse*. New York: Valentine Gallery, 1936.

New York, 1936C — *Retrospective Loan Exhibition of Works by Paul Gauguin*. New York: Wildenstein, 1936.

New York, 1937 — *Toulouse-Lautrec*. New York: Knoedler, 1937.

New York, 1938 — *Great Portraits from Impressionism to Modernism*. New York: Wildenstein, 1938.

New York, 1939 — *Picasso: Forty Years of His Art*. New York: Museum of Modern Art, 1939.

New York, 1940A — *Raoul Dufy*. New York: Carroll Carstairs Gallery, 1940.

New York, 1940B — *Self-Portraits from the Baroque to Impressionism*. New York: Schaeffer Galleries, 1940.

New York, 1941A — *Renoir: Centennial Loan Exhibition for the Benefit of the Free French Relief Committee*. New York: Duveen Galleries, 1941.

New York, 1941B — "Preface." *French Painting from David to Toulouse-Lautrec*. New York: Metropolitan Museum of Art, 1941.

New York, 1942A — *A Selection of 19th Century Paintings*. New York: Galeries Bignou, 1942.

New York, 1942B — *Loan Exhibition of Paintings by Cézanne*. New York: Paul Rosenberg, 1942.

New York, 1943A — *Henri Matisse: Retrospective Exhibition of Paintings, 1898–1939*. New York: Pierre Matisse, 1943.

New York, 1943B — *The Art and Life of Vincent van Gogh*. New York: Wildenstein, 1943.

New York, 1943C — *Fashion in Head Dress*. New York: Wildenstein, 1943.

New York, 1943–1944	"Foreword." *Paris*. New York: Coordinating Council of French Relief Societies, 1943–1944.
New York, 1944A	*Notable Modern Painting and Sculptures*. New York: Parke-Bernet (11 May 1944).
New York, 1944B	*Paris by Pissarro*. New York: Carroll Carstairs Galleries, 1944.
New York, 1945A	*Camille Pissarro: His Place in Art*. New York: Wildenstein, 1945.
New York, 1945B	*Monet*. New York: Wildenstein, 1945.
New York, 1946A	*Twenty Important Modern Paintings from the Collection of the Late Sir William Van Horne*. New York: Parke-Bernet (24 Jan. 1946).
New York, 1946B	*A Loan Exhibition of Paul Gauguin*. New York: Wildenstein, 1946.
New York, 1947A	*Picasso before 1907*. New York: Knoedler, 1947.
New York, 1947B	*A Loan Exhibition of Cézanne*. New York: Wildenstein, 1947.
New York, 1948A	*Pierre Bonnard*. New York: Museum of Modern Art, 1948.
New York, 1948B	*Delacroix and Renoir*. New York: Paul Rosenberg, 1948.
New York, 1948C	*Six Masters of Post-Impressionism*. New York: Wildenstein, 1948.
New York, 1949	*Vincent van Gogh*. New York: Metropolitan Museum of Art, 1949.
New York, 1950	*A Collectors' Exhibition: Impressionist and Post-Impressionist Masterpieces from the Collections of Members of the Advisory Committee of the Institute of Fine Arts*. New York: Knoedler, 1950.
New York, 1975	*Aristide Maillol: 1861–1944*. New York: Solomon R. Guggenheim Museum, 1975.
New York, 1977	*Paris–New York. A Continuing Romance*. New York: Wildenstein, 1977.
New York, 1980	*Pablo Picasso: A Retrospective*. New York: Museum of Modern Art, 1980.
New York, 1983	*Manet, 1832–1883*. New York: Metropolitan Museum of Art, 1983.
New York, 1984	*Van Gogh in Arles*. New York: Metropolitan Museum of Art, 1984.
New York, 1985	*Henri Rousseau*. New York: Museum of Modern Art, 1985.
New Yorker, 1948	"Refuge." *New Yorker*, XXIV (14 August 1948).
New York Herald Tribune, 1946	"Renoir Painting Sold, Proceeds to Aid France." *New York Herald Tribune* (21 November 1946).
Orienti, 1970	Orienti, S. *L'opera completa di Cézanne*. Milan, 1970.
Pach, 1912	Pach, W. "Pierre-Auguste Renoir." *Scribner's* (May 1912).
Pach, 1950	————. *Pierre-Auguste Renoir*. New York, 1950.
Paris, 1876	*2e Exposition de peinture*. Paris: Durand-Ruel Gallery, 1876.
Paris, 1877	*3e Exposition de peinture*. Paris: 6 rue le Peletier, 1877.
Paris, 1879	*4e Exposition faite par un groupe d'artistes indépendants*. Paris: 28 av. de l'opera, 1879.
Paris, 1880	*Oeuvres Nouvelles d'Edouard Manet*. Paris: Galerie de la Vie Moderne, 1880.
Paris, 1884	*Exposition posthume Manet*. Paris: Ecole des Beaux-Arts, 1884.
Paris, 1889	*Monet–Rodin*. Paris: Georges Petit Gallery, 1889.
Paris, 1901	*Exposition de Tableaux de F. Iturrino et de P. R. Picasso*. Paris: Vollard, 1901.
Paris, 1904	*Exposition de l'oeuvre de Camille Pissarro*. Paris: Durand-Ruel, 1904.
Paris, 1908	*Georges Seurat*. Paris: Bernheim-Jeune, 1908.
Paris, 1914	*Rétrospective C. Pissarro*. Paris: Manzi et Joyant, 1914.
Paris, 1918–1919	*Ventes Atelier Degas*. 4 vols. Paris: Galerie Georges Petit, 1918–1919.

Paris, 1921	*Collection de Madame Veuve C. Pissarro*. Paris: Galeries Nunès et Fiquet, 1921.
Paris, 1925A	*Cinquante ans de peinture française*. Paris: Musée des Arts décoratifs, 1925.
Paris, 1925B	*Vincent van Gogh, Exposition retrospective de son oeuvre*. Paris: Marcel Bernheim Gallery, 1925.
Paris, 1927	*Vincent van Gogh, L'époque française*. Paris: Bernheim-Jeune, 1927.
Paris, 1928	*Exposition de Portraits et Figures des Femmes, Ingres à Picasso*. Paris: Galerie de la Renaissance, 1928.
Paris, 1929	*Collection particulière Paul Guillaume*. Paris: Bernheim-Jeune, 1929.
Paris, 1930	*Centenaire de la naissance de Camille Pissarro*. Paris: Orangerie, 1930.
Paris, 1931	*Henri Matisse*. Paris: Georges Petit, 1931.
Paris, 1933A	*Renoir*. Paris: Orangerie, 1933.
Paris, 1933B	*Seurat et ses amis*. Paris: Galerie Beaux-Arts, 1933.
Paris, 1935	*Hommage à Paul Guillaume*. Paris: Petit Palais, 1935.
Paris, 1937A	*Chefs-d'oeuvre de l'art français*. Paris: Petit Palais, 1937.
Paris, 1937B	*Vincent van Gogh, sa vie et son oeuvre*. Paris: Nouveaux Musées, 1937.
Paris, 1946	*Les chefs-d'oeuvre des collections privées françaises retrouvés en Allemagne par la Commission de récupération et les Services alliés*. Paris: Orangerie, 1946.
Paris, 1974	*Charles Despiau: Sculptures et Dessins*. Paris: Musée Rodin, 1974.
Paris, 1980	*Hommage à Claude Monet*. Paris: Grand Palais, 1980.
Paris and London, 1939	*Exposition Cézanne*. Paris and London: Paul Rosenberg, 1939.
Payro, 1942	Payro, J. E. *Aristide Maillol*. Buenos Aires, 1942.
Perruchot, 1958	Perruchot, H. *La vie de Toulouse-Lautrec*. Paris, 1958.
Philadelphia, 1933	*Manet and Renoir*. Philadelphia: Philadelphia Museum of Art, 1933.
Philadelphia, 1948	*Henri Matisse: Retrospective Exhibition of Paintings, Drawings and Sculpture*. Philadelphia: Philadelphia Museum of Art, 1948.
Pickvance, 1963	Pickvance, R. "Degas's Dancers: 1872–6." *Burlington Magazine*, CV (June 1963).
Pissarro, 1972	Pissarro, C. *Letters to His Son Lucien*. John Rewald, ed. 3rd ed. Mamaroneck, N.Y., 1972.
Pissarro and Venturi (cited as PV)	Pissarro, L. R., and L. Venturi. *Pissarro, son art, son oeuvre*. 2 vols. Paris, 1939.
Pollock and Orton, 1978	Pollock, G., and F. Orton. *Vincent van Gogh: Artist of His Time*. New York, 1978.
Preston, 1951	Preston, S. "A Princely Bequest." *New York Times* (29 July 1951).
Proust, 1913	Proust, A. *Edouard Manet, Souvenirs*. Paris, 1913.
Québec, 1949	*La Peinture Française Depuis 1870: Collection Maurice Wertheim*. Québec: Musée de la Province de Québec, 1949.
Quinn, 1926	*The John Quinn Collection of Paintings, Water Colors, Drawings & Sculpture*. Huntington, N.Y., 1926.
Raleigh, 1960	*The Maurice Wertheim Collection: Modern French Art, Monet to Picasso*. Raleigh, N.C.: North Carolina Museum of Art, 1960.
Raynal, 1921	Raynal, M. *Picasso*. Munich, 1921.
Reff, 1976	Reff, T. *The Notebooks of Edgar Degas*. 2 vols. Oxford, 1976.
Reff, 1978	————. "Degas and the Dance." *Edgar Degas*. New York: Acquavella Galleries, 1978.

Reid, 1968 — Reid, B. L. *The Man from New York, John Quinn and His Friends.* New York, 1968.

Reiff, 1968 — Reiff, R. F. *Renoir.* New York, 1968.

Reitlinger, 1961–1970 — Reitlinger, G. *The Economics of Taste: The Rise and Fall of Picture Prices, 1760–1960.* 3 vols. London, 1961–1970.

René-Jean, 1923 — René-Jean. "L'Art français dans une collection suisse." *La Renaissance* (August 1923)

Renoir, 1962 — Renoir, J. *Renoir, My Father.* London, 1962.

Rewald, 1938 — Rewald, J. *Gauguin.* London, 1938.

Rewald, 1939 — ———. *Maillol.* London, 1939.

Rewald, 1944A — ———. *Degas; Works in Sculpture.* New York, 1944.

Rewald, 1944B — ———. "Degas Dancers and Horses." *Art News* (15–31 Oct. 1944).

Rewald, 1946A — ———. "The Realism of Degas." *Magazine of Art,* XXXIX (January 1946).

Rewald, 1946B — ———. *Renoir: Drawings.* New York, 1946.

Rewald, 1948 — ———. *Georges Seurat.* Paris, 1948.

Rewald, 1953 — ———. "Fakes." *Art News,* LII (March 1953).

Rewald, 1957 — ———. *Degas Sculptures.* Zurich, 1957.

Rewald, 1973 — ———. *The History of Impressionism.* 4th ed. New York, 1973.

Rewald, 1978 — ———. *Post-Impressionism: From van Gogh to Gauguin.* 3rd ed. New York, 1978.

Rewald, 1985 — ———. *Studies in Impressionism,* Irene Gordon and Frances Weitzenhoffer, eds. New York, 1985.

Reynolds, 1949 — Reynolds, G. *Nineteenth Century Drawings: 1850–1900.* London, 1949.

Rich, 1935 — Rich, D. C. *Seurat and the Evolution of "La Grande Jatte."* Chicago, 1935.

Rich, 1951 — ———. *Degas.* New York, 1951.

Rindge, 1930 — Rindge, A. "Charles Despiau." *Parnassus* II (March 1930).

Rivière, 1877A — Rivière, G. "L'exposition des Impressionistes." In *Impressionism in Perspective.* B. E. White, ed. Englewood Cliffs, N.J., 1978.

Rivière, 1877B — ———. "Les intransigents et les impressionistes." *L'Artiste* (Nov. 1877).

Rivière, 1921 — ———. *Renoir et ses Amis.* Paris, 1921.

Robaut, 1885 — Robaut, A. *L'Oeuvre complet de Eugène Delacroix.* Paris, 1885.

Robson, 1930 — Robson, E. I. *A Guide to French Fêtes.* London, 1930.

Roger-Marx, 1937 — Roger-Marx, C. *Renoir.* Paris, 1937.

Roh, 1962 — Roh, F. *"Entartete" Kunst: Kunstbarbarei im Dritten Reich.* Hannover, 1962.

Roskill, 1970 — Roskill, M. *Van Gogh, Gauguin and the Impressionist Circle.* Greenwich, Conn.: 1970.

Rotterdam, 1933–1934 — *De Delacroix à Cézanne et van Gogh.* Rotterdam: Museum Boymans–Van Beuninger, 1933–1934.

Rouart and Wildenstein (cited as RW) — Rouart, D., and D. Wildenstein. *Edouard Manet, catalogue raisonné.* 2 vols. Lausanne–Paris, 1975.

Russell, 1965 — Russell, J. *Seurat.* London, 1965.

Saarinen, 1958 — Saarinen, A. B. *The Proud Possessors.* New York, 1958.

Sachs, 1954 — Sachs, P. J. *Modern Prints and Drawings.* New York, 1954.

Sachs, 1958 — ———. *Tales of an Epoch.* 4 vols. 1958 (unpubl. manuscript).

San Francisco, 1940 *Old Master Drawings.* San Francisco: Golden Gate International Exposition, 1940.

San Francisco, 1942 *Vanity Fair: An Exhibition of Styles in Women's Headdress and Adornment Through the Ages.* San Francisco: California Palace of the Legion of Honor, 1942.

San Francisco, 1947 *19th Century French Drawings.* San Francisco: California Palace of the Legion of Honor, 1947.

San Francisco and Washington, 1986 *"The New Painting": Impressionism, 1874–1886.* San Francisco: The Fine Arts Museums of San Francisco, 1986.

Schapiro, 1952 Schapiro, M. *Paul Cézanne.* New York, 1952.

Schapiro, 1968 —————. "The Still Life as a Personal Object—A Note on Heidegger and van Gogh." In *The Reach of Mind: Essays in Memory of Kurt Goldstein,* M. L. Simmel, ed. New York, 1968.

Schaub-Koch, 1935 Schaub-Koch, E. *Psychoanalyse d'un peintre moderne.* Paris, 1935.

Scheiwiller, 1933 Scheiwiller, G. *Henri Matisse.* Milan, 1933.

Scherjon and de Gruyter, 1937 Scherjon, W., and J. de Gruyter. *Vincent van Gogh's Great Period.* Amsterdam, 1937.

Schneider, 1984 Schneider, P. *Matisse.* New York, 1984.

Schwartz, 1959 Schwartz, D. *Selected Poems (1938–1958).* New York, 1959.

Seitz, 1960 Seitz, W. *Monet.* New York, 1960.

Seligman, 1946A Seligman, G. *The Drawings of Georges Seurat.* New York, 1946.

Seligman, 1946B —————. *Merchants of Art* (1946). New York, 1961.

Seurat, 1881 Seurat, G. "Notes on Delacroix" (1881). In *Seurat in Perspective,* N. Brode, ed. Englewood Cliffs, N.J., 1978.

Shapiro, 1980 Shapiro, M. "Degas and the Siamese Twins of the Café-Concert: The Ambassadeurs and the Alcazar d'Eté." *Gazette des Beaux-Arts,* XCV (April 1980).

Shattuck, 1958 Shattuck, R. *The Banquet Years.* New York, 1958.

Sheppard, n.d. Sheppard, E. "Putting Pow in Designing." [Unsourced New York newspaper clipping, early 1960s.]

Shikes and Harper, 1980 Shikes, R. E., and P. Harper. *Pissarro: His Life and Work.* New York, 1980.

Slatkin, 1982 Slatkin, W. *Aristide Maillol in the 1890s.* Ann Arbor, 1982.

Stuckey, 1983 Stuckey, C. F. *Manet.* New York, 1983.

Stuttgart, 1924 *Vincent van Gogh.* Stuttgart: Wurtembergischer Kunstverein, Kunstgebäude, 1924.

Sugana, 1972 Sugana, G. M. *L'opera completa di Gauguin.* Milan, 1972.

Tabarant, 1931 Tabarant, A. *Manet: Histoire Catalographique.* Paris, 1931.

Tabarant, 1947 —————. *Manet et ses oeuvres.* Paris, 1947.

Tokyo, 1972 *The Great Masters of Modern Painting.* Tokyo: Japan Art Center, 1972.

Tokyo, 1979 *European Master Drawings of the Fogg Art Museum.* Tokyo: National Museum of Western Art, 1979.

Toledo, 1936 *Cézanne—Gauguin.* Toledo: Toledo Museum of Art, 1936.

Toronto, 1944 *Loan Exhibition of Great Paintings in Aid of Allied Merchant Seamen.* Toronto: Art Gallery of Toronto, 1944.

Toronto, 1981 *Vincent van Gogh and the Birth of Cloisonism.* Toronto: Art Gallery of Ontario, 1981.

Toulouse, 1932 *XXIIIe exposition des artistes méridionaux.* Toulouse: Palais des Arts, 1932

Toulouse-Lautrec, 1969 Toulouse-Lautrec, H. de. *Unpublished Correspondence*, L. Goldschmidt and H. Schimmel, eds. London, 1969.

Tuchman, 1981 Tuchman, B. W. *Practicing History*. New York, 1981.

Tucker, 1982 Tucker, P. H. *Monet at Argenteuil*. New Haven and London, 1982.

Uzanne, 1899 Uzanne, O. *Les Modes de Paris: Variations du goût et de l'esthétique de la femme, 1798–1899*. Paris, 1899.

Valéry, 1938 Valéry, P. *Degas, Danse, Dessin*. Paris, 1938.

Vallentin, 1957 Vallentin, A. *Pablo Picasso*. Paris, 1957.

Vallier (cited as DV) ———. *L'opera completa di Rousseau il Doganiere*. Milan, 1969.

Vallier, 1961 Vallier, D. *Henri Rousseau*. Paris, 1961.

Van Dorski, 1950 Van Dorski, L. *Gauguin*. Berne, 1950.

Van Gogh (cited as VG) Van Gogh, Vincent. *The Complete Letters*. 3 vols. Greenwich, Conn., 1958.

Varnedoe, 1984 Varnedoe, K. "Gauguin." In *"Primitivism" in 20th Century Art: Affinity of the Tribal and the Modern*. New York: Museum of Modern Art, 1984.

Venice, 1948 *Gli Impressionisti, Biennale di Venezia*. Venice: 1948.

Venturi (cited as V) Venturi, L. *Cézanne, son art, son oeuvre*. 2 vols. Paris, 1936.

Venturi, 1939 ———. *Les Archives de l'Impressionisme*. 2 vols. Paris, 1939.

Vienna, 1903 *Entwicklung des Impressionismus in Malerei und Plastik*. Vienna: Secession, 1903.

Vienna, 1910 *Manet–Monet*. Vienna: H. O. Miethke Gallery, 1910.

Vollard, 1914 Vollard, A. *Paul Cézanne*. Paris, 1914.

Vollard, 1918 ———. *Tableaux, pastels et dessins de Pierre-Auguste Renoir*. 2 vols. Paris, 1918.

Vollard, 1920 ———. *Auguste Renoir*. Paris, 1920.

Vollard, 1938 ———. *En écoutant Cézanne, Degas, Renoir*. Paris, 1938.

Waldmann, 1923 Waldmann, E. *Edouard Manet*. Berlin, 1923.

Walker, 1980 Walker, J. A. "Art History versus Philosophy: The Enigma of the 'Old Shoes.'" *Block*, no. 2 (1980).

Walsh, 1985 Walsh, P. L. "Henri Rousseau and the Twilight of History: A 'Primitive' in the Age of Progress." M. A. Research Project (unpubl.). Harvard University, 1985.

Walter, 1979 Walter, R. "Saint-Lazare l'impressioniste." *L'Oeil*, no. 292 (Nov. 1979).

Washington, 1978 *"The Noble Buyer": John Quinn, Patron of the Avant-Garde*. Washington, D.C.: Hirshhorn Museum, 1978.

Washington, 1982–1983 *Manet and Modern Paris*. Washington, D.C.: National Gallery of Art, 1982–1983.

Washington, 1984 *Degas: "The Dancers."* Washington, D.C.: National Gallery of Art, 1984.

Waterbury, 1941 *Loan Exhibition of Paintings from the Whittemore Collection*. Waterbury, Conn.: Mattatuck Historical Society, 1941.

Wechsler, 1975 Wechsler, J., ed. *Cézanne in Perspective*. Englewood Cliffs, N.J., 1975.

Welsh-Ovcharov, 1976 Welsh-Ovcharov, B. *Vincent van Gogh, His Paris Period, 1886–1888*. Utrecht, 1976.

Wertheim, 1948 Wertheim, M. *Salmon on the Dry Fly*. 1948 (privately published).

White, 1978 White, B. E., ed. *Impressionism in Perspective*. Englewood Cliffs, N.J., 1978.

White, 1984 ———. *Renoir: His Life, Art, and Letters*. New York, 1984.

Wildenstein (cited as W) Wildenstein, D. *Claude Monet: Biographie et catalogue raisonné.* 3 vols. Paris and Lausanne, 1974–1978.

Wildenstein, 1964 Wildenstein, G. *Gauguin.* Paris, 1964.

Wilenski, 1931 Wilenski, R. H. *French Painting.* Boston, 1931.

Wilenski, 1940 ————. *Modern French Painters.* New York, 1940.

Zervos (cited as Z) Zervos, C. *Pablo Picasso.* 33 vols. Paris, 1932–1978.

Zervos, 1927 ————. *Rousseau.* Paris, 1927.

Zervos, 1928 ————. "Un Dimanche à la Grande Jatte et la technique de Seurat." *Cahiers d'Art*, III (no. 9, 1928).

Zink, 1978 Zink, M. L. "Gauguin's *Poèmes barbares* and the Tahitian Chant of Creation." *Art Journal*, XXXVIII (Fall, 1978).

Zurich, 1919 *Französische Kunst des 19. und 20. Jahrhunderts.* Zurich: Kunsthaus, 1919.

Index of Artists and Works

(The numbers refer to catalogue entries)

Paintings and Drawings

Bonnard, Pierre — *Interior with Still Life of Fruit* (35)

Cézanne, Paul — *Still Life with Commode* (17)

Degas, Edgar — *The Rehearsal* (2)
Singer with a Glove (3)

Dufy, Raoul — *Race Track at Deauville, the Start* (36)

Gauguin, Paul — *Poèmes Barbares* (20)

Guys, Constantin — *A Lady of Fashion* (1)

Manet, Edouard — *Skating* (11)

Matisse, Henri — *Geraniums* (28)
Still Life with Apples (29)
Mlle. Roudenko (Dancer of the Ballets Russes) (30–33)
Nude Leaning on Her Left Elbow (34)

Monet, Claude — *Red Boats, Argenteuil* (4)
The Gare Saint-Lazare; Arrival of a Train (5)
Madame Paul (6)

Picasso, Pablo — *Young Girl Wearing a Large Hat* (22)
Woman with a Chignon (23)
Mother and Child (24)
The Blind Man (25)
Mother and Daughter (26)

Pissarro, Camille — *Mardi Gras on the Boulevards* (21)

Renoir, Pierre-Auguste — *Self-Portrait at Thirty-Five* (7)
Seated Bather (8)
Two Nude Women, Study for the "Large Bathers" (9)
Gabrielle in a Red Dress (10)

Rousseau, Henri — *The Banks of the Oise* (27)

Seurat, Georges — *Vase of Flowers* (12)
Seated Figures, Study for "A Sunday Afternoon on the Island of the Grande Jatte" (13)
Woman Seated by an Easel (14)

Toulouse-Lautrec, Henri de — *The Black Countess* (15)
The Hangover or *The Drinker* (16)

Van Gogh, Vincent — *Three Pairs of Shoes* (18)
Self-Portrait Dedicated to Paul Gauguin (19)

Sculptures

Degas, Edgar

Horse Trotting, the Feet Not Touching the Ground (37)
Grande Arabesque, Third Time (38)

Despiau, Charles

Portrait of Mme. Henri de Waroquier (42)
Seated Man, Statue for a Monument to Mayrisch (43)

Maillol, Aristide

Head of a Woman (39)
Bust of Renoir (40)
Ile de France (41)

Photograph Credits

All photographs of items in the Wertheim Collection by Michael Nedzweski and Rick Stafford.

Photographs of reference illustrations have been supplied, in the majority of cases, by the owners or custodians of the works. The following list applies to photographs for which a separate acknowledgment is due:

Bachrach Studios, New York: Introduction, fig. 1.
John D. Schiff, New York: cat. 3, fig. 1.
Jones-Gessling Studio, Huntington, New York: cat. 8, fig. 2.
Photo Archives Matisse: cats. 30–33, fig. 1.
Photographie Bulloz, Paris: cat. 9, fig. 2.
Réunion des Musées Nationaux, Paris: Introduction, fig. 5; cat. 5, fig. 1; cat. 10, fig. 1; cat. 19, fig. 1.

This book is set in Monotype Walbaum, a type-face cut by J. E. Walbaum (1768–1839), a founder at Goslar and Weimar, Germany, in the early years of the nineteenth century. Although Walbaum's matrices are still in the possession of the Berthold foundry, which acquired them in 1919, the Berthold version—used here—was not cut from the originals. The Walbaum face was first introduced into England by the Curwen Press in 1925.